D1095581

david goldblatt
PHOTOGRAPHS

david goldblatt
PHOTOGRAPHS

contrasto

Curator Martin Parr
Concept David Goldblatt
Project Manager: Roberto Koch
Digital imaging and reproduction - Tony Meintjes
Graphic Design - Francois and Debbie Smit, Quba Design and Motion
Set in Berkeley Old Style
Production supervision - Barbara Barattolo
Separations, printing and binding - EBS, Verona, Italy

Published in connection with the exhibiton: *David Goldblatt* presented in:
Arles, Rencontres internationales de la Photographie, 2006
Winterhur, Fotomuseum, 2007
Milano, Forma - Centro Intenazionale di Fotografia, 2007

First edition 2006
ISBN 10 digit 88-6965-015-4
ISBN 13 digit 978-88-6965-015-4

INTRODUCTION

David Goldblatt is an exemplary documentary photographer. He has been photographing his home country of South Africa for over 50 years and has documented the struggles and changes in this volatile and compelling country.

Goldblatt is still shooting now, with the same consistent enthusiasm that has been his hallmark throughout his long career.

What gives his work such resonance is the way in which he reveals the layers of politics and meaning in the everyday life of South Africa. He achieves this, not so much by photographing head on, but rather taking a sideways glance at these issues. By doing this he has continued to reinvent the language of representation of South Africa through photography. Goldblatt's work has evolved as much as the society he has documented, by putting his finger on the pulse of change and its vulnerability.

This entirely new selection of his work will show 8 very distinctive bodies of work.

Black and White

1 The Early Icons.

Selected from his early work and books "On the Mines" 1973 and "Some Afrikaners Photographed" 1975.This selection show how a younger Goldblatt develops a strong style and voice to document ordinary life during the earlier days of apartheid.

2 The Transported.

A selection from this work shot in the 1983/4 showing black workers commuting on buses, to and from their jobs. Millions of blacks were forced because of apartheid, to travel from their tribal homelands to cities for work. Goldblatt photographed the people from KwaNdebele, one such homeland, some on an 8 hour commute: 4 hours to be at work in Pretoria at 7am, and 4 hours to get home at night.

3 In Boksburg.

This important project is about the small town middle class white community of Boksburg, near Johannesburg, taken in 1979/80. The images are all the more resonant for their apparent coolness.

4 Particulars.

Shot in the mid 1970s these images show close up details of both blacks and whites, often relaxing in a parks. Goldblatt was keen to explore ideas about bodies, clothes and what these conveyed. The book of this work , published in 2004, won the Rencontre D'Arles book prize.

5 South Africa: The Structure of Things Then.

This substantial body of work was mainly taken in the 1980s, during the most oppressive days of apartheid. Goldblatt turned his camera away from people towards the structures that they built, Revealing again, much about people and society of South Africa.

In 1999 Goldblatt was invited to photograph in Australia and chose to photograph the effects of blue asbestos mining in Western Australia. Mining was an established interest for Goldblatt but when a friend of his died from a cancer caused by blue asbestos, he was determined to explore this further.

He decided that as the waste was blue he should shoot this in colour and so the latest chapter of Goldblatt's work started. Since then he has photographed in South Africa in colour and for this exhibition I have selected 3 bodies of work to exhibit.

This new colour work examines the post –apartheid era of the New South Africa. They often show how the blacks are empowering themselves through business and trading.

Goldblatt could never entertain the idea of shooting colour photography for his personal work before the end of apartheid, as he felt it would almost feel too decorative.

6 Painters.

In the suburbs of Johannesburg, Goldblatt has photographed small advertisements for black painters and handymen as part of the urban landscape.

He has contacted some of these painters on their mobile phones and taken their portraits. The images of these adverts and their authors are shown together.

7 Municipal Office Workers.

Part of the new system of government is a new municipal dispensation.

Goldblatt has photographed both individual and groups of black and white Municipal workers in their offices, or at their work location. These feature both rural and urban settings, and demonstrate the gradual emancipation of South African society.

8 Johannesburg Streets.

Goldblatt has photographed with a large format camera many urban street scenes in Johannesburg. These images feature commercial activity on the side of the road, through to urban landscapes of this sprawling city.

Although Goldblatt is known as a photographer, he has never had a major exhibition in France and many european countries. This book, together with the exhibition, will offer a unique opportunity, to explore in depth, how his work has developed throughout his long career. This will also be the first chance to see how his new colour work relates to his earlier black and white photography, and to understand the natural progression to be found in his work.

By isolating the most poignant of Goldblatt's work the viewer will witness why he has emerged as one of the major figures of post war documentary photography.

Martin Parr

THE SPIRIT OF DAVID GOLDBLATT

David Goldblatt's photography is a body of work I hold especially dear. Its field is South African people and the evidence of their lives. I think I can best suggest the spirit of his approach by saying I believe his explorations are motivated by a quest: What is the human and moral truth of this society? And this is an expression of his fascination with the whole human mystery. Therefore, though he has an impassioned concern with the moral issues he can never be reduced to the narrowness of mere protest. His awareness goes far and subtly beyond the notorious features of our society, into the textures and range of experience. He can see into the intimate and innocent centres of personal life without losing his vision of our history and its accusations. Photography is at least as much a a matter of creating images as of simply recording them, and unlike some, Goldblatt would not cite the 'factuality' of the pictures in order to indemnify against responsibility (whether for the images he makes, or to the reality they reflect and impinge on): the element of organisation in his photographs, though restrained, is frank, yet he does not manipulate the visible world into evidence for a case, but allows it to yield its own meaning.

I am not at all saying that he retreats into a realm of aesthetic considerations from which he surveys the arena of conflict with merely curious indifference. Responsiveness is one of his chief characteristics. At times there is a satirical intent in the way he points his camera, at times a rueful humour, or admiration., or anger, or dismay, and he is never indifferent to the suffering he records, never separated from the human identity of his subject, never without compassion.

This sympathetic participation is revealed as much through what Goldblatt

refrains from doing as through his positive choices. He never simplifies a moral statement, never sensationalises a situation. With rare exceptions he does not record crises, whether of action, violence or suffering. Sensitized to meaning, he prefers to render visible the quieter phases of existence, resorting at times even to a constructed stillness, a pose, in which something outside the moment may be distilled. The stillness eliminates the distraction of what is momentary (no, rather produces a tension with the moment, which can never be eliminated from living faces), and permits a transparent view of character. This only partly explains why so often, facing one of Goldblatt's portraits, in which not only is the person clothed but frequently, surrounded by possessions, one is awed by the feeling that an extraordinary kind of nakedness has been achieved.

He seems to be governed by the faith that the meaning of people's lives, their character or spirit, is made manifest in all their visible signs, the shape of their bodies, their features, their gestures, their clothes, their surroundings and possessions, their structures, the marks they leave on the earth around them. This is why he does not have to seek out what is exceptional. He is always aware that so much of what is amazing, mysterious, shocking, profoundly significant, inheres in the everyday.

Most of us are half-blinded by the sheer familiarity of the everyday, so there is a fragile fugitive quality in such images (time takes them imperceptibly from us at the very time that we take them for granted). By holding them in the photographic frame in the code of black-and-white, Goldblatt endows them with a powerful poignancy – we see what is familiar somehow for the first time - as well as making them available as information and bases for generalisations. And while his search is always for the wholeness of things, he can afford to give himself to minutiae, fragments, particulars, because the essence can be concentrated there. Similarly, while his concern is never with anything other than people, their individual or collective character, he frequently makes

pictures without a human subject – and how much he makes us apprehend about the lives concerned when he shows us a sitting-room or bedroom, a wall across a stretch of naked veld, a little old shop, or a dog outside a block of flats. Many of his interiors, whether peopled or not , make us feel that we have been admitted to the sanctum that is the source or focus of action or passion.

He has a particular fascination with the images of aspiration. The people in many of his pictures are surrounded by objects, marks, decorations that imply not only what they are but what they have chosen to be and what they wish to be. Sometimes this element of self-image or dream is crystallised in pictures of possessions alone – a house, a half-built boat on a suburban lot. Often there is a distance and a tension between present circumstances and the aspirations, an ironic incongruity, and this results in a special wry poignancy not always remote from humour. The response can be more painful when the aspiration is too limited, too mean or too stiflingly conventional.

The pursuit of character in its visible dimensions is not incidental to Goldblatt's South African consciousness but is the means by which he has chosen to express it, and this has a double appropriateness. It is appropriate that this moral concern, a concern about what happens to people in this anomalous society, should be expressed in his sensitivity to the way people have been moulded by their lives. And it is appropriate that a photographer who is philosophical should submit, and even subjugate, his ideas to the complex and subtle minutiae of what is visible.

Appropriate and valuable. In a sense our public vision of our world has been asleep and blind to the full range and variety of experience. We are emphatically aware of certain ideas about what it is to be South African and they hold our thoughts in a stark dry cage, while we exclude from the definition those perceptions that are ambiguous or neutral as far as the issues are concerned. Goldblatt's approach brings both aspects of our reality together, and because

of his double breadth, of scope and of response, his work goes some way toward supplying a tradition of full consciousness that has been lacking in this country.

He renders South African lives visible in the fullness of their complexity, thus implying their significance, not as mere socio-political counters but as 'spirits'. So while protesting against a shallow and fragmented culture, a brutal and brutalising system, disruptions and deprivation, a whole apparatus of lies, he is simultaneously always affirming the potentiality, the richness and value of human life, qualities he can only reveal through the very images that support his protest. The implication is that the issues of life here have a universal import, and that to participate here, to witness here, is not to be wasted or lost. It is a profoundly consoling affirmation in a time when expectations of a slide into cataclysm and the collapse of meaning are rife, the more persuasive and marvellous in that it comes very often from looking straight at the evils those fears are based on and seeing them in the living context of the present.

Lionel Abrahams
Johannesburg, January 1983

DAVID GOLDBLATT,
ONE BOOK AT A TIME

rory bester

1

When I first asked David Goldblatt about the photographic selections reproduced here, he responded with his own question: "Which of my books have you got?" Not which photographs had I seen on exhibition, or which essays had I read in magazines, but rather, which books? It is a telling question about the uniqueness of Goldblatt's oeuvre in the history of South African photography. While he started out in magazines in the 1950s and has of late increasingly become the focus of international exhibitions, Goldblatt's books are central to the evolution of his career. I cannot think of another South African photographer who has so consistently published his photographs in meticulously printed hardcover books, and whose books have become collector's items in their own right.

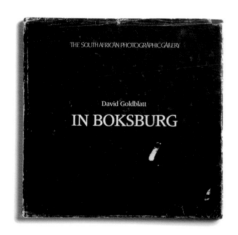

Goldblatt has produced a number of books: *On the Mines* (Cape Town: C. Struik, 1973), *Some Afrikaners Photographed* (Johannesburg: Murray Crawford, 1975), *In Boksburg* (Cape Town: The Gallery Press, 1982), *Lifetimes: Under Apartheid* (New York: Knopf and London: Jonathan Cape, 1986), *The Transported of KwaNdebele: A South African Odyssey* (New York: Aperture, in association with the Duke University Centre for Documentary Photography, 1989), *South Africa The Structure of Things Then* (Cape Town: Oxford University Press, 1998 and New York: Monacelli, 1998), *Particulars* (Johannesburg: Goodman Gallery Editions, 2003), and *Intersections* (Munich: Prestel, 2005).[1]

Goldblatt does not start photographing with a book in mind: "The books became possible as the essays progressed," he says, "but sometimes a book eventuated and sometimes it didn't".[2] There are a whole set of components that Goldblatt considers when producing his books: the selection and sequencing of photographs into a long essay; filling each page with single or multiple photographs, bordered within the page or bled to the edge; the extent of the wrapping of photographs by book titles, extracts from poetry and lyrics, acknowledgements, essays, and captions (and extensions thereof); when to bring the various iterations of text forward, and when to leave them quietly in the background; the choice of typeface, paper and the ever increasing number of inks just to print in black and white; the print run, limited or not by an edition, signed or unsigned; and all of this

1 The only book not included here is *Cape Dutch Homesteads* (Cape Town: C. Struik, 1981), a commissioned work photographed in collaboration with Margaret Courtney-Clarke.

2 Unless otherwise stated, all attributions to David Goldblatt are from two interviews with the photographer, conducted in his home on Sunday, 26th February 2006, and by telephone on Monday, 25th March 2006.

for a publisher who might or might not be interested in his book.[3] This essay is an exploration of the making of Goldblatt's books, and considers some of the questions and choices the photographer faced in preparing his first book for publication in 1973, and the subsequent experiences, refinements and changes that each book necessitated.

<div align="center">

2

</div>

The 56 photographs in *On the Mines* were taken between 1965 and 1971, and appeared in two separate photo-essays in *Optima* magazine prior to the publication of the book in 1973. Charles Eglington, the magazine's editor, accepted the first essay for publication based on an evolving body of photographs that Goldblatt had shown him. The resulting 16-page spread, entitled 'The Witwatersrand: A Time and Tailings', includes the same opening quote by Albert Camus and text by Nadine Gordimer that are reproduced in the book. However, only a few of the photographs reproduced in the magazine eventually ended up in the book. *Optima* also published 'The Sinkers', a 15-page spread on shaftsinking that is here accompanied by Errol Fyfe's text detailing the technicalities of mine shaftsinking. By including photographs taken in the periods before and after actual shaftsinking work, the thirteen photographs in the magazine offer more respite than the sheer claustrophobia of the exclusively underground selection for the 'Shaftsinking' section of *On the Mines*.

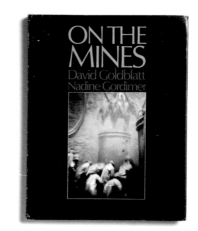

The book design of *On the Mines* was undertaken by Goldblatt himself. Aside from the few high contrast photographs that open the book, and the low light grain in the shaftsinking photographs (set on black backgrounds), the photographs in the book are mostly reproduced one to a page, bled to the edges or neatly set within the right page. Except for the short captions, the left page is on the whole clean. Rather than page numbers, the sequence is marshalled by the numbers of the photographs. Published by C. Struik, then a specialist Africana publisher, *On the Mines* is divided into three parts: 'The Witwatersrand: A Time and Tailings', 'Shaftsinking', and 'Mining Men'.

'The Witwatersrand' opens with a substantial and significant essay by Nadine Gordimer.[4] She traces how activity below ground, so much further down than the original scratchings for gold in 1886, impacted on the physical and human geography of 'The [Mine] Property' above ground, including its architecture, planning, social rituals and labour practices. Gordimer also traces the slow disappearance of this mining archive within a landscape of urban growth and sprawl. Goldblatt's photographs in this section of the book repeat the dying surfaces of mine architecture, interiors and machinery with an acute sensitivity to their graphic

3 Once he has a book in mind, Goldblatt tries to consider the book in as much detail as possible before approaching a publisher: "When I go to a publisher, I make sure I have a tight proposal. Then I know what I might be compromising when the publisher wants to change or omit something. If I just go in with a vague idea and a box of photographs, I am likely to end up with a book that is more the publisher's than mine".

4 In his 'Acknowledgements' in *On the Mines*, Goldblatt recognizes the influence that Gordimer's *Face to Face* (1949) – a collection of short stories that originally appeared in magazines such as *The New Yorker* and *Harper's* – had on sharpening his sense of a South African milieu: "... over the years, as I sought expression in photography, her writing came to be peculiarly relevant: challenging, affirming, always extending my understanding of what we both so often seemed to find significant". While the collaborative effort between Gordimer and Goldblatt is not immediately apparent in reading through the essay, Goldblatt is adamant about their shared experience: "We both grew up near mines. When I'd done a lot of the photography I showed it to her. When she indicated to me that she wanted to respond to the photographs with a piece of writing, we visited different mines together. So it really was done collaboratively".

detail. They are mostly too cropped to be called landscapes, and are quite ghostly in their desertion of people. The only close-up human focus in this section of the book is the headless upper body of a 'Boss Boy' in Photograph No. 12 (and repeated on the back dustcover of the book). In her essay, Gordimer so very perceptively describes "the busy arrangement of the paraphernalia of watches, badges, cline rules, pens and pencils worn by Boss Boys, caricature and apotheosis of white red tape".

Goldblatt's introduction to 'Shaftsinking' is an account of what he witnessed at President Steyn No. 4 Shaft in Welkom in 1969 and 1970, at depths up to 1,500 metres.[5] In a style less technical than Errol Fyfe's text that appeared in *Optima* magazine, Goldblatt describes in detail the unremitting noise of sinking a mine shaft, from treacherous blasts through to relentless drilling and clearing that often takes up more 'white' water than rock. In making repeated references to the condition of the light, Goldblatt's text also becomes a clear marker of the conditions under which he photographed. Not surprisingly it is these same conditions, so often cut by dust, moisture and sheer distance from the surface, which overwrites the movement of men and machinery in these photographs.

'Mining Men' is the third and final section of *On the Mines*. It is without an introduction, the first indication that they were a later addition to the original book concept: "I didn't think of originally including the portraits,"

says Goldblatt, "but realised that they would add considerably to the texture and weight of the whole essay". 'Mining Men' comprises a series of individual and group portraits. Master sinker, sinker's helper, greaser, spanner man, shift boss, lashing men: just some of the designations that might seem strange to anyone far from a mine, but undoubtedly clear and component markers of function to those within its mechanistic system. And to this glossary of rank, Goldblatt's subjects respond with individuating gestures that complicate their grade. It is their hands – apart and clasped, holding and unholding, in front and behind, that designate so much in these quiet portraits.

3

Even though *Some Afrikaners Photographed* (1975) was published two years after *On the Mines*, Goldblatt started photographing Afrikaners much earlier than miners, in 1961, and had completed work for the second book by 1968. That it took from 1968 to 1975 to get the photographs published in book form, and then eventually have it published by a friend rather than an established publisher, points to the difficulty of the material at the time of its publication. The photographs in *Some Afrikaners Photographed* are not definitive in their representation of a community and culture. In his introduction, Goldblatt writes: "For a while, I thought of photographing *the* Afrikaner People. It took time to understand that for me such a project would be grossly pretentious and probably impossible to achieve in any meaningful sense – in any case it is not what I wanted".

Unlike *On the Mines*' clear sections, *Some Afrikaners Photographed* moves seamlessly from one photograph to the next, the accumulation this time marked by page rather than photograph numbers. The photographs in the book

<hr />

5 Photograph No. 31 was taken at South Vaal in 1968.

gently swing between the impenetrable walls of a dominant culture and the defensive cracks whose barely visible holes speak volumes about the vulnerability that lies so close to the surface order of white supremacy. How can the determined distance of 'whiteness', in a group of farmers at a cattle auction in the Northern Cape be reconciled with the touching intimacy of a farmer's son and nursemaid in the Marico bushveld? It is this irreconcilability, without definitiveness, that marks off *Some Afrikaners Photographed* as one of South Africa's most powerful photographic statements of 'whiteness' and difference.

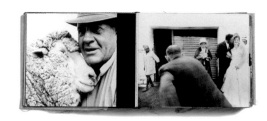

The first design concept for *Some Afrikaners Photographed* was conceived by Sam Haskins.[6] Goldblatt photographed Sam and Alida Haskins as potential subjects for the essay on Afrikaners, and the two photographers soon became friends. In 1968, Haskins, who had designed his own photography books to great international acclaim, offered to put together a dummy concept for *Some Afrikaners Photographed*. He cut up the rough prints and put them together into layouts not dissimilar to his own books: bold and imaginative organisations using high contrast printing, and butted up images that played off each other. "They were extremely powerful layouts," says Goldblatt, "and I was knocked out by the pages". Goldblatt then did a full mock up of the book based on Haskins' designs and travelled to London to meet Haskins' publisher, The Bodley Head. They were interested in *Some Afrikaners Photographed*, but required a co-publisher to make the book project feasible. Goldblatt went off to New York to find a co-publisher, but none was interested.

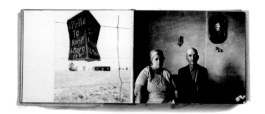

Back in South Africa, Goldblatt showed the book dummy to Barney Simon, a recently returned theatre director who was interested in the photographer's work. According to Goldblatt, Simon's response was to "white ant" him:

"He would undermine your belief system from below so that eventually you questioned the very foundations of your precepts and beliefs. And that's what he did to me. He questioned whether the meanings and relationships set up between my pictures by Sam's interlocking layouts were what I intended them to have. Very reluctantly I had to admit that the photographs were 'speaking' to each other in ways that I had never intended. So I made a completely new dummy at the opposite extreme of design: one picture to a spread, lots of white space and very carefully considered short captions. And that's how I published it."

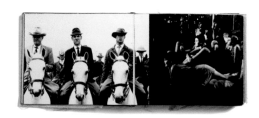

But importantly, Haskins' dummy gave Goldblatt an acute understanding of the design and composition of books of photographs: "It was an enormously important experience working through Sam's dummy and finally coming to what the book was".[7] *Some Afrikaners Photographed* was published by Murray Crawford, whom Goldblatt had met while taking a privately commissioned portrait of the businessman and his brother.

6 Haskins, a designer and photographer, works in advertising, and also produces his own books of art photography. He is famous for his groundbreaking and bestselling early books on nudes, including *Five Girls* (1962), *Cowboy Kate and Other Stories* (1964, and winner of the Prix Nadar) and *November Girl* (1966), as well as *African Image* (1967), a book of photographs on African decorative art and ritual.

7 As has already been mentioned in this essay, while *On the Mines* was published prior to *Some Afrikaners Photographed*, the latter book was designed first. Which is why Goldblatt's revelations about book design and layout were cemented with *Some Afrikaners Photographed*, why some of the first photographs in *On the Mines*, designed later, still reflect Haskins' style, and why, by the time one reaches the end of *On the Mines*, the layouts had changed to something more akin to the general style in *Some Afrikaners Photographed*.

According to Goldblatt, "Murray Crawford said to me, 'This book of yours is very important and it needs to be published. If I lose my money it doesn't matter. I just want to see it published'". The book was published as a limited edition of 1,000 copies, each signed by the photographer, but didn't make any money for the photographer or publisher.

4

In 1979 Milner Erlank, *Optima* magazine's editor, asked Goldblatt to produce a set of photographs to accompany an essay by Alan Paton on the relationship between Afrikaans- and English-speaking whites in South Africa. At the time, Goldblatt, who was doing commercial work in Boksburg, had also begun a personal project of photographing the new suburbs that were burgeoning around this town east of Johannesburg. Goldblatt suggested to *Optima* that he continue to photograph Boksburg as a microcosm of South Africa. But by the time Goldblatt was ready to present the photographs, the editorship of *Optima* had again changed hands and John Gaunt, its new editor, did not care for Goldblatt's view of white South Africa. Instead Alan Paton's essay was published with photographs by Struan Robertson.

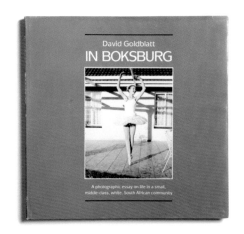

Someone who was passionate about Goldblatt's photographs of Boksburg was Paul Alberts, himself a documentary photographer and a friend of Goldblatt's.[8] It was partly Alberts' outrage at *Optima*'s refusal to publish the Boksburg photographs that convinced him to publish them himself. Alberts had started The Gallery Press in c.1980 in an attempt to overcome the dismal conditions for publishing books of documentary photographs in South Africa. Greatly influenced by the photographic projects of the Farm Security Administration (FSA), Alberts also intended for the prints used for the reproduction of each book to be donated by the photographer to an archive to be called the South African Photographic Gallery Series.[9]

Unlike what he calls his 'encounter' portraits – a knowing encounter between photographer and subject, made conscious in the image – which he produced in Soweto, Hillbrow and Johannesburg's northern suburbs in the early 1970s, Goldblatt intentionally photographed Boksburg without an overt photographic presence. He tried to minimise his presence in the pictures by nearly always using a 'normal' lens, avoiding dramatic printing techniques, and ensuring that the people he photographed were not obviously aware of him and his camera.

Goldblatt opens his introduction to *In Boksburg* as follows: "These photographs are about life in a small-town, middle-class, white community in South Africa." Ironically, the first photograph in the book, 'Saturday morning at the corner of Commissioner and Trichardts Streets', presents mainly black pedestrians with a presence that is nowhere else in the book. More than *Some Afrikaners Photographed*, this book is a rigorously constructed long photo-essay. Not as sparsely laid out as *Some Afrikaners Photographed*, images appear on every page in the book's almost square format. The photographs suggest something of the impact of architecture and urban planning on

8 Unless otherwise stated, all attributions to Paul Alberts are from an interview with the photographer, conducted by telephone on Saturday, 25 March February 2006.

9 In addition to *In Boksburg*, there were two further books published in the Series. The second was Albert's *The Borders of Apartheid* (1983), a portfolio of photographs on the Apartheid homeland of Bophuthatswana, and the third and last book in the Series was *South Africa: The Cordoned Heart* (1986, co-published with W.W. Norton and Company of New York), a book of photo-essays by twenty South African photographers for the Second Carnegie Inquiry into Poverty and Development in Southern Africa.

social psyches, a theme he would later explore at length in *South Africa The Structure of Things Then* (1998).

It is amongst this featureless sprawl eastwards from the city of Johannesburg that Goldblatt fixed on the extent to which Boksburg "is shaped by white dreams and white proprieties. … Blacks are not of this town. They serve it, trade with it, receive charity from it and are ruled, rewarded and punished by its precepts. Some, on occasion, are its privileged guests. But all who go there do so by permit or invitation, never by right".[10] Shot in 1979 and 1980, the photographs, almost without exception, offer a version of white visibility that is ritualised over black invisibility. The photographs' captions – a flag raising on Republic day, ballroom dancing, childhood ballet, a meeting of Voortrekker girls,[11] mowing the lawn, choir rehearsal, and a billboard advertising new suburban homes – could have come from a book Goldblatt had only briefly encountered: Bill Owens' *Suburbia* (1972), that photographic anthropology of the people, environments and rituals constituting an American suburbia clinging to the tarnished dreams of older decades. What the two books also share is a sense of absurdity that accumulates as one moves through the photographs. But where Owens tends towards a mocking humour, Goldblatt builds a relentless vision that records elevations and reductions of the racially marked body.

According to Alberts, his choice of Goldblatt as the first photographer to be published in the South African Photographic Gallery Series was itself controversial. Goldblatt was considered to be an 'intellectual' photographer, not an activist drawing battle lines with anti-apartheid documentary records, and therefore not worthy of the attention signalled by such a publication. But Alberts' likens *In Boksburg* to James Joyce's *Ulysses* – far ahead of its time. So ahead, perhaps, that the book hardly moved off the shelves and caused the near financial ruin of Alberts.

5

Lifetimes: Under Apartheid (1986) reunited Nadine Gordimer and Goldblatt into an anthological collaboration of photography and writing. The book came about after Frank Platt, a friend of Gordimer's, initially suggested publishing a new edition of *On the Mines*.[12] Gordimer and Goldblatt instead offered a new book, which Platt packaged and proposed to the eventual publishers. A little looser than most of Goldblatt's earlier books, *Lifetimes* consisted of 'clusters' of text with an adjacent 'cluster' of related photographs: Goldblatt and Gordimer looked through her texts, came to passages that could stand on their own, and then looked through his photographs for images that sat well with the texts.

The anthological character of the book is more in Gordimer than Goldblatt. Her extracts – never more than a page – were all from existing texts. Goldblatt's photographic contribution to *Lifetimes* repeats selections from *On the Mines*, *Some Afrikaners Photographed* and *In Boksburg*, as well as some of his photographs of Soweto and Transkei that had originally been published in *Optima* magazine in 1973 and 1975 respectively. However, there are two

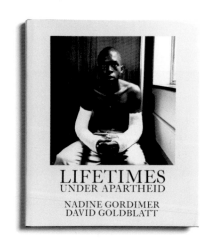

10 Goldblatt, 'In Boksburg' in David Goldblatt, *In Boksburg*, Cape Town: The Gallery Press, 1982, np.

11 The Voortrekkers was a nationalist youth organization that provided Afrikaans-speaking children with an alternative to the Girl Guides and Boy Scouts.

12 Goldblatt, interviews.

significant features to the photographic selections in *Lifetimes* that mark off this book in Goldblatt's oeuvre. The first is that, unlike Gordimer, much of Goldblatt's material was not strictly anthological, as it hadn't yet been congealed into the book form that was by now becoming his convention. *Lifetimes* shows for the first time work that would later be published in *The Transported of KwaNdebele: A South African Odyssey* (1989) and *Particulars* (2003).

The second feature of the book's photographic selection is that Goldblatt, more directly than before, introduces the physical violence that was so much a part of Apartheid and so much the focus of the work of activist photographers at the time. The last four photographs in *Lifetimes*, all taken in the year before the book's publication, signal something quite unlike Goldblatt's earlier work on the theatres of 'whiteness' and 'blackness'. The first is a photograph of the funeral of a trade union leader, taken from behind and within the thick of the procession. The second is of a combined police and army patrol in the township. And the third is of a child giving the ANC salute at the graves of assassinated community leaders. They are iconic photographs of anti-apartheid struggle, so familiar in collected volumes such as *South Africa: The Cordoned Heart* (1986) and *Beyond the Barricades: Popular Resistance in South Africa* (1989). 'Fifteen year old youth after release from detention. 1985' ends the short sequence. It is also the image on the dustcover, clearly locating the book's photographic context and words within a time of political ferment.

<div align="center">

<u>6</u>

</div>

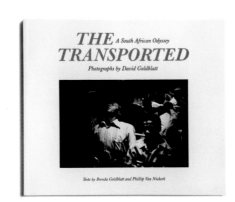

There are two features in *Lifetimes: Under Apartheid* that are carried over into Goldblatt's next book, *The Transported of KwaNdebele: A South African Odyssey* (1989, and henceforth *Transported*). The first is a focus on the brutal weight of living under Apartheid, and the second is the predominance of text, but for different reasons and with different effect than in *Lifetimes*.

For the white South Africans of *Some Afrikaners Photographed* and *In Boksburg*, home was close to work, and if it was not, various modes of transportation allowed fairly easy travel to and fro. Black South Africans, meanwhile, were often forced to face enormous distances between home and work. This barrier to travel played itself out at its most extreme in the daily journeys of black workers between their unchosen homes in the semi-independent homeland of KwaNdebele and their places of work in the white metropolitan city of Pretoria. The distances between the homelands and the commercial centres necessitated the establishment of expensive subsidized bus and train services between 'home' and work. Goldblatt's photographs, taken in 1983 and 1984 for the Second Carnegie Inquiry into Poverty and Development in Southern Africa, document the three-hour PUTCO (Public Utility Transport Company) bus journey between the Wolwekraal depot in KwaNdebele and the Marabastad terminus outside Pretoria. With the first bus leaving KwaNdebele just before 3am, one-way journeys could be as long as 160 kilometres and take over three

hours to complete.[13]

By the time Goldblatt began work on the project, at least 3.5 million people had been forcibly removed to fit the dreams of Apartheid's ideological mapmakers.[14] Goldblatt's photographs of the journeys between these two 'homes' – where black people were forced to live and where they might have liked to live – powerfully capture this experience of alienation. They show the interiors of buses crowded with sleepy passengers who sit, slouch, and stand, their listless, swaying bodies frozen by the camera. Some of the images reveal in their visual texture the effects of the buses' dim lighting and of the rough riding over rutted, dusty roads.

Some of the photographs which finally appeared in *Transported* had already been published twice in 1986, in Gordimer and Goldblatt's *Lifetimes* and Omar Badsha's edited volume, *South Africa: The Cordoned Heart*.[15] *Transported* has longer captions whose clockwatching reiterate the sheer banality of the journey. The book also has the most varied author list of any of Goldblatt's books. In addition to Goldblatt's introduction, Brenda Goldblatt, his daughter and a producer of television documentaries who had previously worked on KwaNdebele, provided the accounts of passengers travelling on the buses. Phillip van Niekerk, a print journalist, wrote an essay on the complicated story of the formation of the homeland. And Alex Harris' 'Afterword' contextualises Duke University's involvement in the book:

> "In September of 1985 … I travelled to South Africa under the auspices of the Duke Centre for Documentary Photography and Carnegie Corporation of New York. There we worked closely with twenty South African photographers to bring out *South Africa: The Cordoned Heart*, a book and exhibition about poverty in southern Africa. … It seemed clear that Duke University could build on the success of *The Cordoned Heart* by forming a partnership with individual South African photographers and writers to provide another vehicle for continued communication with their countrymen and women and with the rest of the world."[16]

Transported was published by Aperture, in association with the Centre for Documentary Studies at Duke University,[17] and introduced two small departures in Goldblatt's book template: it was soft-cover, and in a landscape format. This time it was the dramatic unfolding of history that conspired against successful sales: "*Transported* came out just before F.W. de Klerk's speech in 1990," says Goldblatt, referring to the State President's announcement in Parliament of the unbanning of the ANC and the imminent release of Nelson Mandela from prison, "which killed off an interest in Apartheid from the publishing trade. The book just never got off the ground".

13 For many people on the bus there was further travel by local transport from the Marabastad terminus to their workplace, making the total journey even longer.

14 Phillip Van Niekerk, 'The Bus Stop Republic' in David Goldblatt, *The Transported of KwaNdebele: A South African Odyssey*, New York: Aperture, in association with the Centre for Documentary Studies, Duke University, p.67.

15 Two of Goldblatt's photographs of the bus riders in KwaNdebele also illustrated a magazine essay on black urbanisation. See John Kane-Berman, 'The Irresistible Tide', *Leadership* 2(4), Summer 1983, pp.27-34.

16 See Alex Harris, 'Afterword' in David Goldblatt, *The Transported of KwaNdebele: A South African Odyssey*, New York: Aperture, in association with the Centre for Documentary Studies, Duke University, p.76.

17 The Centre for Documentary Studies at Duke University became interested in materially opposing apartheid in the mid-1980s, in addition to helping fund the short-lived Centre for Documentary Photography at the University of Cape Town, co-published three books of photography on South Africa: *South Africa: The Cordoned Heart* (1986), Goldblatt's *Transported* (1989) and *Beyond the Barricades: Popular Resistance in South Africa* (1989). The latter two books were co-published with the New York-based Aperture Foundation, and also included texts by Alex Harris from Duke University's Centre for Documentary Studies.

Nine years passed before Goldblatt published his next book, *South Africa The Structure of Things Then* (1998, and henceforth *Structures*).[18] While landscapes had appeared in Goldblatt's previous books, the photographer remained ambivalent about landscapes at this time: "It seemed self-indulgent to work seriously with landscape when there were so many more pressing issues to be examined. When I was photographing these structures, I was again faced with the possibility of photographing landscapes because the landscape itself is in many ways a structure that embodies values. The land has shaped us and we have shaped the land. But I largely refrained, because the landscapes seemed too remote from the immediate structures I was trying to grapple with".

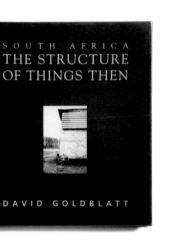

Based on the premise that South African structures reflect the values of the peoples who built them, Goldblatt's *Structures* is a photographic exploration of the various ways in which colonial and Apartheid values were expressed in the construction and destruction of structural landscapes. Goldblatt's 135 photographs, taken between 1964 and 1994 – although the overwhelming majority of the photographs were produced in the 1980s) – grapple with the impact of built environments upon the landscapes and peoples.[19] Structures, such as monuments, places of worship, shopping centres, suburban homes and graveyards, marked the landscape in ways that have not only come to reflect, but also contribute towards, a notion of separate development in South Africa. To this end, they are an archive of the history of white domination and black disempowerment. The book's images capture, with a meticulous and mindful vision that leaves nothing for sentimentalism, the various moments of banality, grandeur, starkness and brutality in the structures of the South African landscape.

These structures are primarily marked by a politics of race. More particularly, within the divisive language of apartheid, they are marked by being 'white' or 'non-white'. Important here is prevalence of white public structures. Goldblatt probes the effect of these disparities, capturing the extent of the social regimentation of the built environment. In his introduction to the book, Goldblatt acknowledges a preoccupation with places of worship. The many photographs of the defiant monumentality of Afrikaner Protestantism's places of worship stand in stark contrast to the humility of the fewer images of African places of worship.

Goldblatt's photographs capture apartheid's often-brutal, hierarchical ownership and control over space and its organisation. In terms of this organisation of space, the expansive, panoramic spaces of 'whiteness' – in images such as 'Bloubergstrand and Table Bay' – stand in stark contrast to the collective congestion of 'non-whiteness' in 'South-east wing, African men's hostel'. In weaving these kinds of images through the book, Goldblatt sets up

18 In its original concept, the book was titled *South Africa The Structure of Things Here*. Importantly, this simple change shifted emphasis from the spatial to the archival.

19 Photographs from *Structures* had previously been published in two photo-essays by Goldblatt in *Leadership* magazine, and also in *Camera Austria*.

tensions – in terms of a politics and history of segregation – that simply have not been engaged before in any of the many books on South African structures.

Like *Transported*, with its volume of authors and many long captions, *Structures* is a text heavy book. It includes Goldblatt's longest introduction to date, an essay by Neville Dubow and, for the first time, following on from the photographs, 79 pages of extended captions. It was important for Goldblatt to resolve the particular relationship between pictures and text in *Structures*: "Even though I was addressing South Africans, I felt the need to make clear what the weight of these structures meant. When you build something, you express values. I wanted to retain the centrality of this thought, and wrote the introduction and extended captions with that in mind". In their detail to the personal and shared histories of structures and the peoples who inhabit them, it is a mammoth addition by Goldblatt, meticulously extending the intellectual work that the photographs do in contemporary debate about South Africa.[20] Also like *Transported*, the book includes a glossary that leads the unfamiliar through the particular inflections that Apartheid has wrought on our language.

<div align="center">

8

</div>

Particulars (2003) is Goldblatt's second limited edition book, of which five hundred copies were printed. Of these, one hundred signed and numbered copies were made available in slipcases that also included a signed silver print by Goldblatt. As with *Some Afrikaners Photographed*, it was the publisher – here Goodman Gallery Editions – who recommended the limited edition. *Particulars*, with its greater page size than ever before, and five inks – black and four greys –saturating each page of black-and-white photographs, is a book of unmatched quality. It won the Rencontres d'Arles Book Prize in 2004.

Particulars consists of 27 black-and-white photographs. Each 16x16" portrait shows only the details of bodies (not unlike his truncated mode of drawing attention to reading bodily meaning in 'Boss Boy' from *On the Mines*). The captions lead us to the public parks around Johannesburg, but the photographs keep us on the details of the physical body, swayed by different degrees of grooming, dress and adornment. So particular are the details that they unequivocally suggest class, race, time and space. But not anthropologically, as has often been the case with the history of photographic observations of the body. Goldblatt's introduction not only outlines his "consciousness of bodily particulars", but also sets the tone for a sensual reading of bodily surface and form that came from observing and taking on something of his father's skill for reading and clothing the body. It is a simple anecdote that Goldblatt invokes in the introduction, but one that captures something of the observation and measurement of bodily particulars that in turn clearly places these photographs in another place.

The photographs in *Particulars* were mostly taken in 1975,[21] the year in which Goldblatt also published *Some Afrikaners Photographed*. It was a time of deceptive quiet, and just one year before student protests in Soweto and

20 The intellectual weight of *Structures* seems a natural fit with its publisher, Oxford University Press, whom Goldblatt approached after initially being unable to find a publisher for the book in the United States. The book was eventually also published by Monacelli in New York in 1998.

21 The three photographs not produced in this year were taken in 1982, 1983 and 2003 respectively.

other townships highlighted the frustration and anger of living under the weight of Apartheid. Peter Magubane's *Soweto*, published in 1978, is an iconic account of the violence acted out in this period of heightened political urgency. It was a time that increasingly required insistent photographic narratives, and one in which the quiet details of the photographs that now constitute *Particulars* would have seemed out of place. As Apartheid tightened itself into a knot and eventually choked to a suffocating halt, the photographs remained without publication. While some of the photographs had been published in *Lifetimes* in 1986, it was nearly thirty years later, at the beginning of a century in which local renditions of post-Apartheid South Africa have become more nuanced and detailed, that a book of photographs became possible. *Particulars* is the longest wait for any of Goldblatt's books.

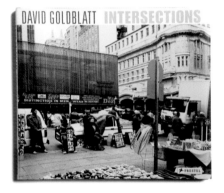

<div align="center">

9

</div>

Particulars is a departure, away from the thickness of history, and into the thinned out surfaces of self. *Intersections* (2005) is another departure: in a landscape format and containing a significant number of landscape photographs, it is in colour.[22] The end of Apartheid, a consequent desire to photograph more widely and in colour, and technical advances – new colour negative films and digital printing on rag papers – worked to make this departure possible.

The use of colour appears jarring at first – understandable for anyone pleasured on nearly thirty years and seven books in black and white – but one is soon drawn into the images in the recognition of the cutting light that is so much a feature of being outdoors in South Africa. It is not an easy light to feel on one's eyes, and one that has so often been ignored or over-mediated by other South African photographers. Goldblatt is one of the first photographers to play with the essence of this light and the way it colours our landscapes. Between negative and printing is 'darkroom' work that Goldblatt does entirely in front of a computer, crafting contrast and saturation with Tony Meintjes,[23] until it congeals with Goldblatt's own particular sense of local colour and light. The photographs in *Intersections* invoke a version of light that makes one want to screw up one's eyes, but always want to look again.

After the use of colour has stopped feeling so strange, the question of the landscape persists in the duplicating formats of the photographs and the book orientation. While not all of the photographs in *Intersections* are landscapes, they stand out in a book that also includes portraits and structures. There is something of the South African landscape in *Some Afrikaners Photographed*, and a little more in *Structures*. But it is only in *Intersections* that Goldblatt seems at ease about leaving people and structures to the side of, or entirely out of, the frame, and allowing the landscape to mediate itself. And while *Some Afrikaners Photographed* and *Structures* share an encompassing scope with *Intersections*, there is a stronger sense in this latest book of journeys rather than destinations, of being at an intersection of more or less significance, and looking around at nothing that dominates your view. It is only in *Intersections* that it becomes clear that Goldblatt has completely shaken the "self-indulgent"

22 While Goldblatt made extensive use of colour photography in his commercial work, he produced and exhibited colour photographs for the first time in 1999, when asked to exhibit at the Art Gallery of Western Australia.

23 Until recently Tony Meintjes was a leading advertising photographer in South Africa. He has since shifted his focus and now specialises in the many delicate facets of digital image reproduction.

tag from this category of image.

The sense of intersecting journeys rather than final destinations punctured by ends is reiterated in the order of the book. Unlike before, there is no introduction by Goldblatt, no characteristic statement of the motives that quietly worked to make a book.[24] The reader pages straight into the 80 photographs, taken between 1999 and 2005. *Intersections* has no overt sections, only blank pages that imply divisions and themes. These divisions mark neither geographies nor subjects. Instead they intersect and repeat themselves, doubling back with new insights: makeshift and temporary places of domesticity and work around Johannesburg; wide open vistas of nothingness, sectioned by rocks, roads and fences; rural habitats coloured by a lack of water; remnants of asbestos mining in the Northern Cape, its enduring toxicity largely silent in the landscape; signs of death, on rocks and wire fences, in the banal repetition of the Aids ribbon; overprotected and desecrated memorials to known and unknown 'heroes'; and 'Municipal People', their sparse offices often only distinguished by what's on the wall.

It might be because of his method of photographing for *Intersection* that Goldblatt acknowledges that this book is a work in progress: "It is not intended to be a tightly focused set of ideas, as with my other books. The book is much more diffused. But I've allowed this because I feel that this is a new South Africa – and in many ways it is 'new' – and I wanted to experience a wider variety of phenomena". But it might also be because *Intersections* signals a shift in the relationship between book and exhibition. Whereas all the previous books were conceived as books before they were unevenly exhibited, *Intersections* started out as an exhibition entitled *David Goldblatt: Intersections*, held at the museum kunst palast in Düsseldorf in 2005.[25] Originally planned as a catalogue for the exhibition, *Intersections* became an independent book published by Prestel in Munich.

10

The shift that *Intersections* marks in the sequential relationship between book and exhibition can be traced back to the publication of *Structures*, the first book to be accompanied by exhibitions that comprehensively dealt with the published content. Every book since then has been closely associated with a carefully produced exhibition. But while these exhibitions have been fairly faithful to the organisation of the associated books, there is something in the nature of the exhibition itself – something, I suspect, to do with randomly walking through space – that allows the photographs to take on critical meanings that are wider than the intellectual parameters of the book. The exhibition is able to pollinate meaning – proliferate it, germinate it anew, and grow it into something that replicates or evolves – in ways that are quite different to the book.

One of the consequences of this pollinating effect is the increasing number of books and exhibitions *about* rather than *by* Goldblatt. Aside from the present book, there are two other extant works about Goldblatt: *David Goldblatt 55*, a book published by Phaidon in 2001, and *David Goldblatt, fifty-one years*, a travelling exhibition

24 It is left to Michael Stevenson, Goldblatt's Cape Town gallerist, to most clearly articulate Goldblatt's concept: "Although Goldblatt's colour work covers many different subjects, he views it all as part of his *Intersections* series, a concept that allows him to weave in anything that seems apposite to his interest in post-apartheid South Africa: cross-currents of ideas, values, ethics, postures, people and things". See Michael Stevenson, 'Markers of Presence: David Goldblatt's Intersections with the South African Landscape' in David Goldblatt, *Intersections*, Munich: Prestel, 2005, p.100.

25 The exhibition was the initiative of Cologne-based gallerist Thomas Krings-Ernst, who approached museum Kunst palast to produce an exhibition. Curated by Christoph Danelzik-Brüggemann, the head of the graphic arts collection at the museum, the exhibition toured to Camera Austria in Graz, from December 2005 to February 2006.

and book-length catalogue curated and edited by Corinne Diserens and Okwui Enwezor, also in 2001.[26]

David Goldblatt 55 is a book of 55 photographs selected from the same books that have been featured in this essay. In addition to an introduction by Lesley Lawson, the book includes a set of commentaries that follow each of the captions. But rather than the sheer gravitas of the detail of the extended captions used in *Structures*, these commentaries serve the bigger intentions of Phaidon's 55 Series: to make a range of photographic practices accessible to new and emerging audiences. *David Goldblatt, fifty-one years* is at the opposite extreme of compaction. It is probably the most comprehensive account and analysis of Goldblatt to date. The touring exhibition, produced by the Museu d'Art Contemporani de Barcelona (MACBA), opened at the AXA Gallery in New York in August 2001. The exhibition and catalogue reveal Goldblatt's work in the chronological order of the taking of the photographs rather than in the order of their collation into publications. But these original books, in the ways in which their details are repeated in both the exhibition and 456-page catalogue, maintain enough of a presence to remind viewers and readers of the predominance of the book as Goldblatt's mode of constituting and circulating his photographic output. And in what has become a signature of the bound matter that accompanies Okwui Enwezor's exhibitions, the *David Goldblatt, fifty-one years* catalogue has an archival scope and attention to detail that makes it more stand-alone book than attendant catalogue. It brings a large part of Goldblatt's oeuvre into a new field of meaning, cross-pollinating their conceptual foci into a finely textured weave of the photographer's true intellectual weight.

11

While the sheer volume of exhibitions is a recent phenomenon that is recognising the fine art of his photographs, the book has for the most part remained Goldblatt's consistent mode of conceptual refinement and display. The book is a contained form whose economy of scale and scope for detail are quite different from the form of the exhibition. For Goldblatt, "the book as a medium has great charm and advantages. It offers the possibility of bringing together a coherent set of ideas, in the way that one puts photographs together, brings in text, and presents the whole as a well constructed piece of work".

But it's not any book that can compete with the scale and atmosphere of the exhibition. The quality of the reproduction in Goldblatt's books comes as close as any photographer to the quality of his prints. With *On the Mines* in 1973 he pioneered the use of duotone printing in books of black-and-white photographs produced in South Africa. The use of five different inks – black and four greys – in *Particulars* (2003), his most recent book of black-and-white photographs, has again placed Goldblatt at the forefront of photographic book production.

It is in part because of this attention to printing quality that Goldblatt's books have their schizophrenic associations with publishers and why, on the face of it, he was never associated with the 'alternative' press in South Africa. But a consideration of his demands on the production process make it quickly apparent that these small, independent presses were not able to finance the quality of printing that Goldblatt demanded in his books. Goldblatt's early books were financial disasters, which again might go some way to explaining the wide range of

26 It should be noted that while these examples are about Goldblatt, the photographer was intimately involved in their conceptualization and realization.

publishers who have been associated with his work.[27]

Each of Goldblatt's books offers a unique story about photographic production and publication in South Africa, and his collected works speak to the natural and artificial divides between Apartheid and post-Apartheid photography in South Africa. This is one of the significant insertions into readings of South African history, and Goldblatt himself makes this distinction in his own work:

> "During the years of Apartheid I became involved in trying to photograph coherently around a set of tightly focused ideas. That meant I produced books that were also quite tightly focused. … In post-Apartheid South Africa my sense of the things around me has not been directed by anger, fear and the wish to cut incisively into the system itself."

A number of Goldblatt's books have in varying degrees alluded to, referenced and engaged Johannesburg, but a book on the city hasn't yet eventuated from Goldblatt's hand. It is the South African city most marked by this shift between past and present, and one that is struggling most willingly with its future. From Soweto to Hillbrow to the northern suburbs, from the 1950s to now, Johannesburg sits in moments in Goldblatt's archive, waiting to be loosened into book form.

27 *On the Mines* and *Some Afrikaners Photographed* had to be remaindered at R3 and R2.50 respectively. *In Boksburg* and *The Transported of KwaNdebele* hardly sold. *South Africa The Structure of Things Then* and *Intersections*, both published by international companies, provided Goldblatt with a royalty (but one that bears little relation to the cost of making the photographs. The entire print-run of *Structures* sold out.

THE PHOTOGRAPHS

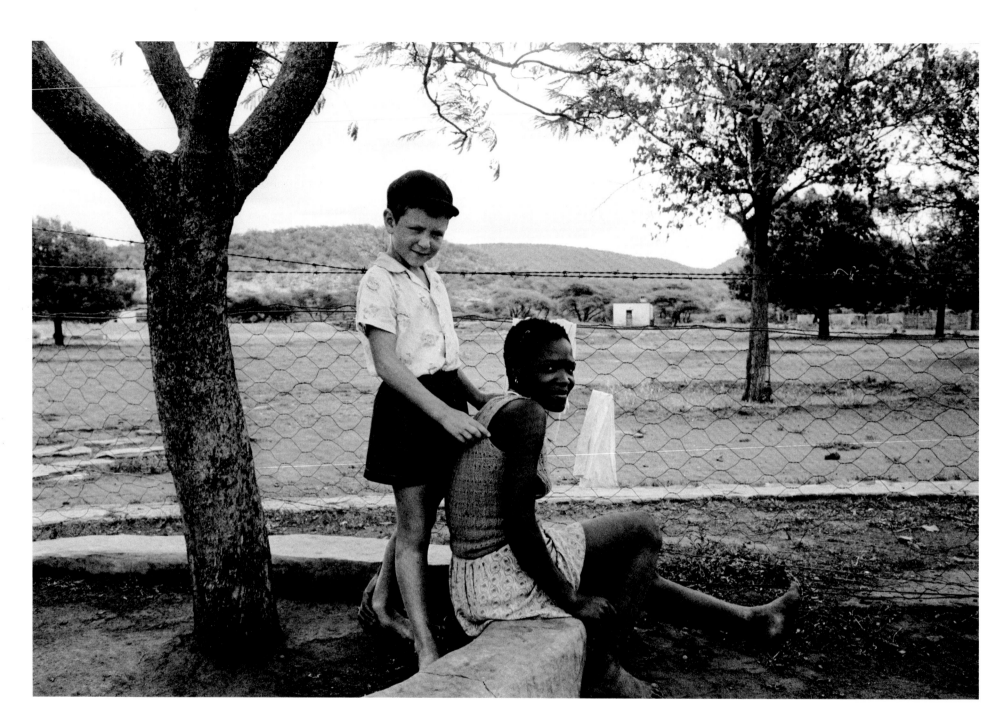

PHOTOGRAPHS FROM

Some Afrikaners Photographed a book published
in 1975 by Murray Crawford, Johannesburg

Early Johannesburg work

On the Mines a book published in 1972 by Struik,
Cape Town

A farmer's son and his nursemaid, Heimweeberg, Marico Bushveld, Transvaal. 1964

Commando of National Party men escorting their leader, Dr Hendrik Verwoerd,
to the party's fiftieth anniversary celebrations, de Wildt,
Transvaal. October 1964

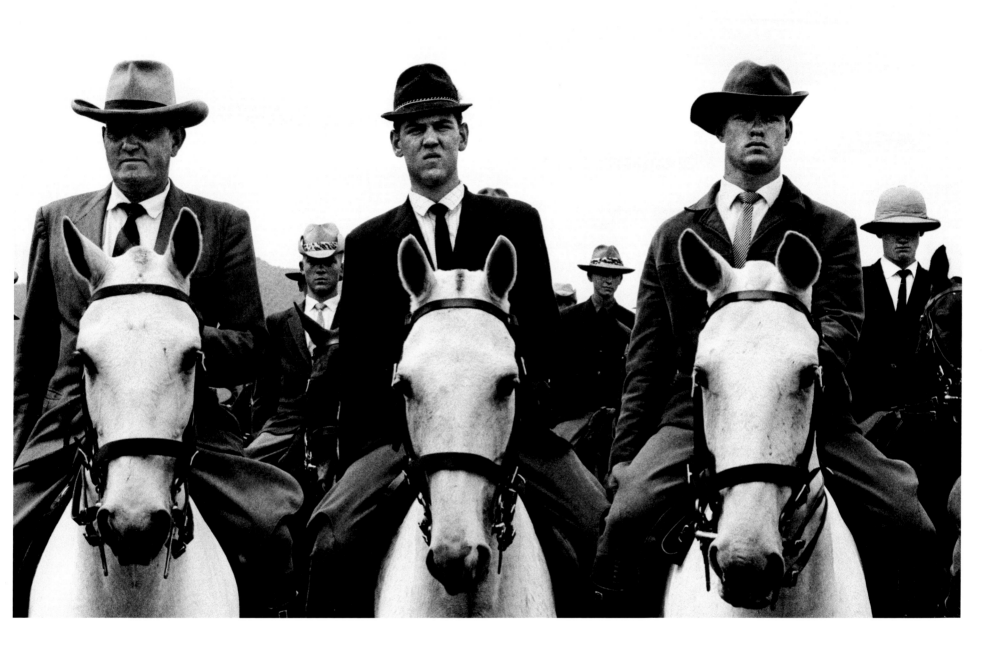

A plotholder and the daughter of a servant, Wheatlands, Randfontein,
Transvaal. 1962

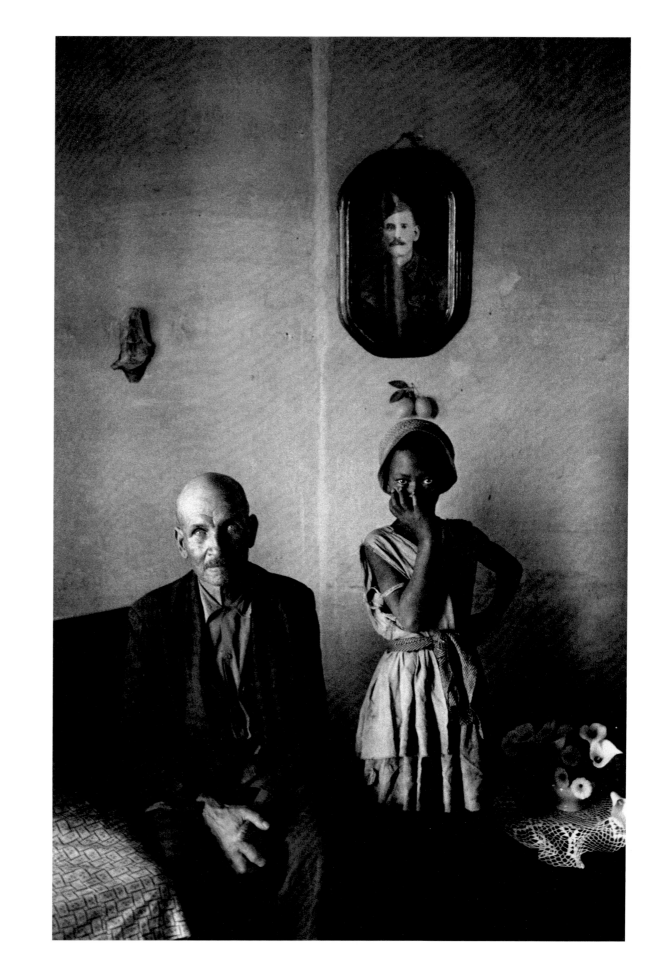

New Year's Day picnic at Hartebeespoort Dam,
Transvaal. 1965

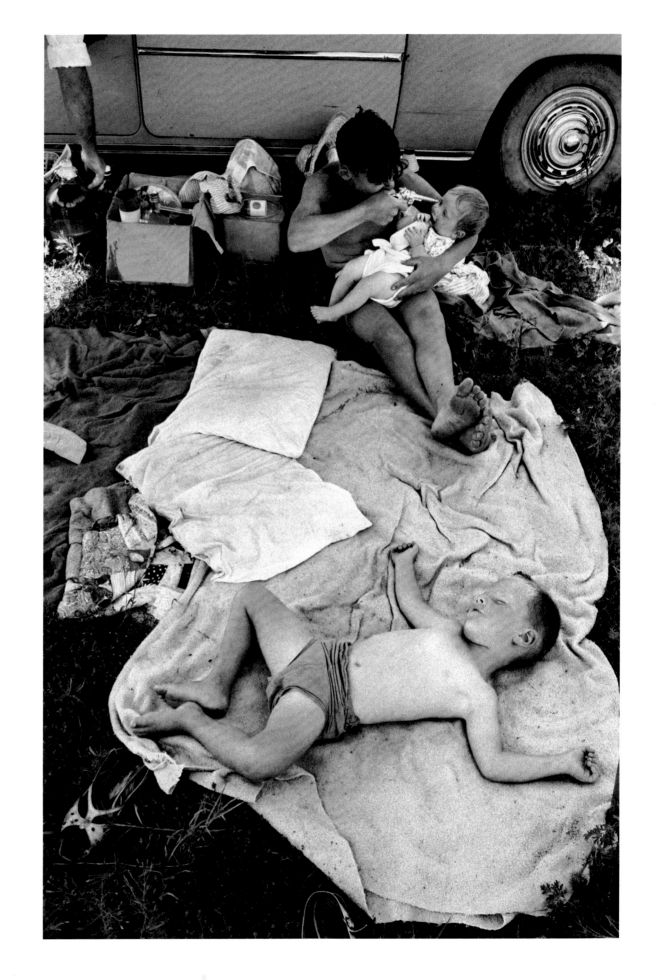

Farmers at a cattle auction, Vryburg,
Cape Province. August 1965

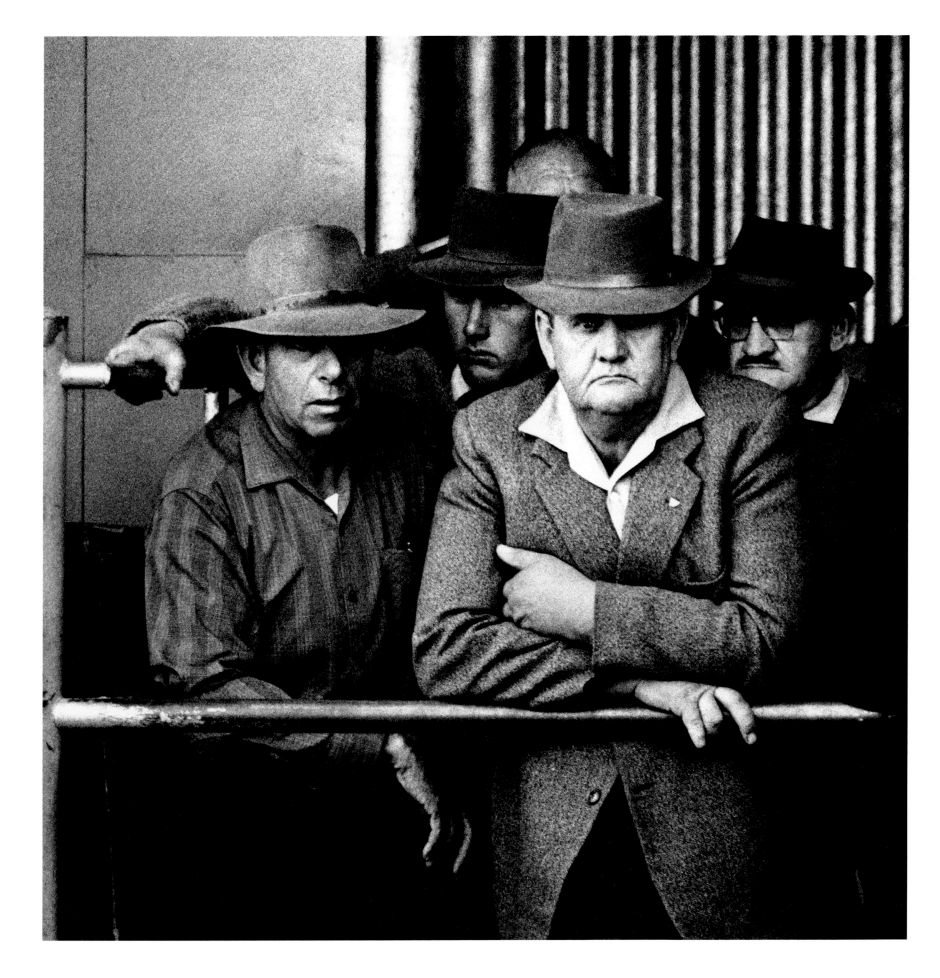

A plot-holder, his wife and their eldest son at lunch, Wheatlands, Randfontein, Transvaal. September 1962

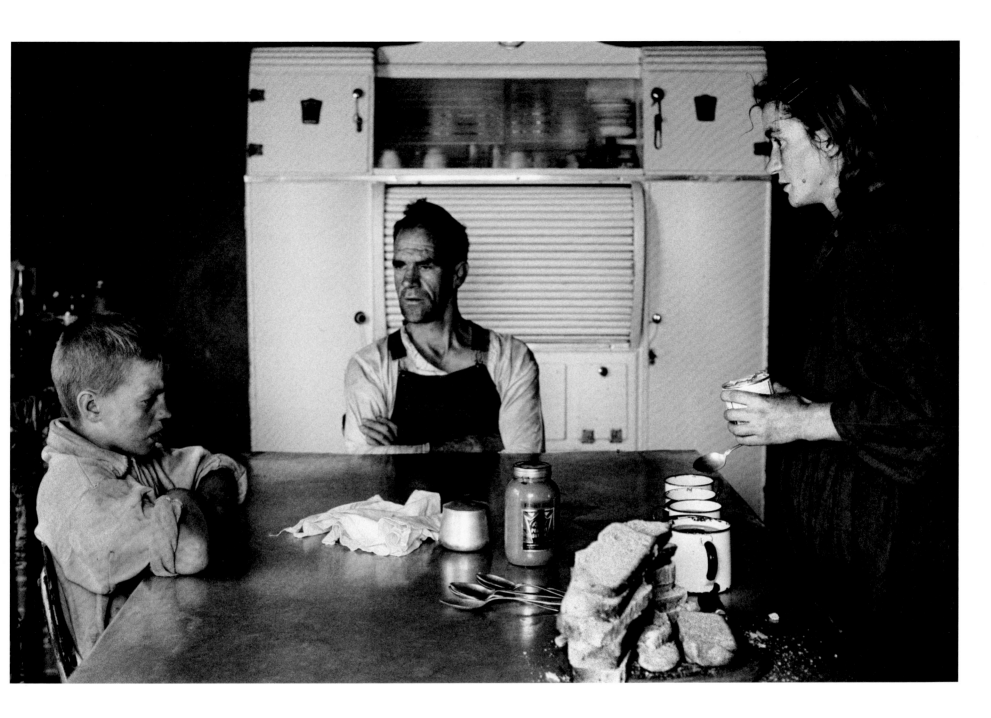

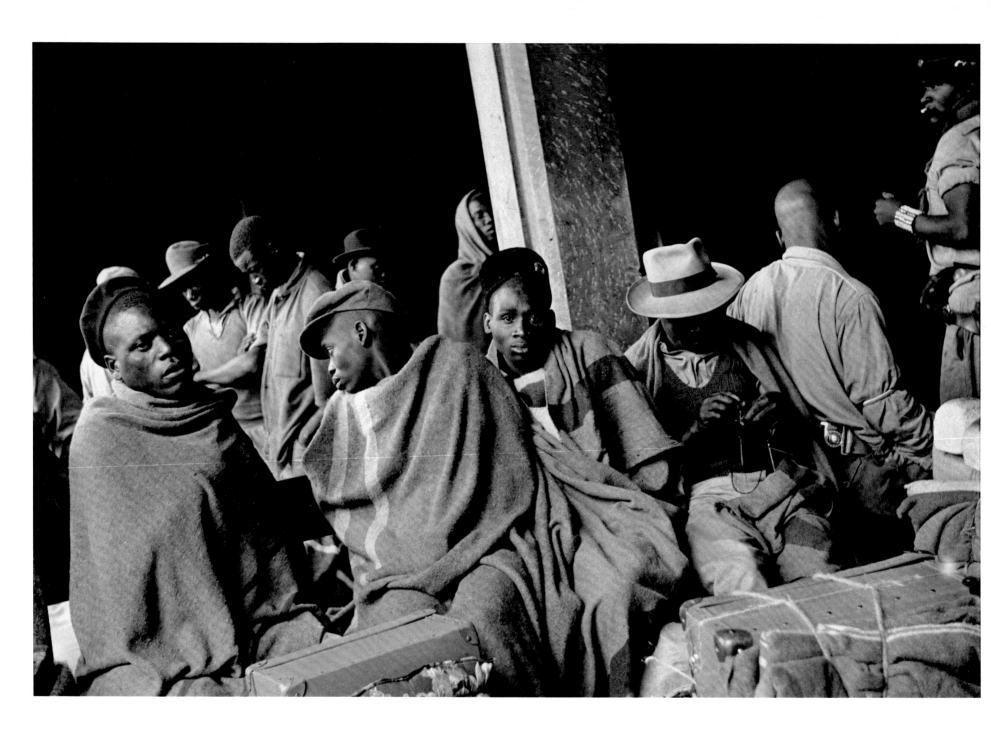

38
■ Miners going home to Nyassaland (Malawi) after serving their twelve-month contracts on the gold mines,
Mayfair railway station, Johannesburg. December 1952

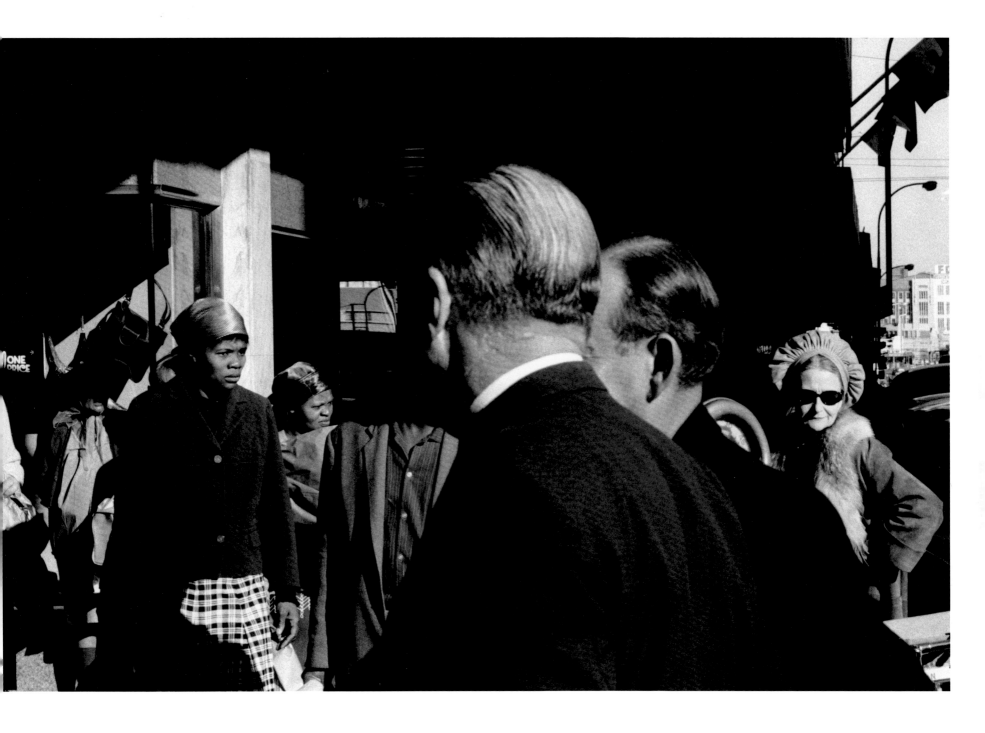

On Eloff Street,
Johannesburg. May 1966

'Boss Boy', Battery Reef, Randfontein Estates Gold Mine, Randfontein, Transvaal. 1966

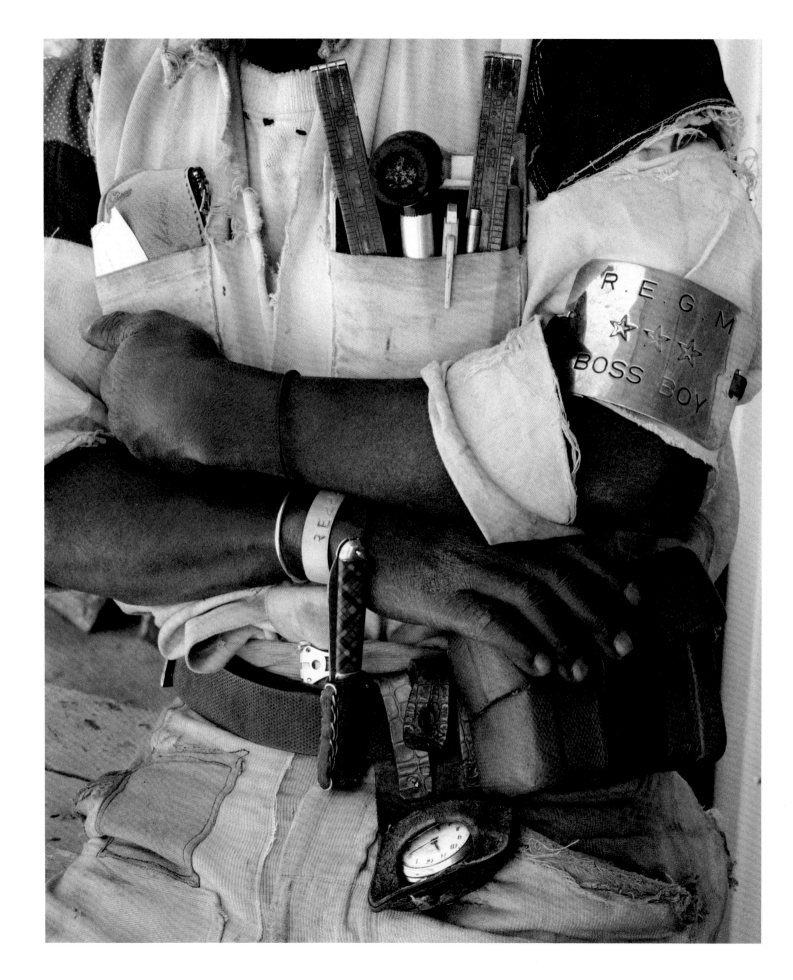

Time office clerks and a miner, City Deep Gold Mine,
Johannesburg. 1966

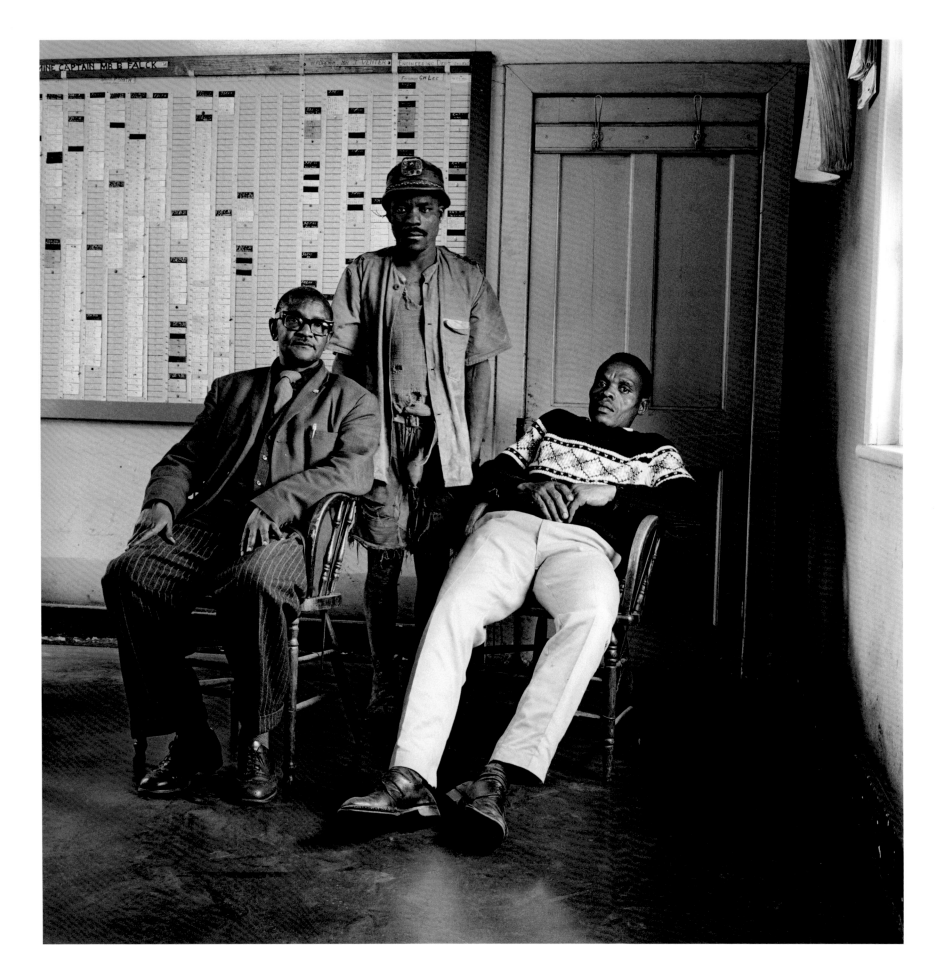

At about 5000 feet underground during the sinking of the vertical shaft for a new goldmine:
The cactus grab, looming over the kibble in the background, has dumped the last load of
larger rocks into the kibble. Now the team clear the smaller stones from the shaft bottom,
'lashing' or loading the kibble with shovels.
President Steyn No 4 Shaft, Welkom, Orange Free State. June 1969

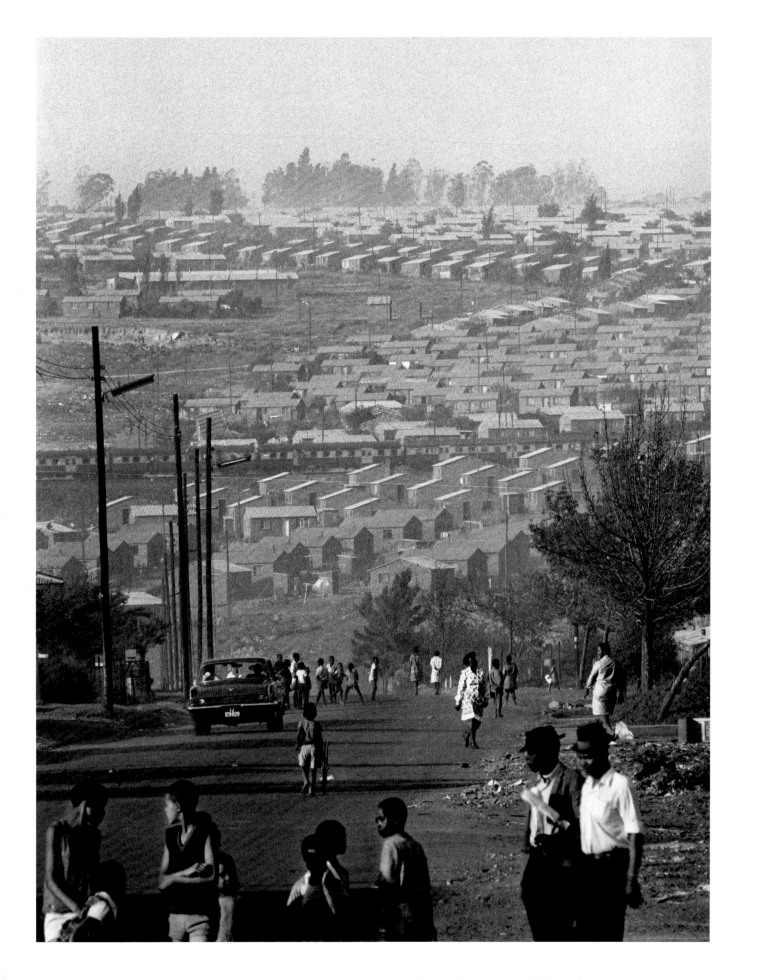

PHOTOGRAPHS FROM

'Soweto', an essay published in 1972 in *Optima*,
Johannesburg
Joburg People, suburban portraits

Mofolo South, Soweto,
Johannesburg. September 1972

Butchering a coal merchant's horse for its meat, Tladi, Soweto,
Johannesburg. November 1972

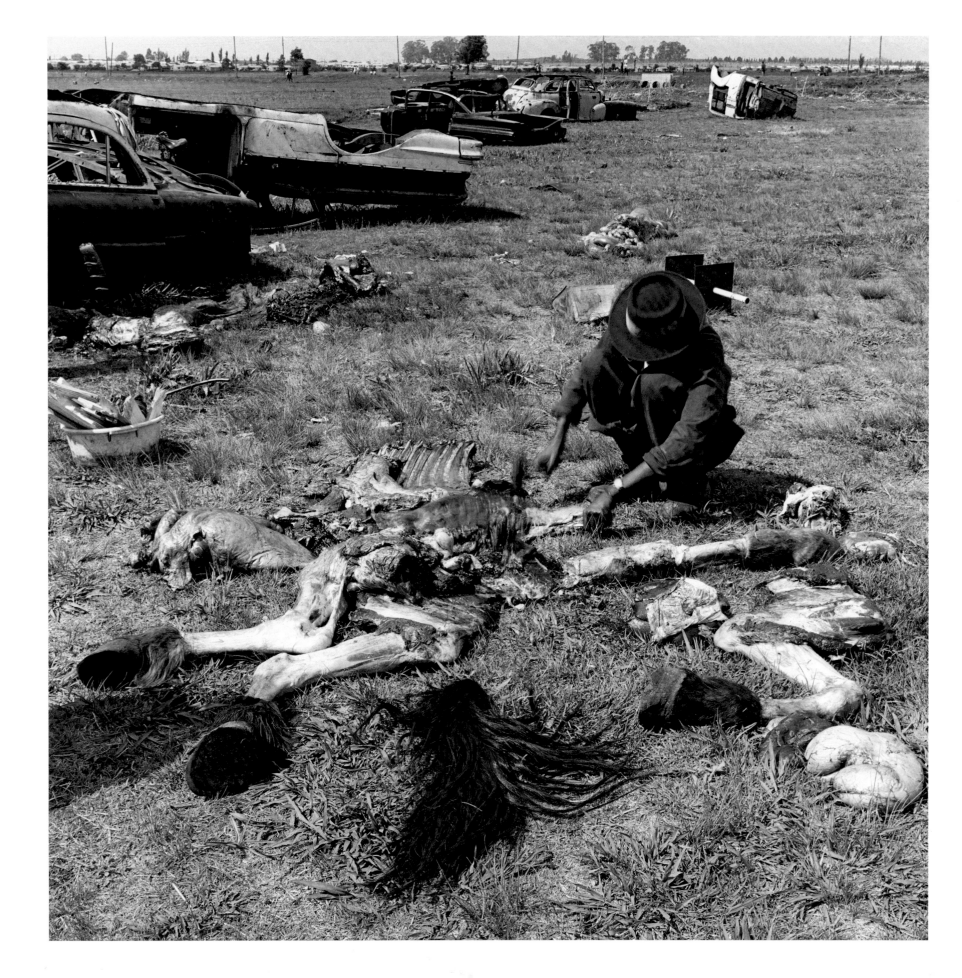

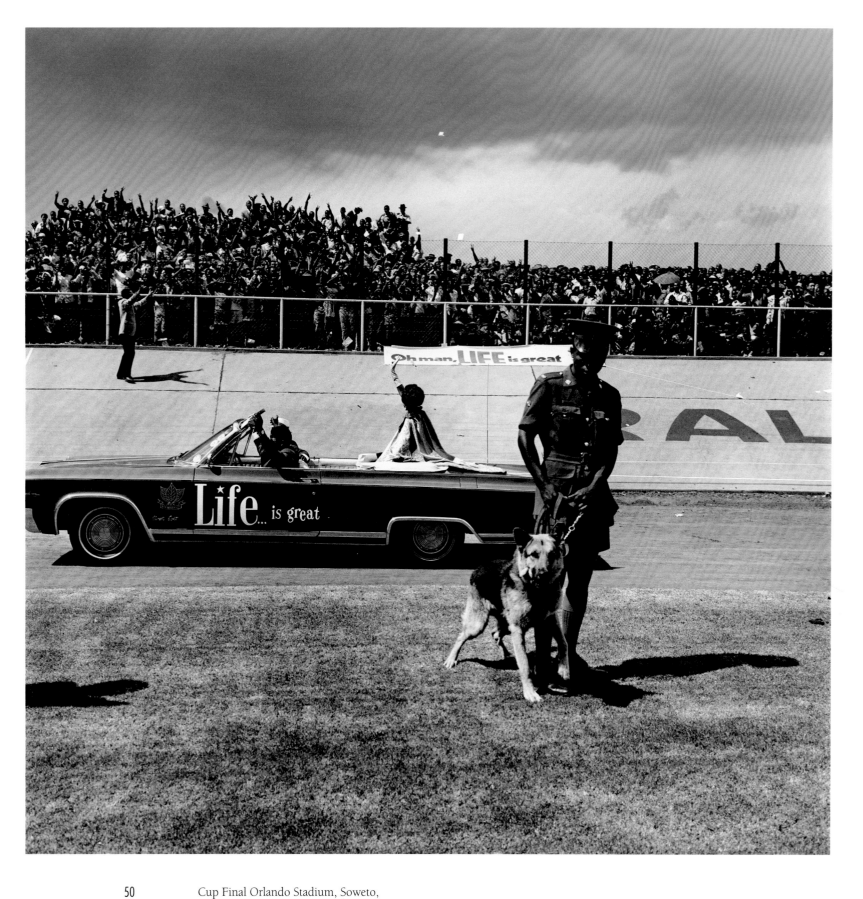

50　　　　　Cup Final Orlando Stadium, Soweto,
■　　　　　Johannesburg. 1972

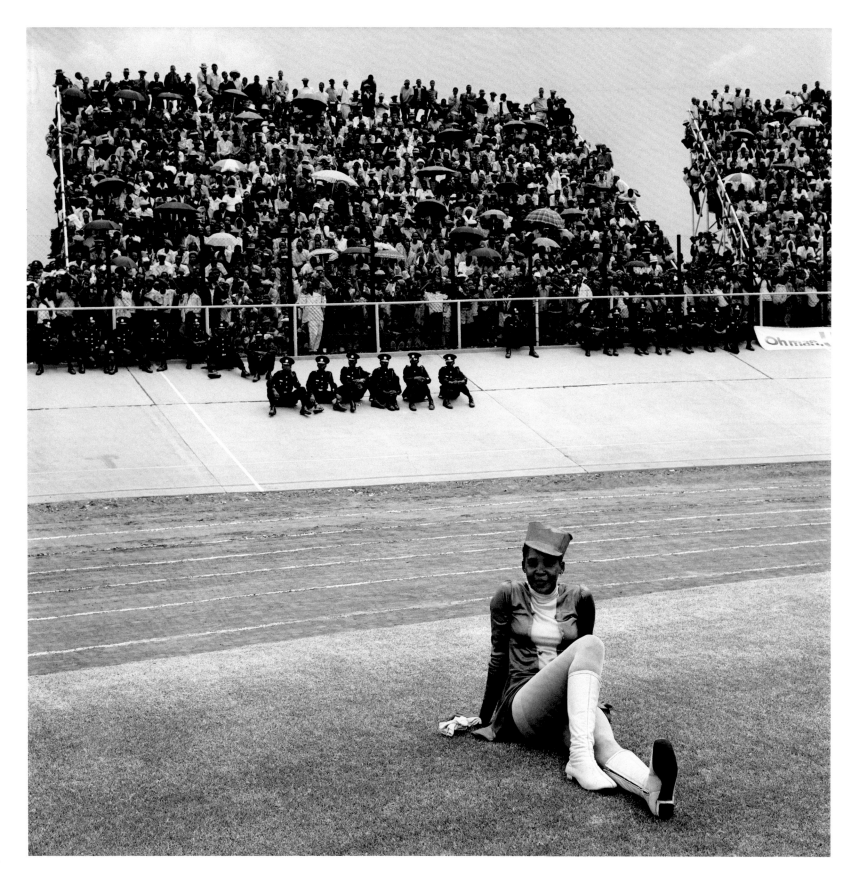

Drum majorette, Cup final, Orlando Stadium,
Soweto, Johannesburg. 1972

In the office of the People's Funeral parlour, Orlando West, Soweto,
Johannesburg. August 1972

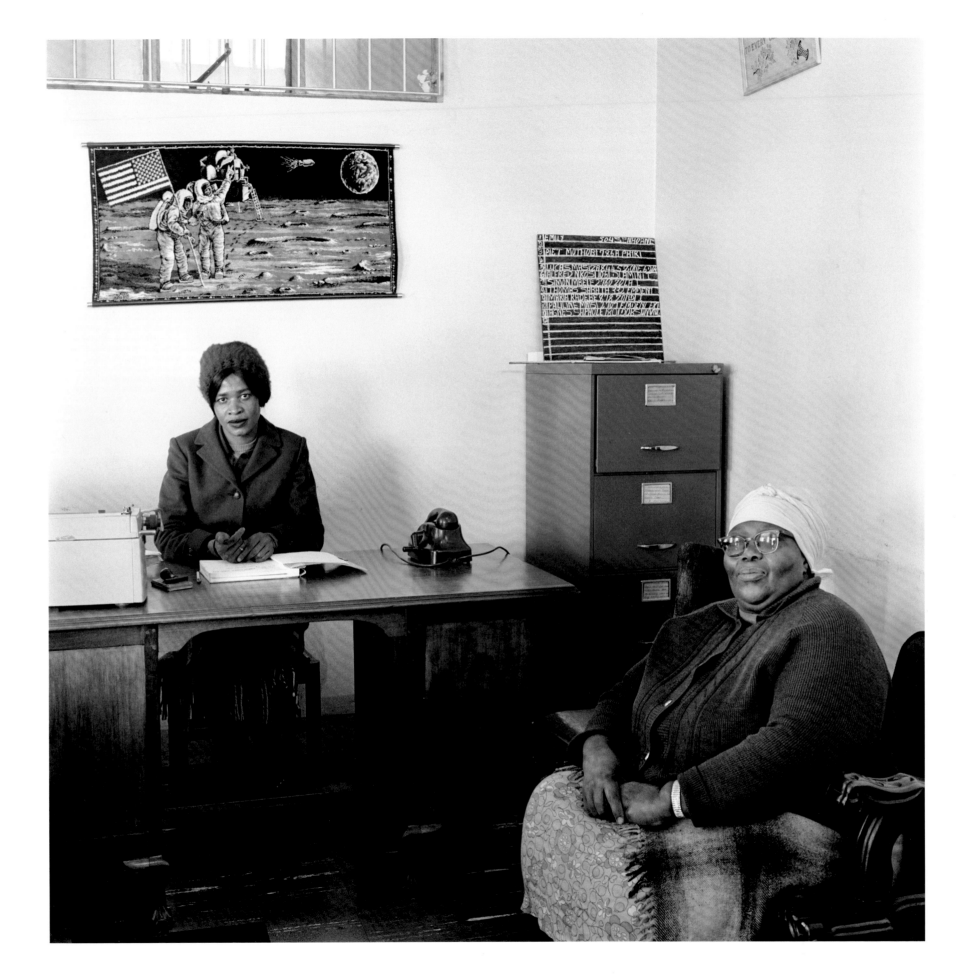

Young men with dompas, White City, Jabavu, Soweto,
Johannesburg. November 1972

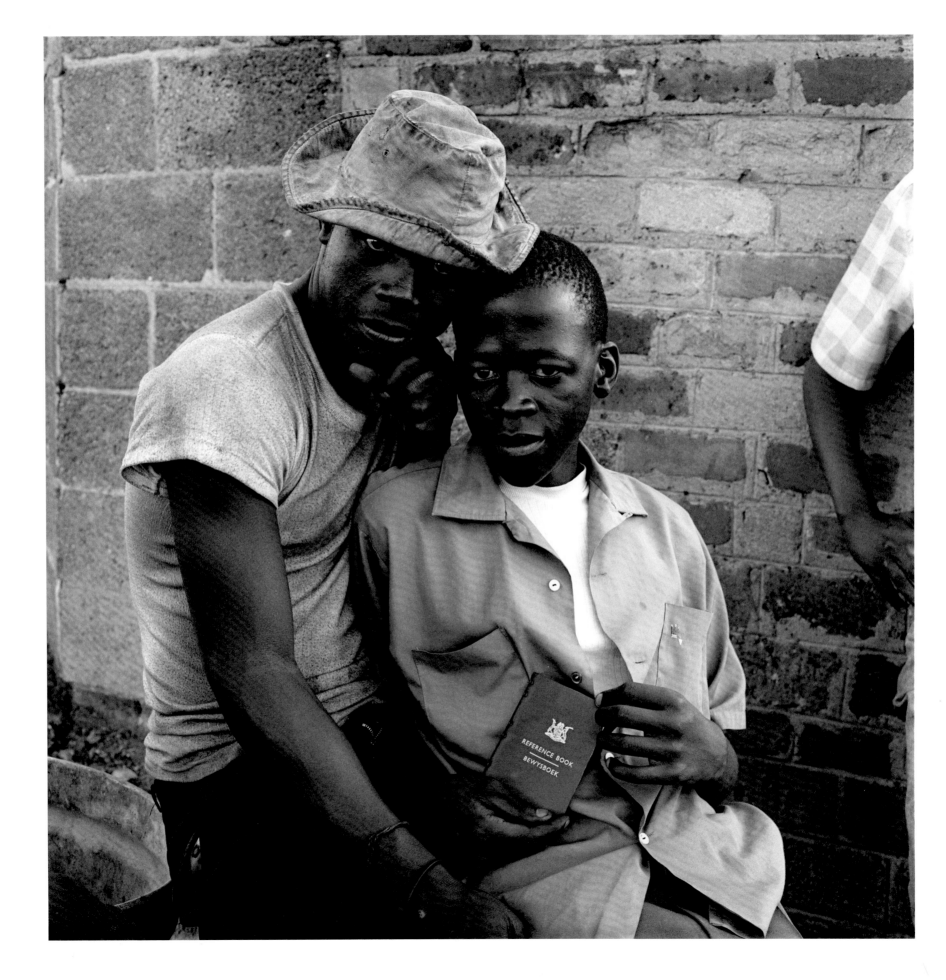

Margaret Mcingana who later became famous as the singer Margaret Singana, Zola, Soweto, Johannesburg. October 1970

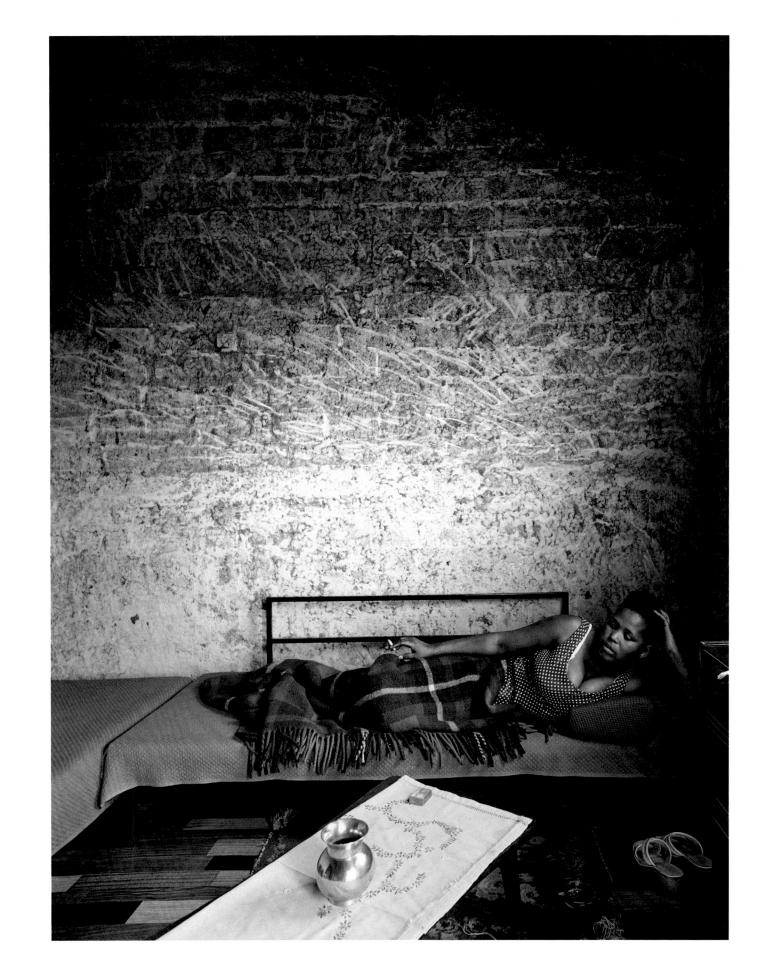

George and Sarah Manyane in their house, 3153 Emdeni Extension, Soweto, Johannesburg. August 1972

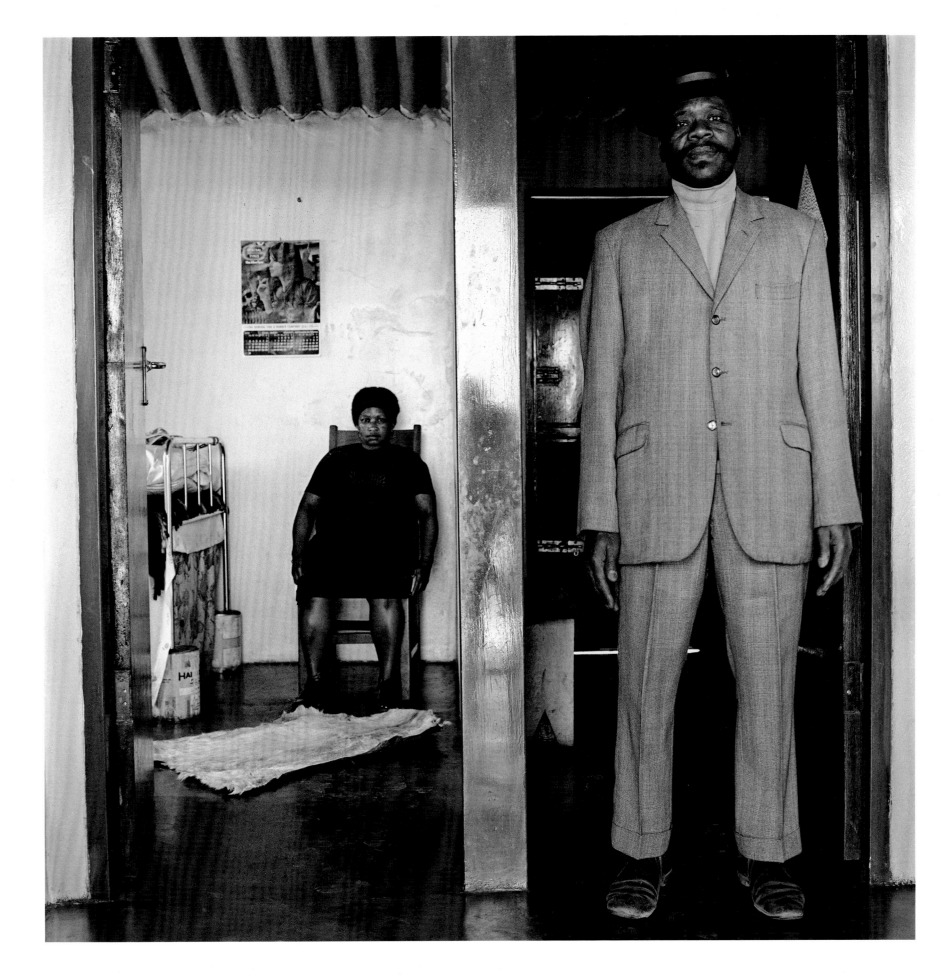

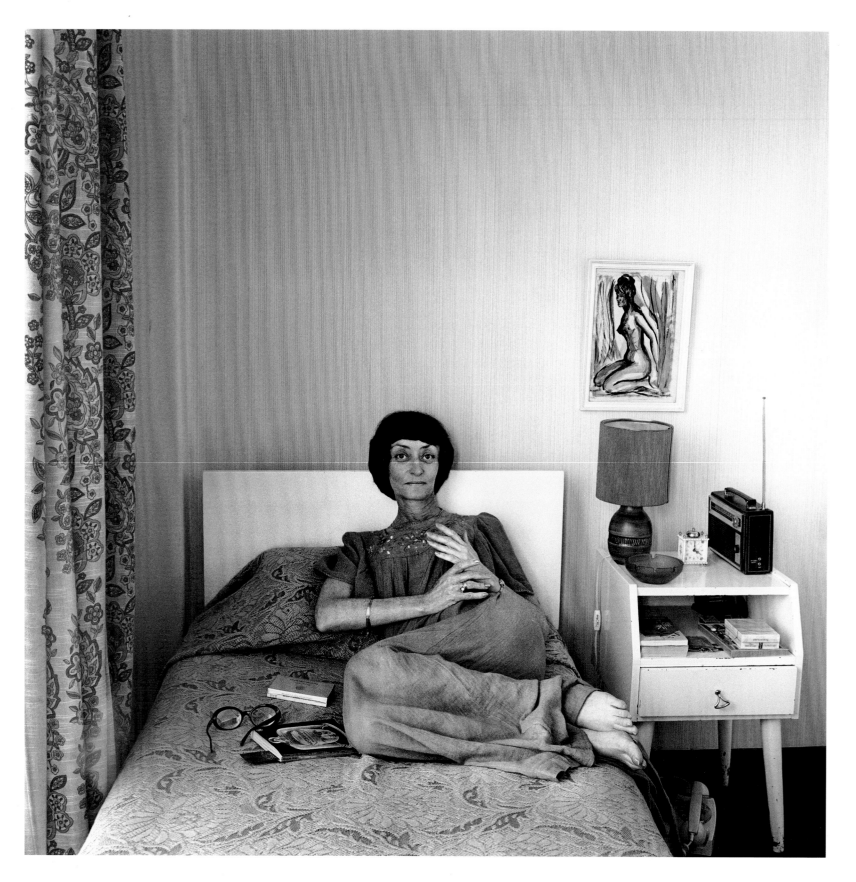

60
■ Sylvia Gibbert in her apartment, Melrose,
Johannesburg. October 1974

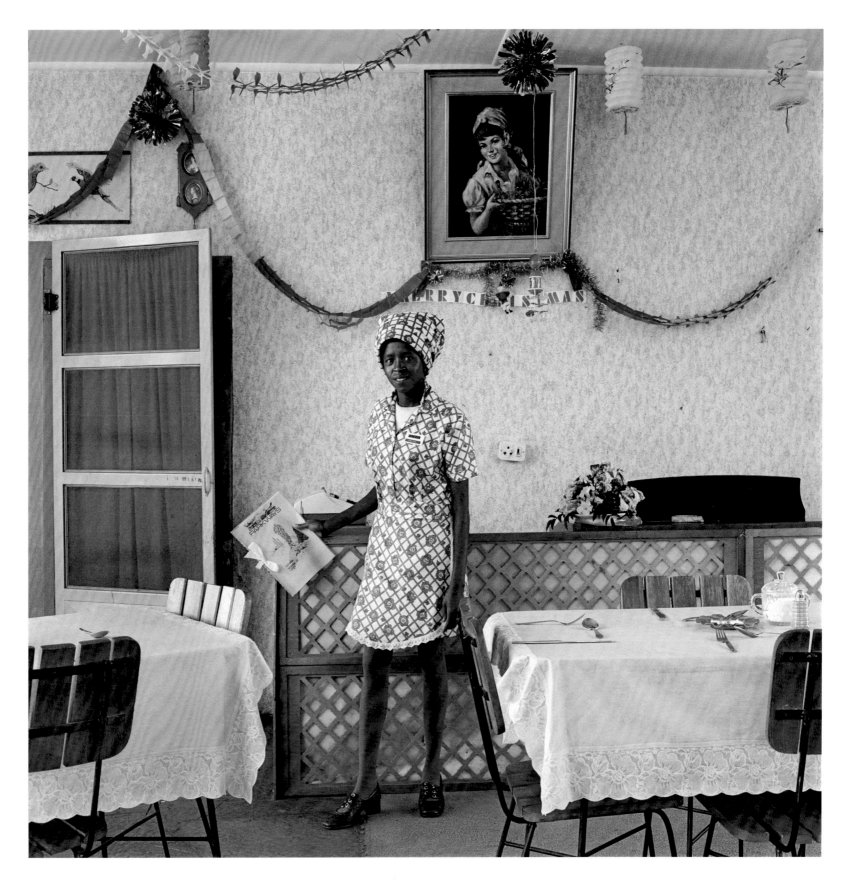

Waitress, Bezuidenhout Park,
Johannesburg. November 1973

61

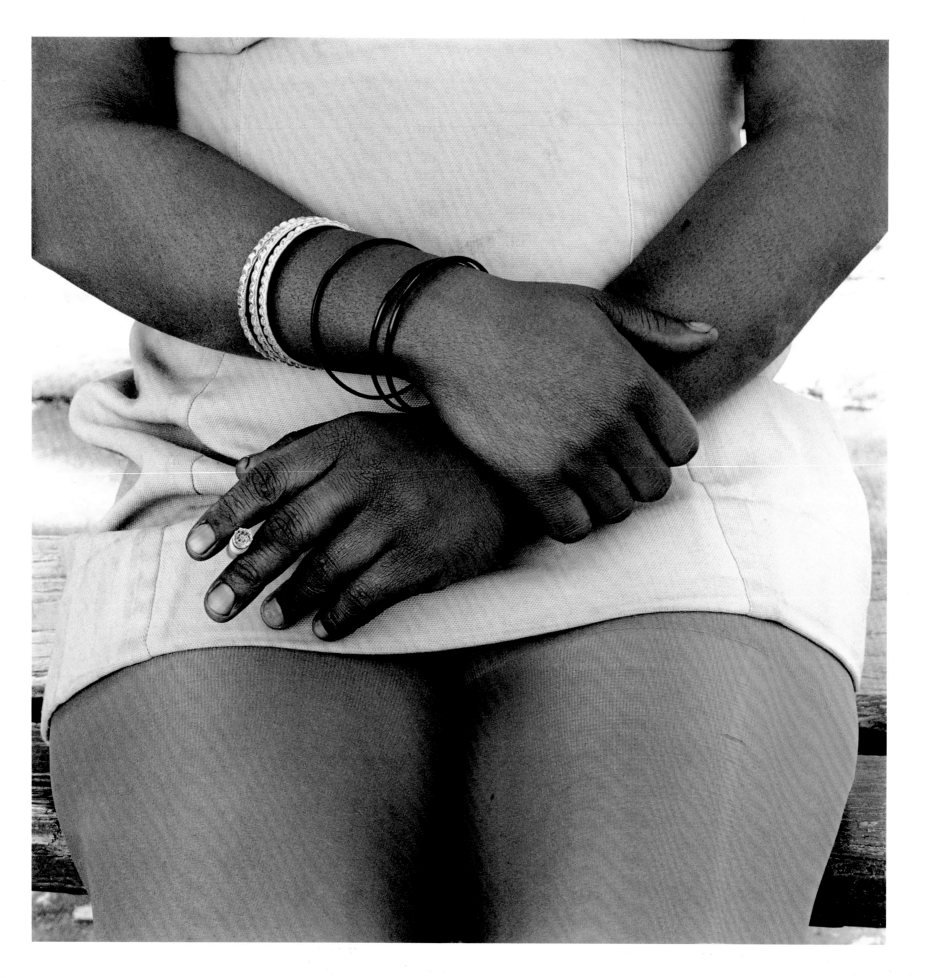

PHOTOGRAPHS FROM

Particulars a book published in 2003 by Goodman
Gallery Editions, Johannesburg

Woman smoking, Fordsburg,
Johannesburg. 1975

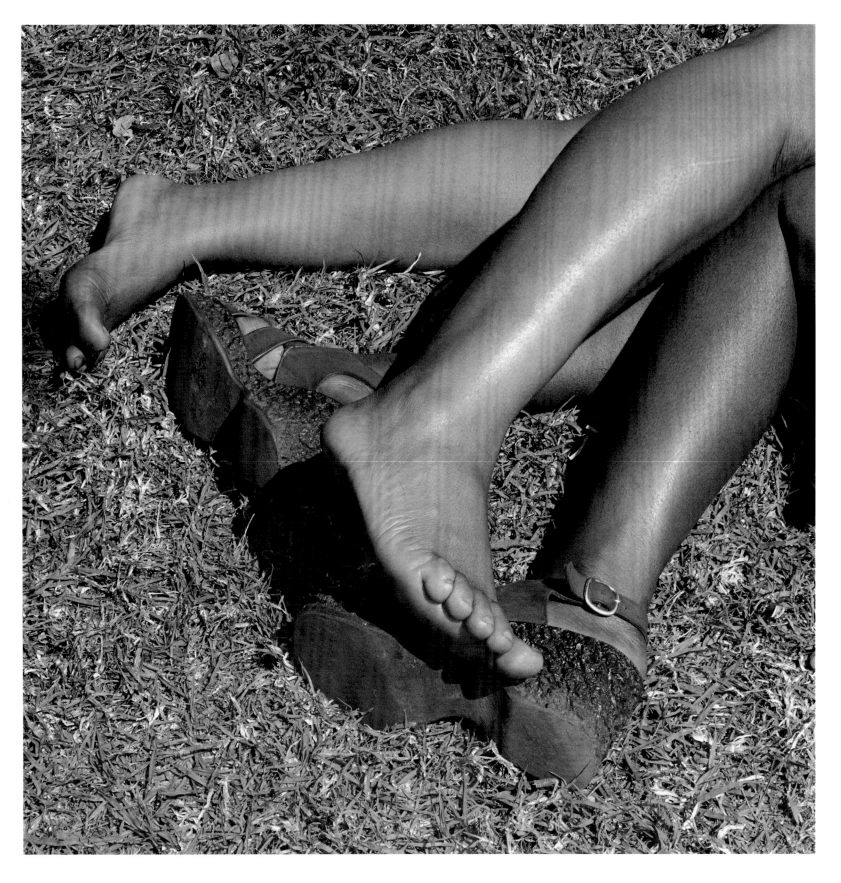

64
■ Women at play during their lunch-hour, Pieter Roos Park,
 Johannesburg. 1975

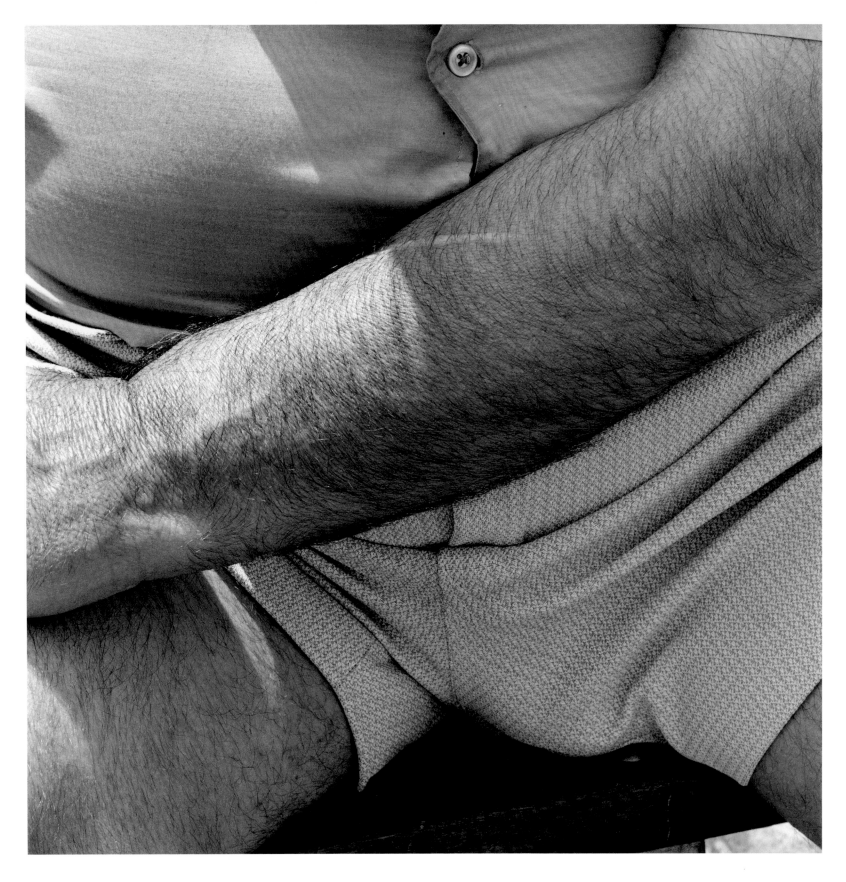

Man on a bench, Joubert Park,
Johannesburg. 1975

65
■

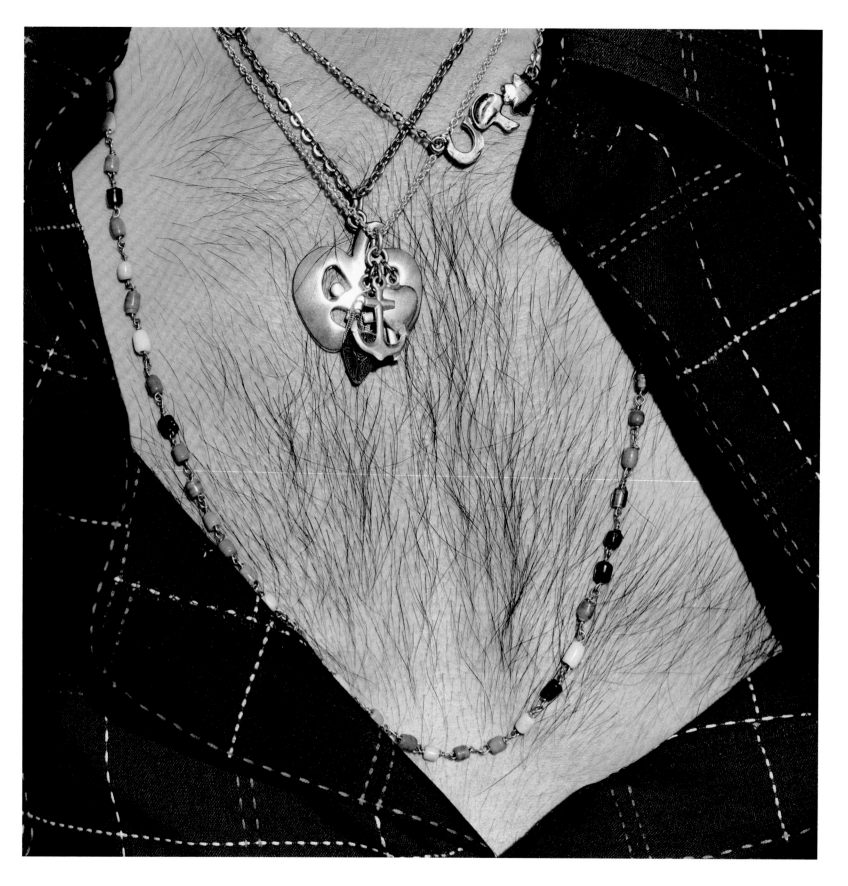

66 Man with necklaces, Joubert Park,
 Johannesburg. 1975

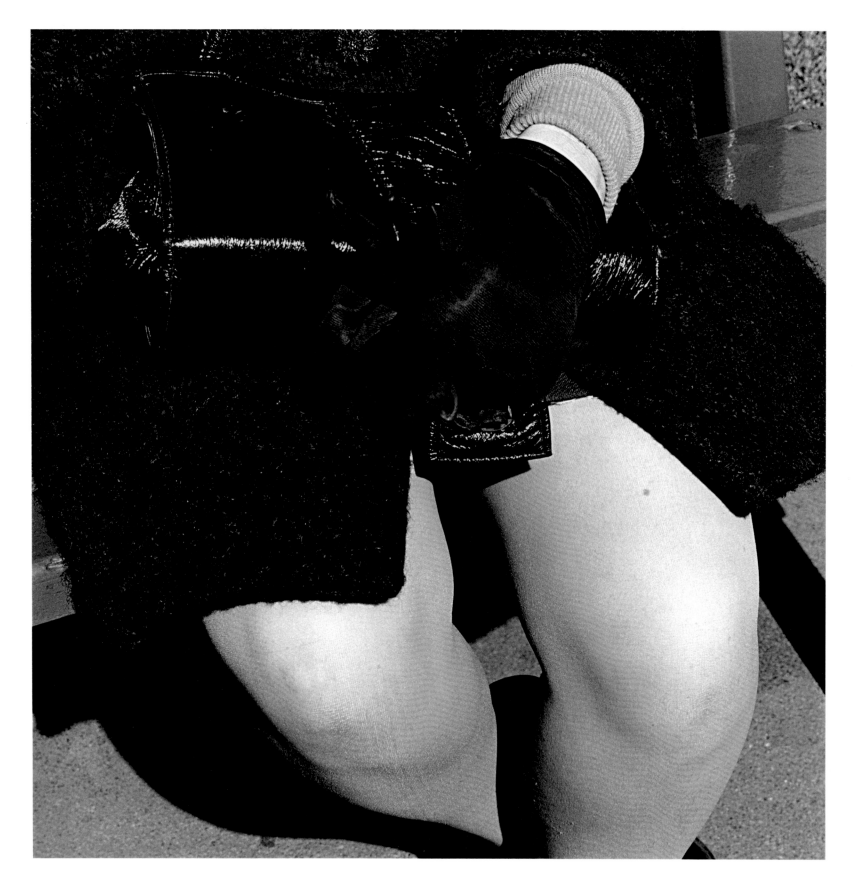

Woman dressed for an occasion, Joubert Park,
Johannesburg. 1975

67

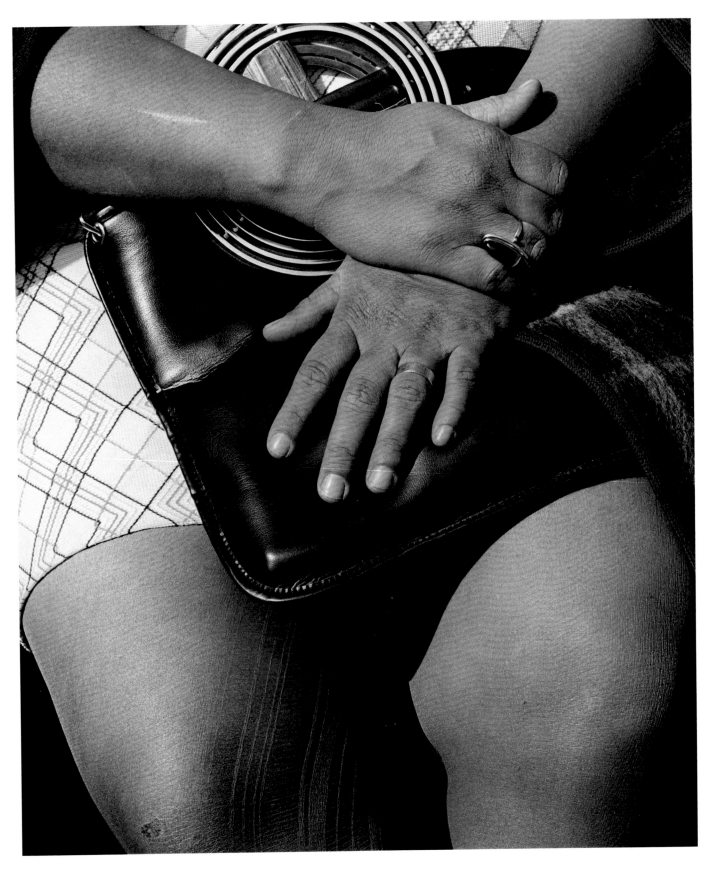

68
Woman resting on her way to work, De Villiers Street Park,
Johannesburg. 1975

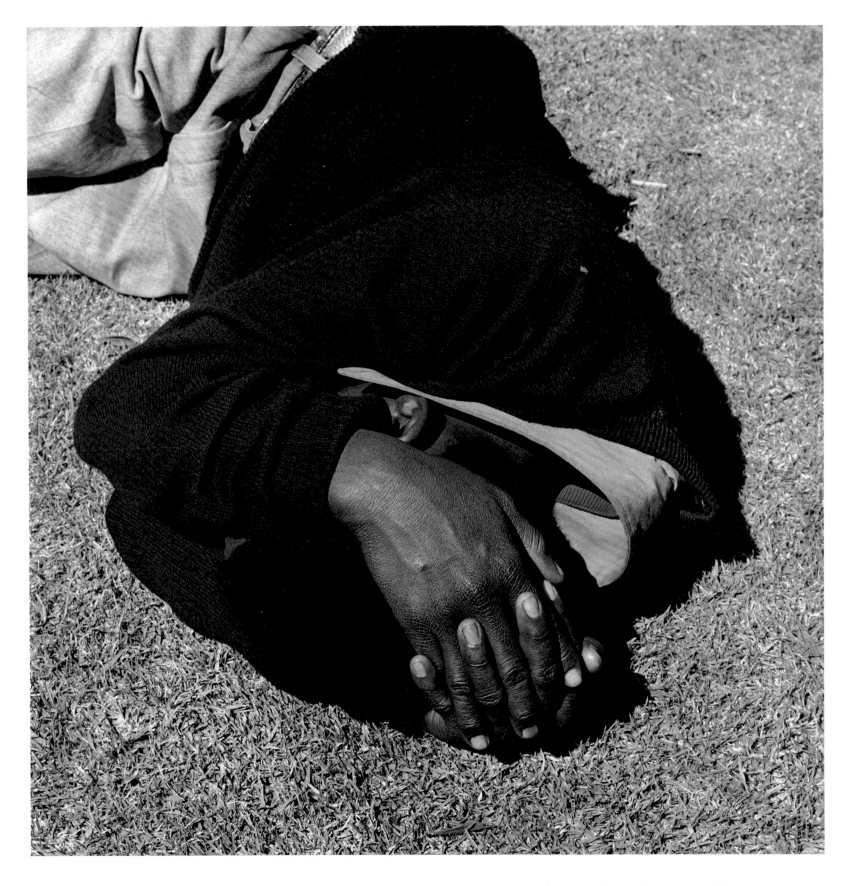

Man sleeping, Joubert Park,
Johannesburg. 1975

69
∎

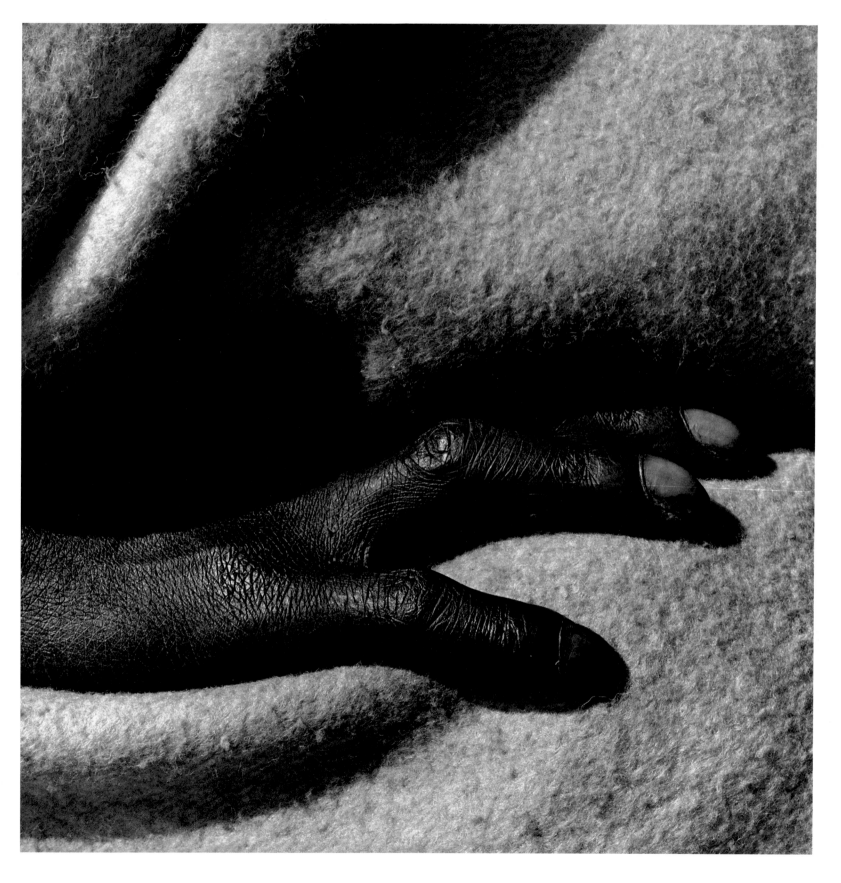

70
■ Blanketed man at the trading store, Hobeni, Bomvanaland,
Transkei. 1975

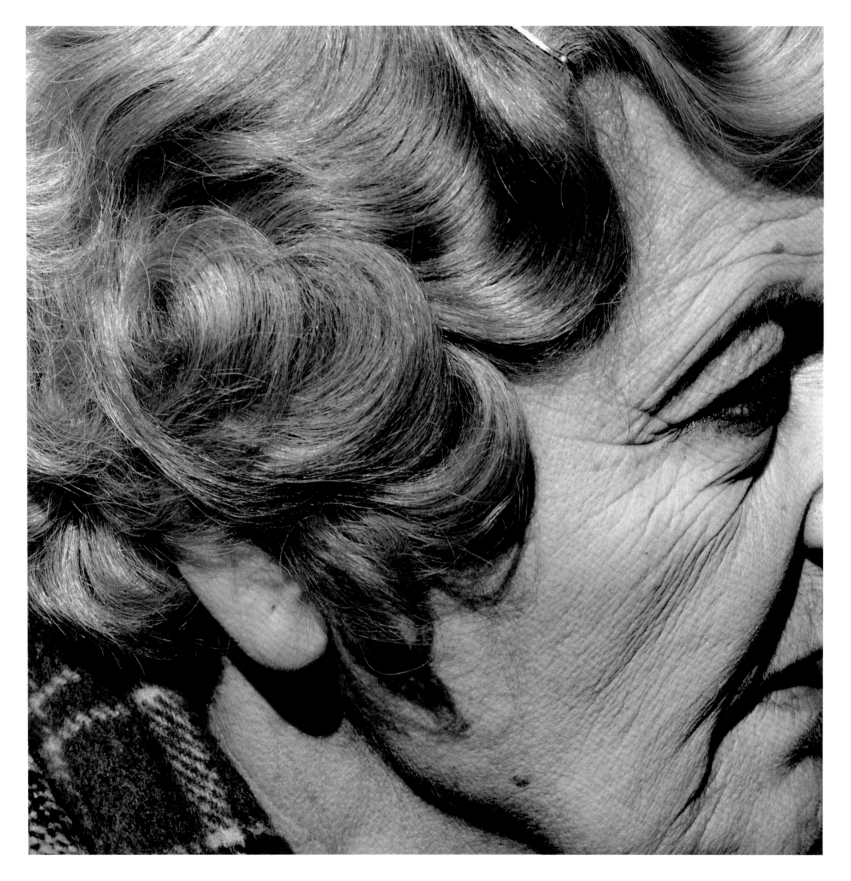

Woman with pierced ear, Joubert Park,
Johannesburg. 1975

71
■

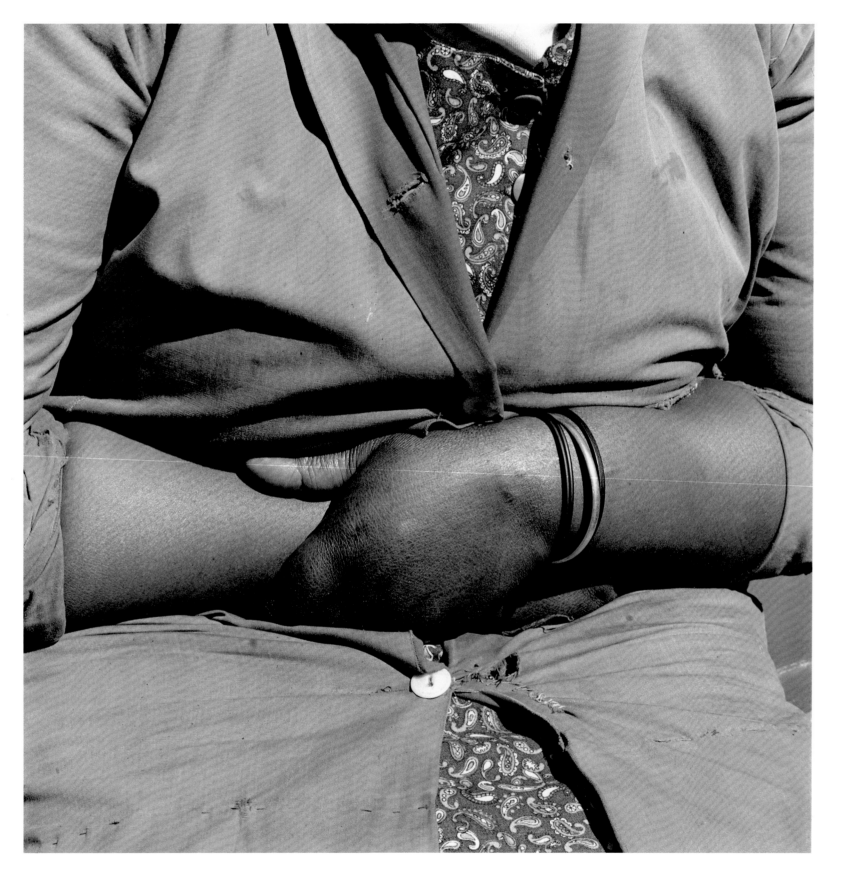

72　　　　　Child minder, Joubert Park,
■　　　　　Johannesburg. 1975

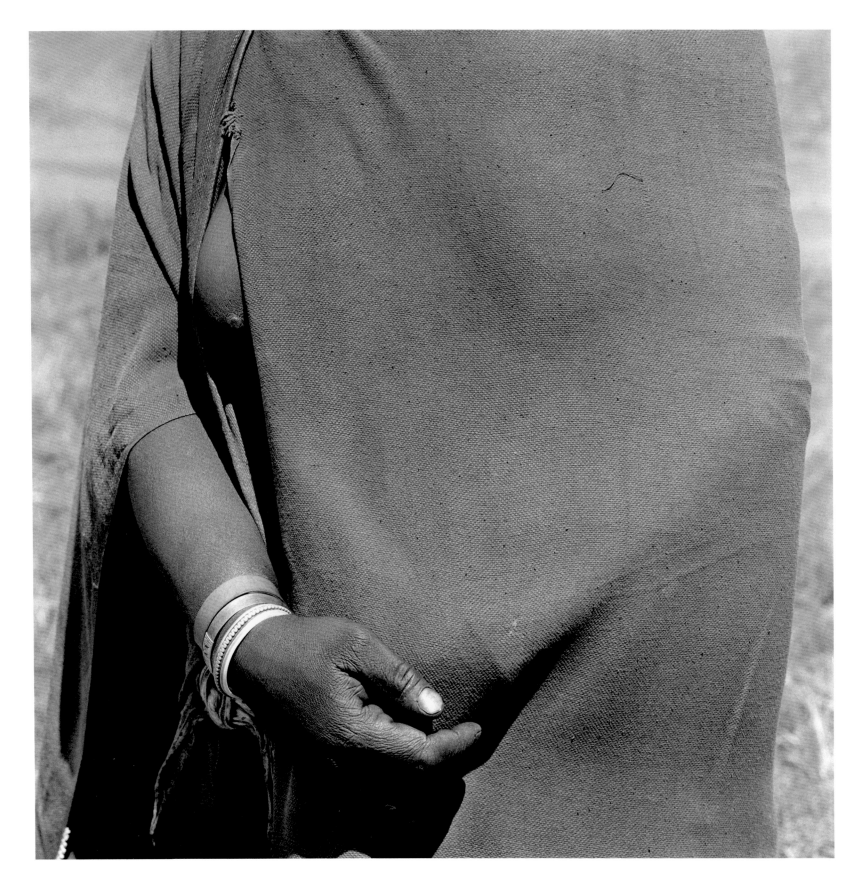

Woman going to the trading store holding money under her blanket, near Flagstaff, Transkei. 1975

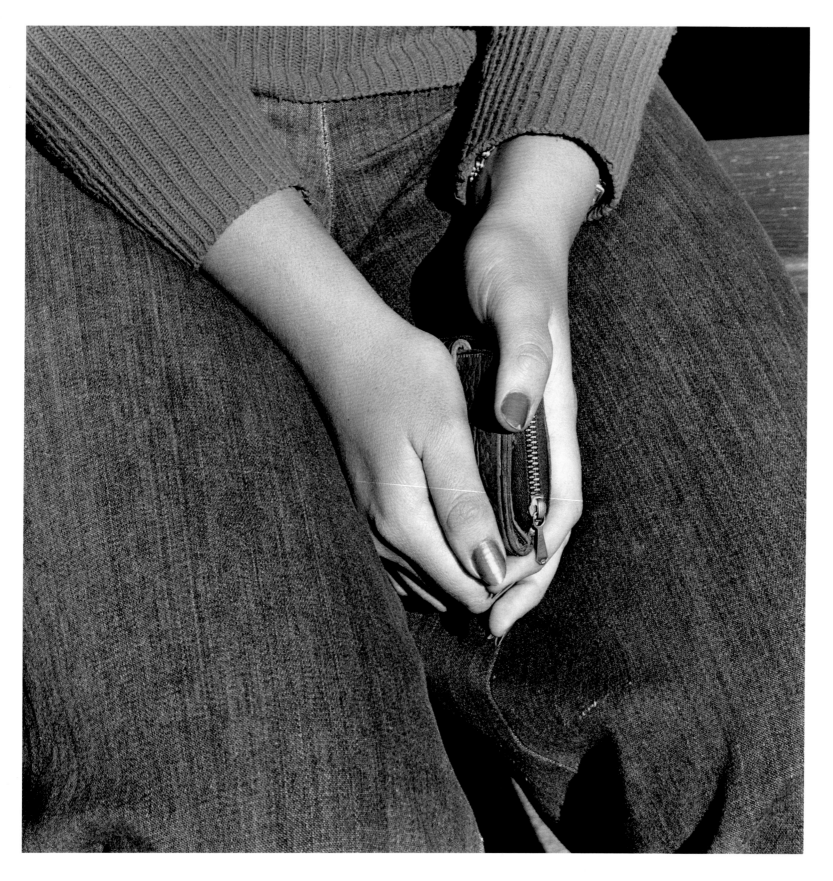

74　　　　Girl with purse, Joubert Park,
■　　　　Johannesburg. 1975

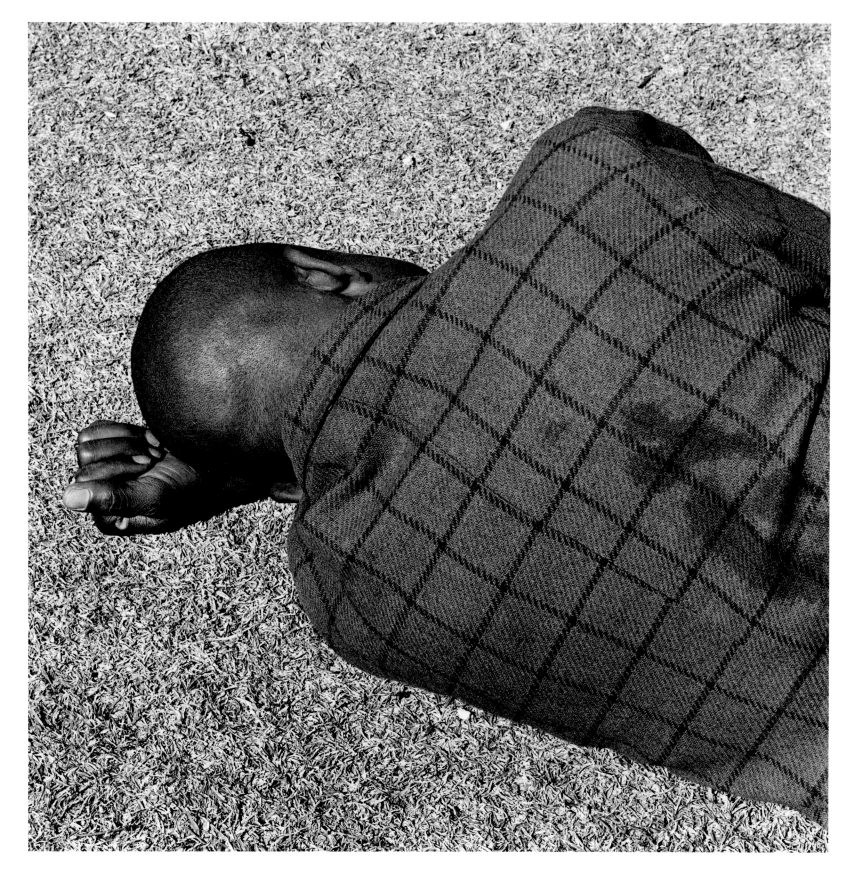

Man sleeping, Joubert Park,
Johannesburg. 1975

75
∎

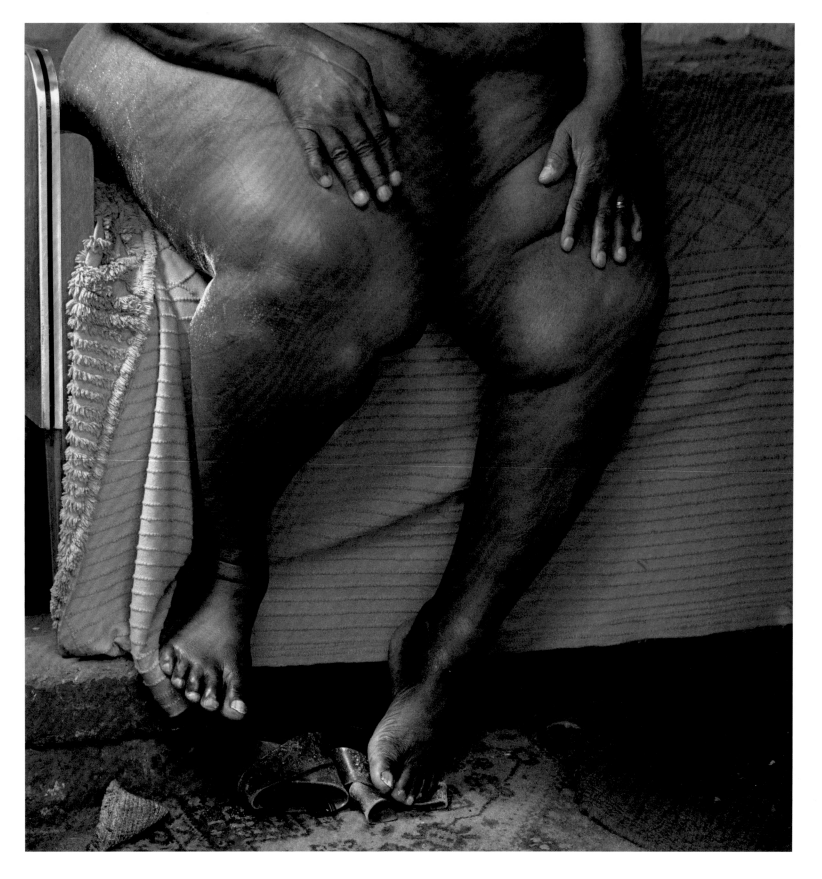

76

Woman on her bed, Yeoville,
Johanesburg. 1983

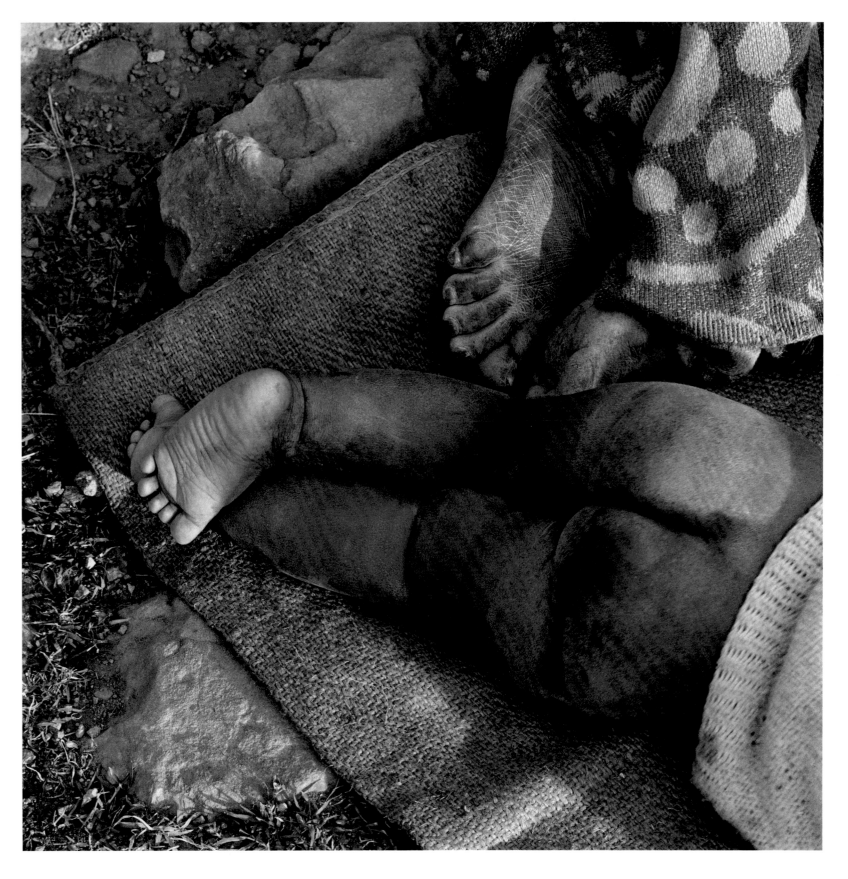

Grandmother and child, 77

Transskei. 1975 ∎

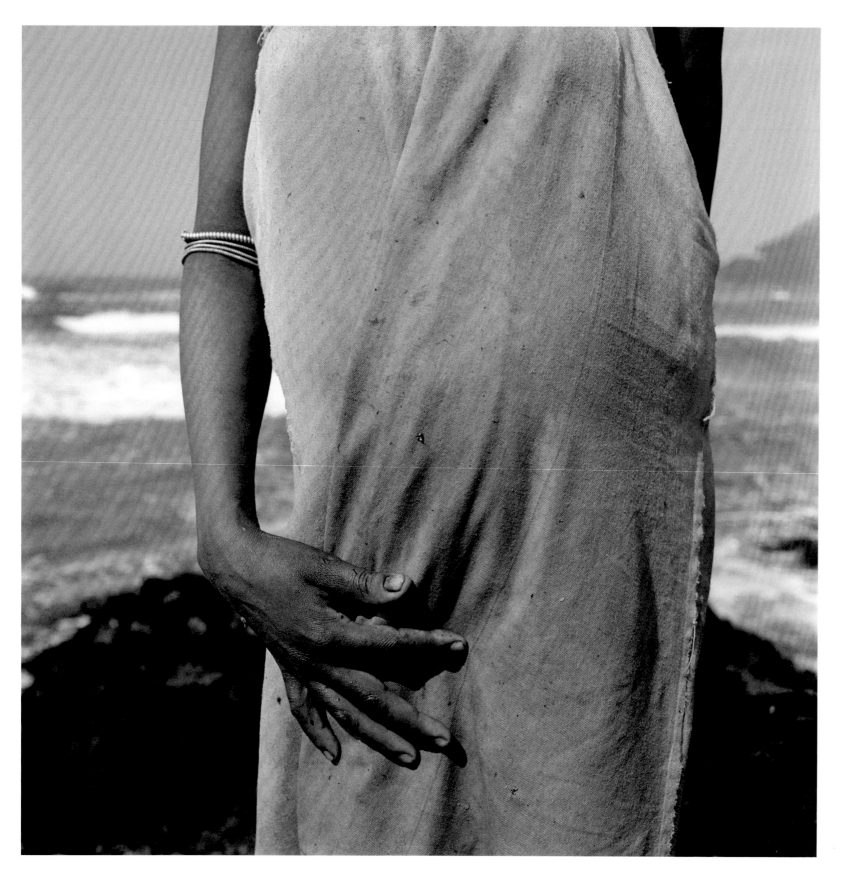

78 Woman collecting shellfish, Port St Johns,
 Transkei. 1975

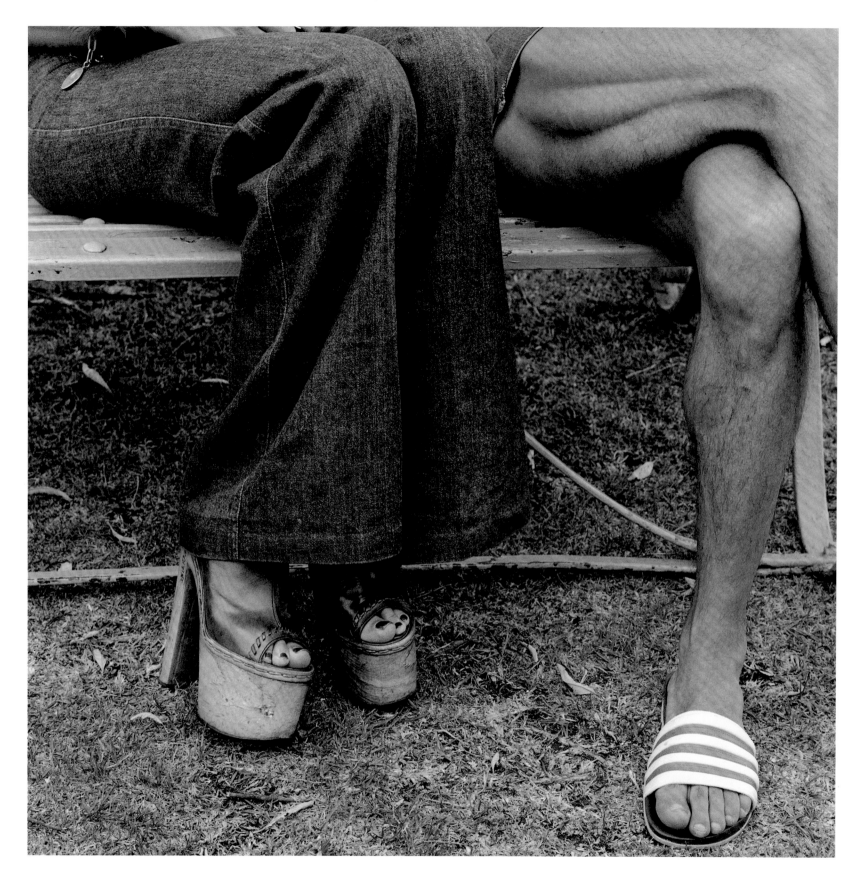

Couple at the Wilds,
Johannesburg. 1975

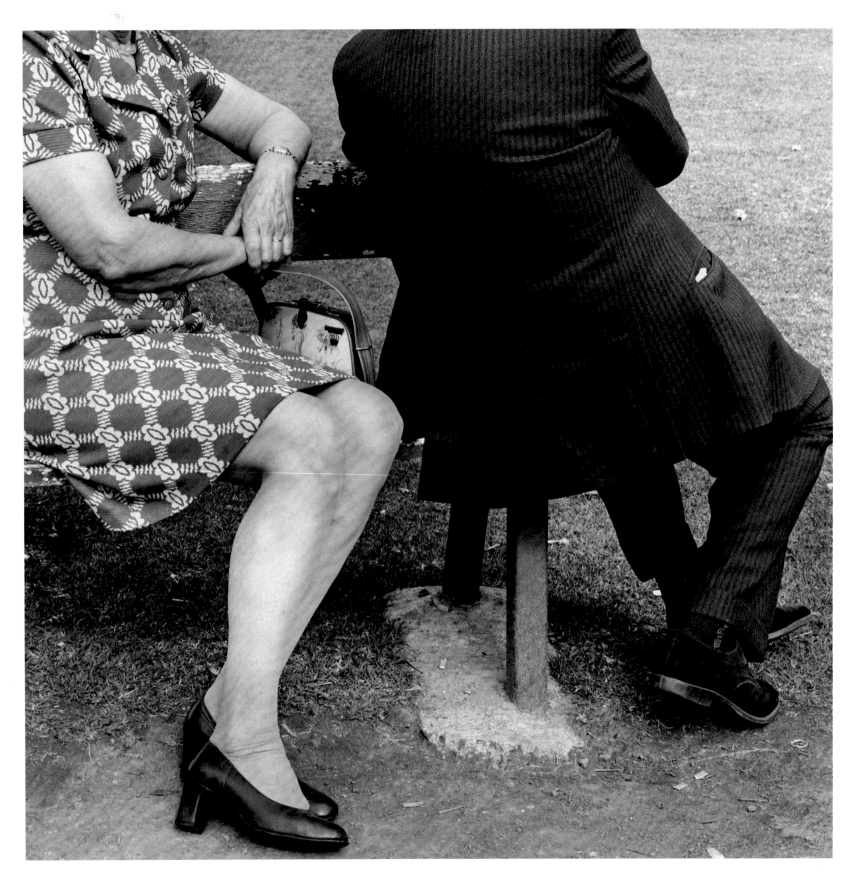

80
■ Couple on a Sunday afternoon, Zoo Lake,
Johannesburg. 1975

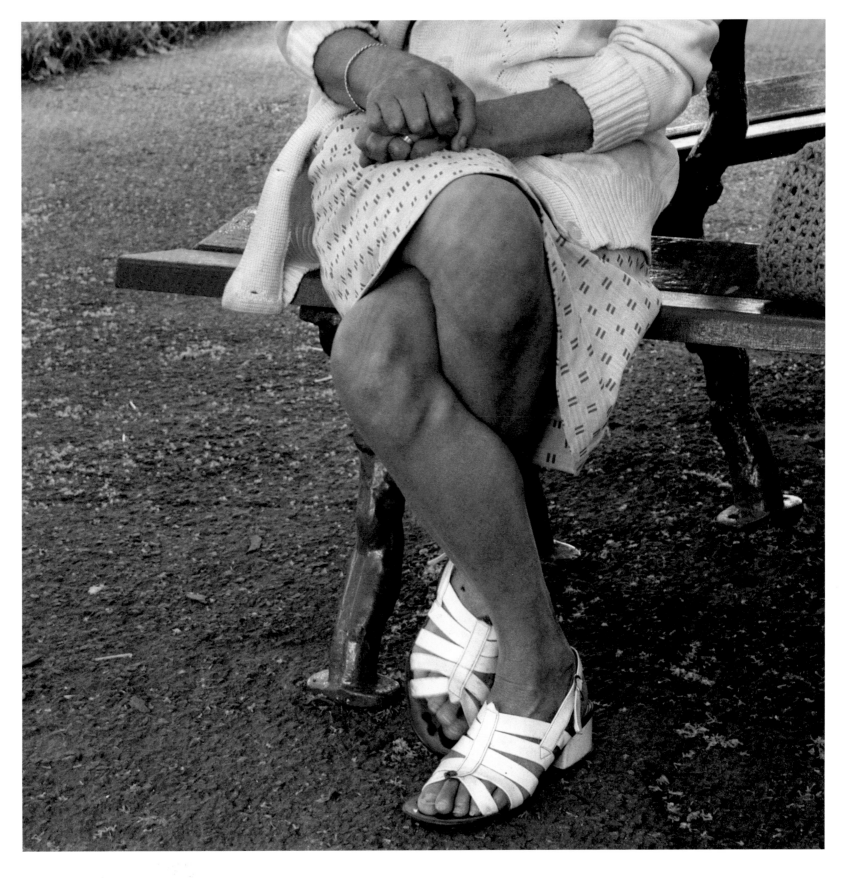

Woman on a bench, Joubert Park,
Johannesburg. 1975

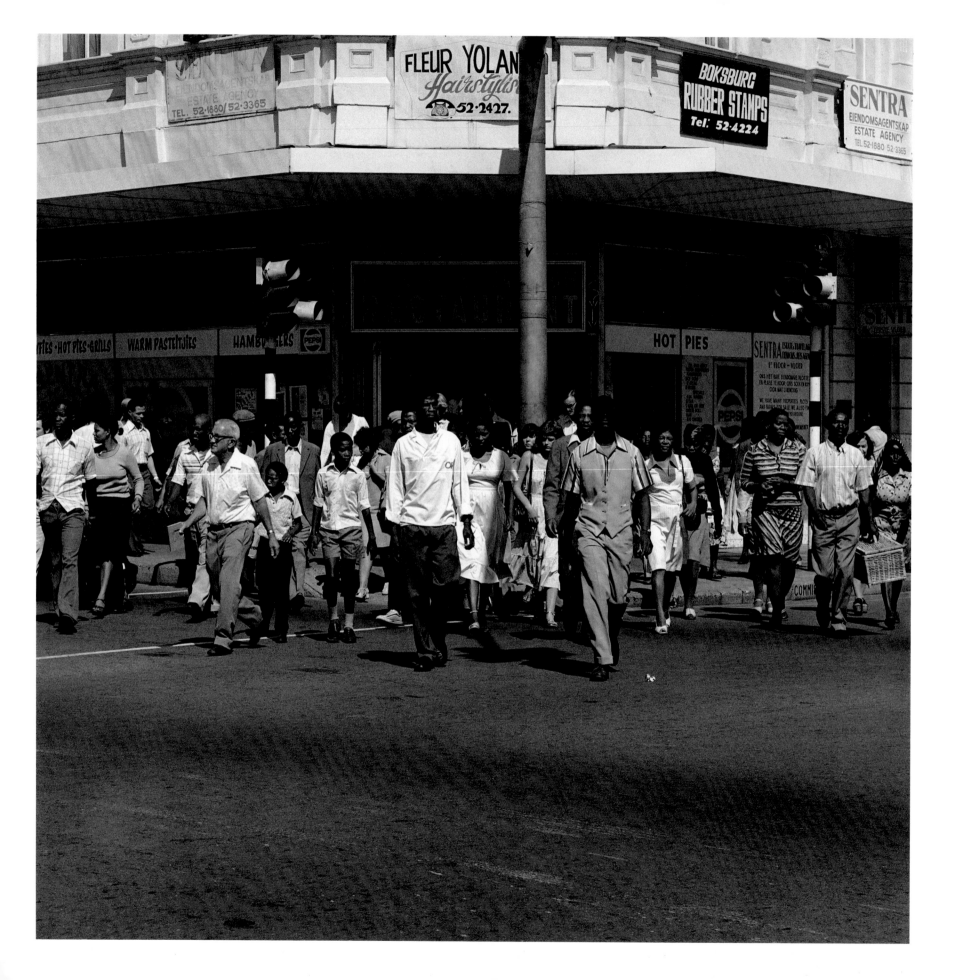

PHOTOGRAPHS FROM

In Boksburg a book published in 1982 by the
Gallery Press, Cape Town

Saturday morning at the corner of Commissioner and Trichardts Streets, Boksburg,
Transvaal. 1979

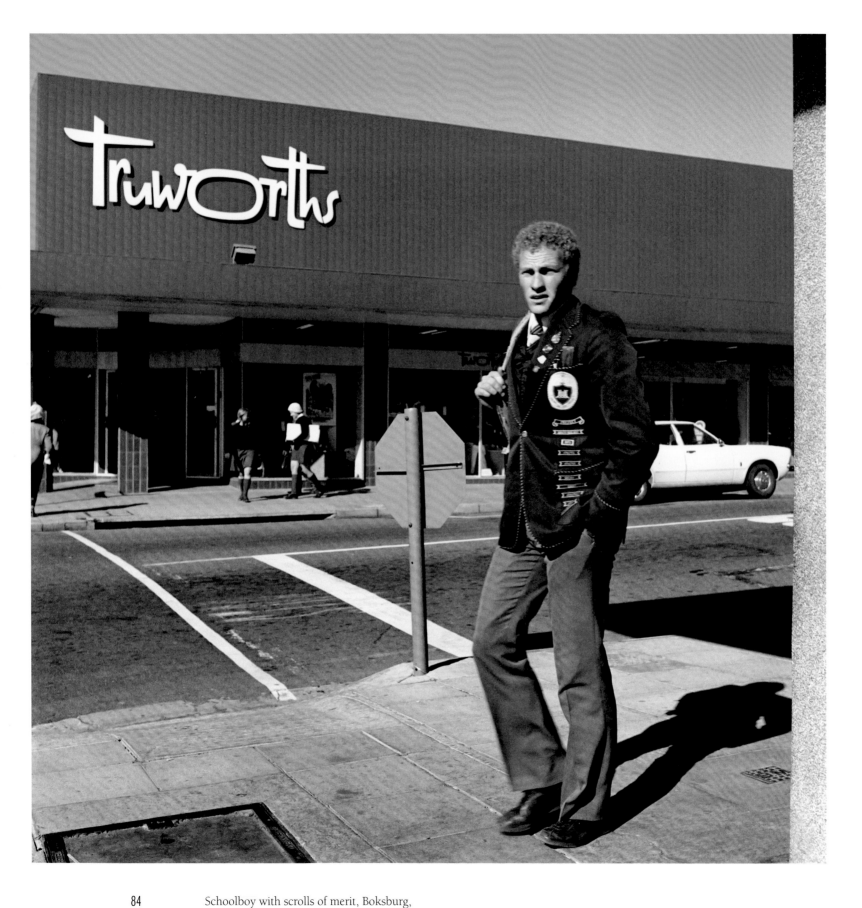

84 Schoolboy with scrolls of merit, Boksburg,
■ Transvaal. April 1979

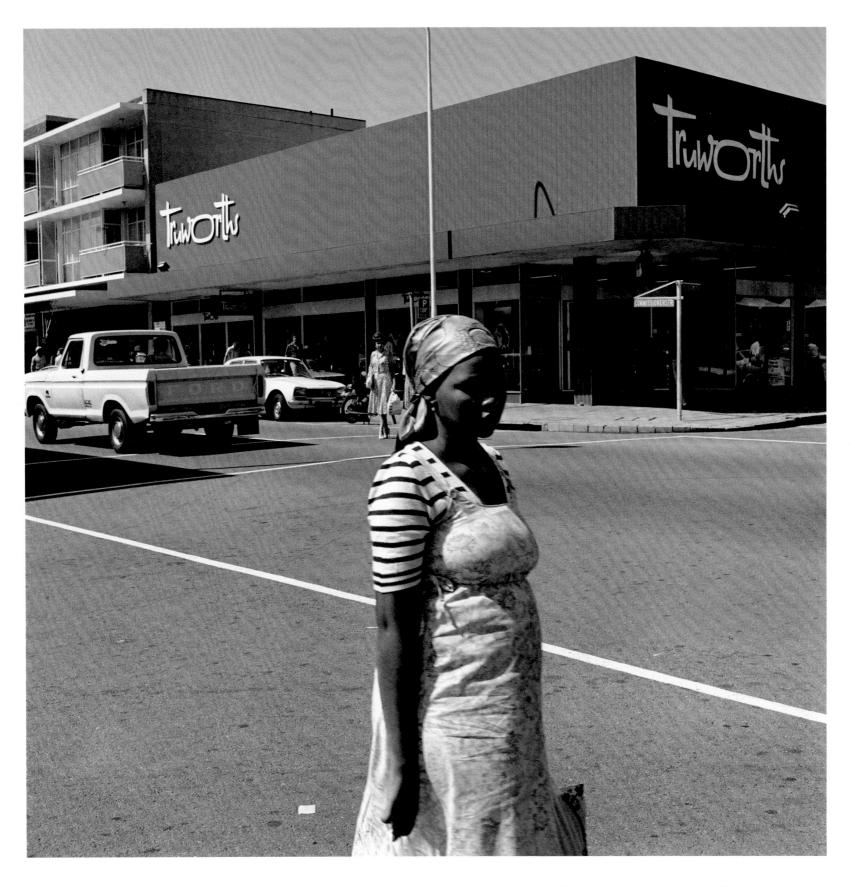

On the corner of Commissioner and Eloff Streets, Boksburg,
Transvaal. April 1979

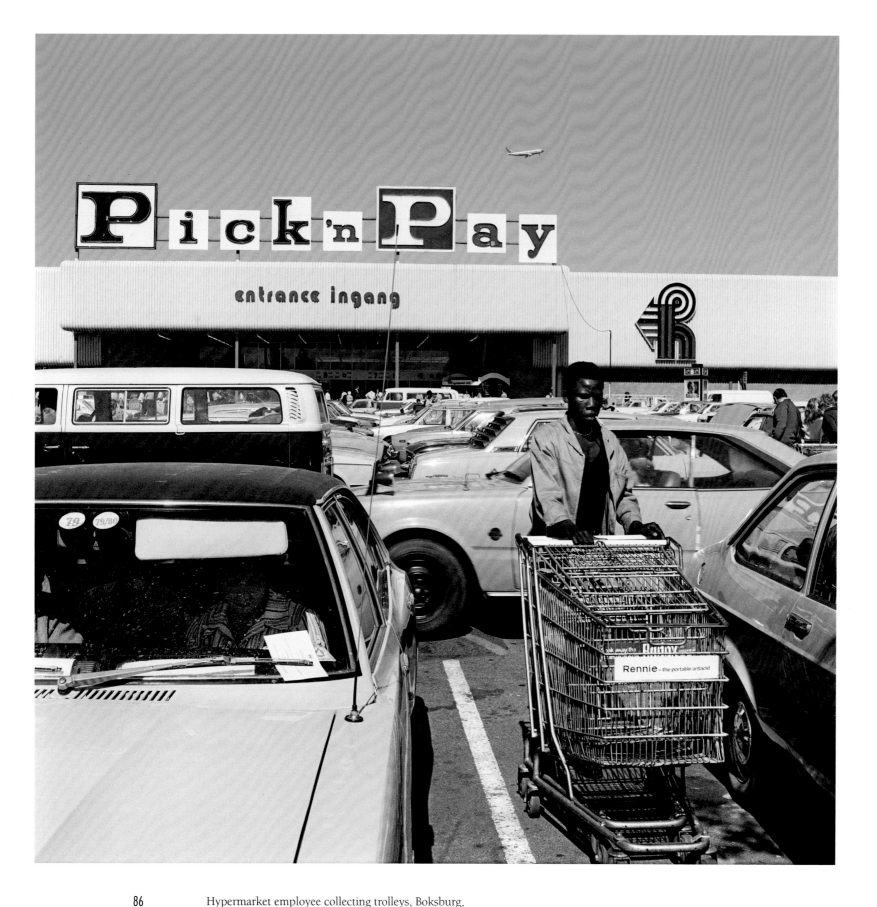

86
■ Hypermarket employee collecting trolleys, Boksburg,
Transvaal. 1980

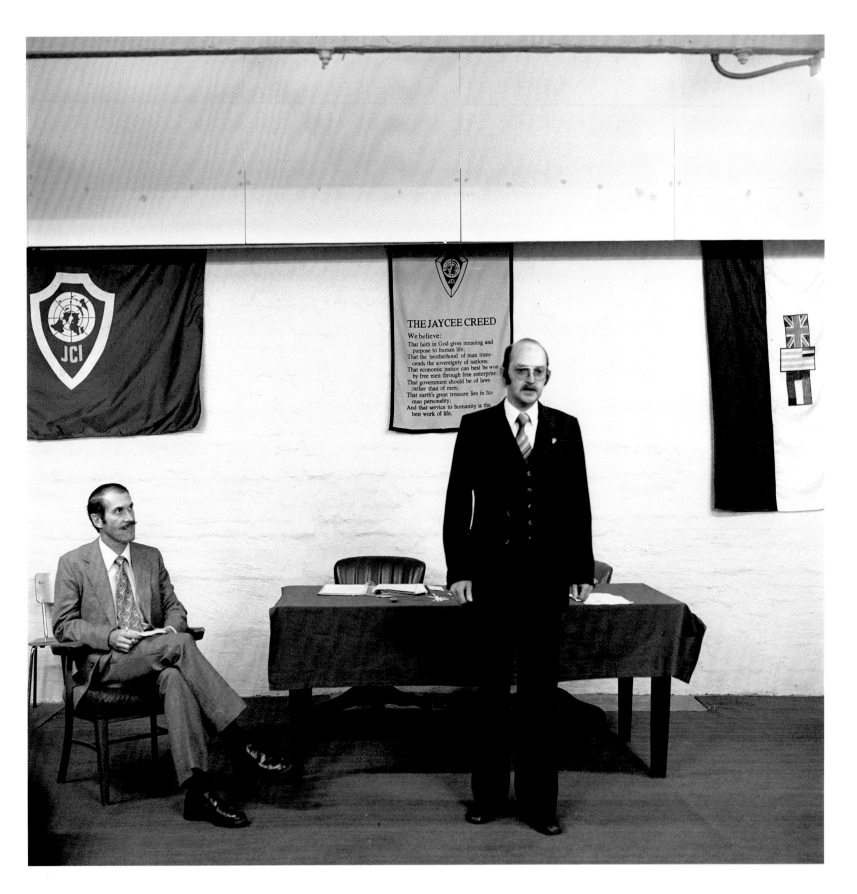

Jaycee member giving an impromptu speech during a course in effective public speaking,

at the Jaycee clubhouse in a disused goldmine building, Boksburg, Transvaal. May 1980

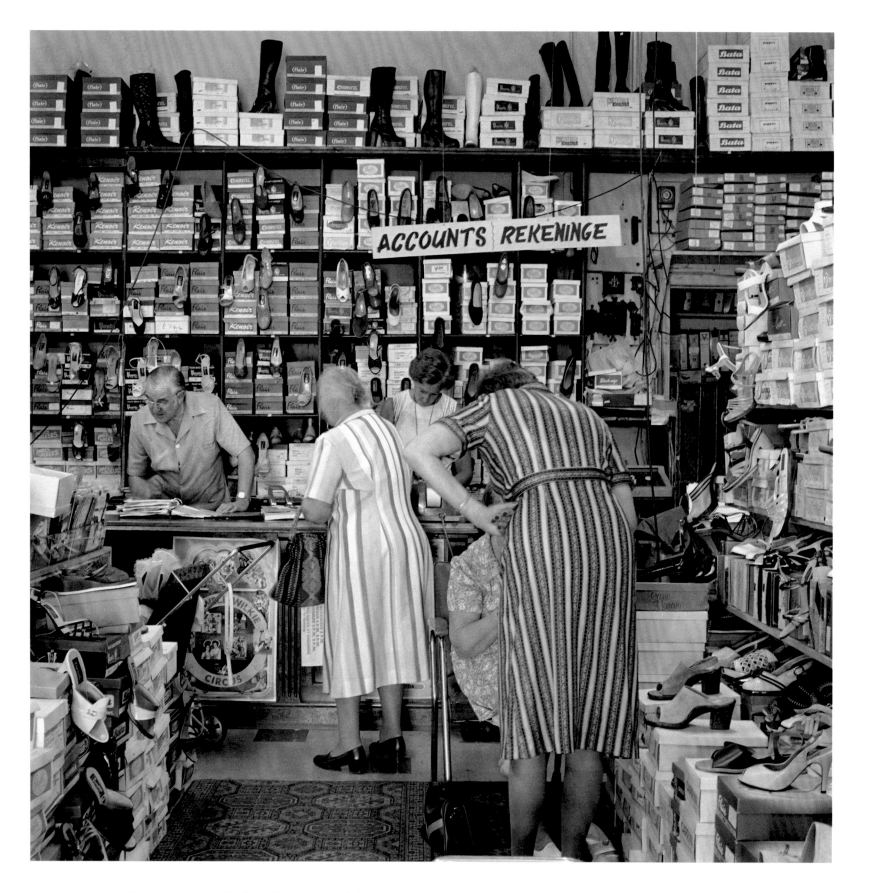

88
■ In a family outfitting store, Boksburg,
Transvaal. 1980

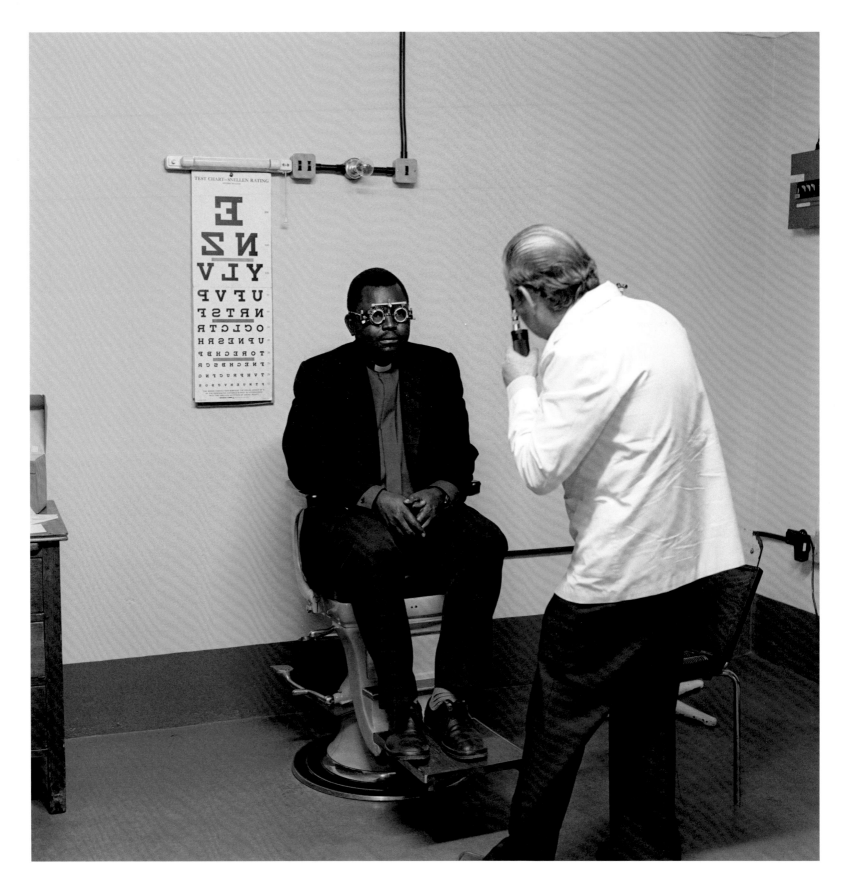

Eyesight testing at the Vosloorus eye Clinic of the Boksburg Lions club, Boksburg, Transvaal. 1980

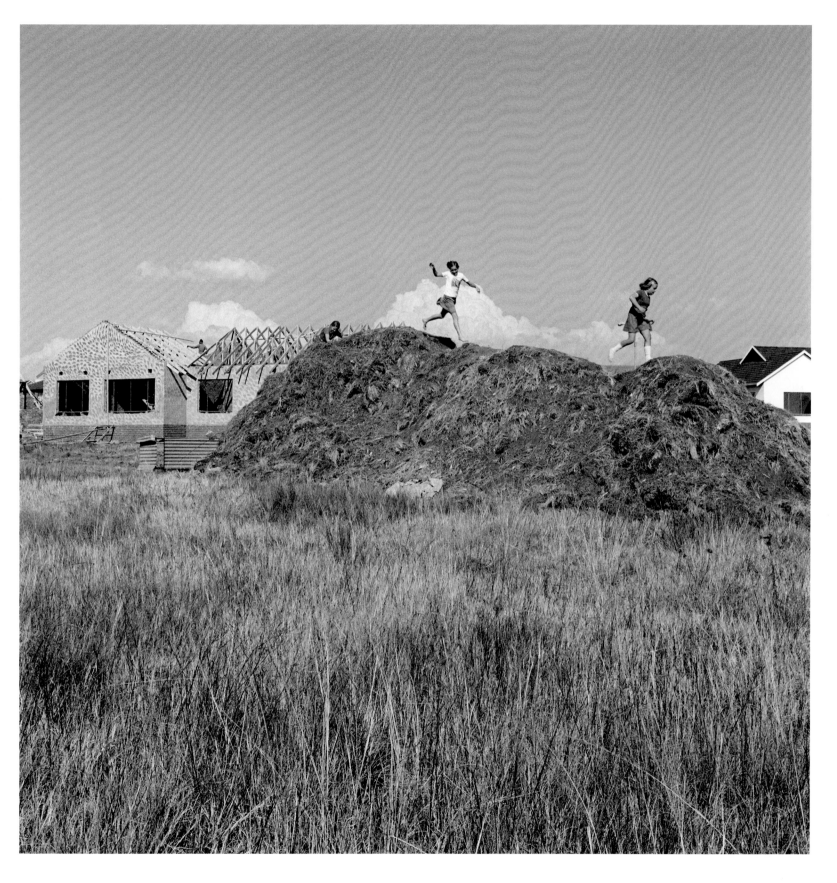

90 'Spec' housing and children on the veld at Parkrand, Boksburg,
■ Transvaal. 1979

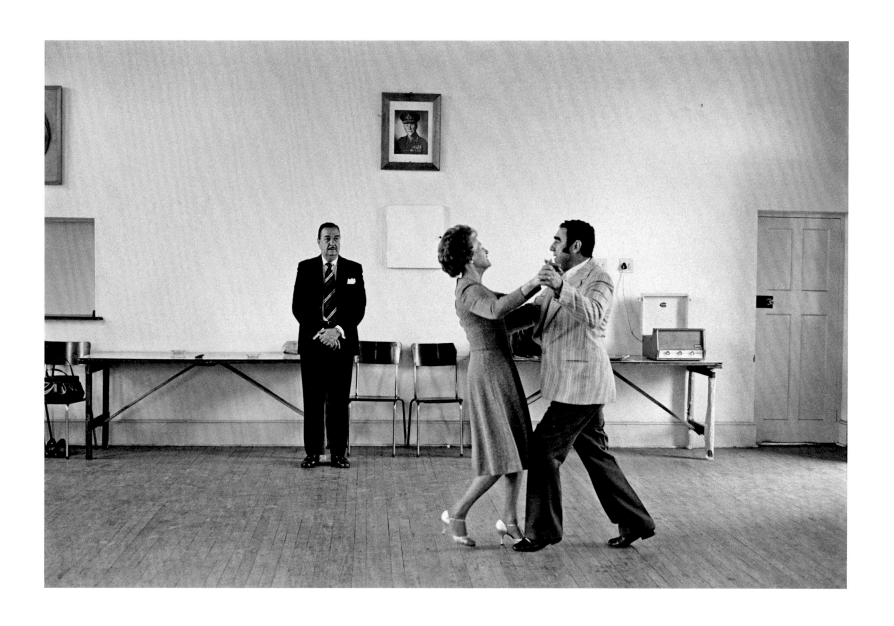

Dancing-master Ted van Rensburg watches two of his ballroom pupils, swinging to the music of a recording of Victor Sylvester
and his Orchestra, in the hall of the Memorable Order of Tin Hats, at the old Court House, Boksburg, Transvaal. May 1980

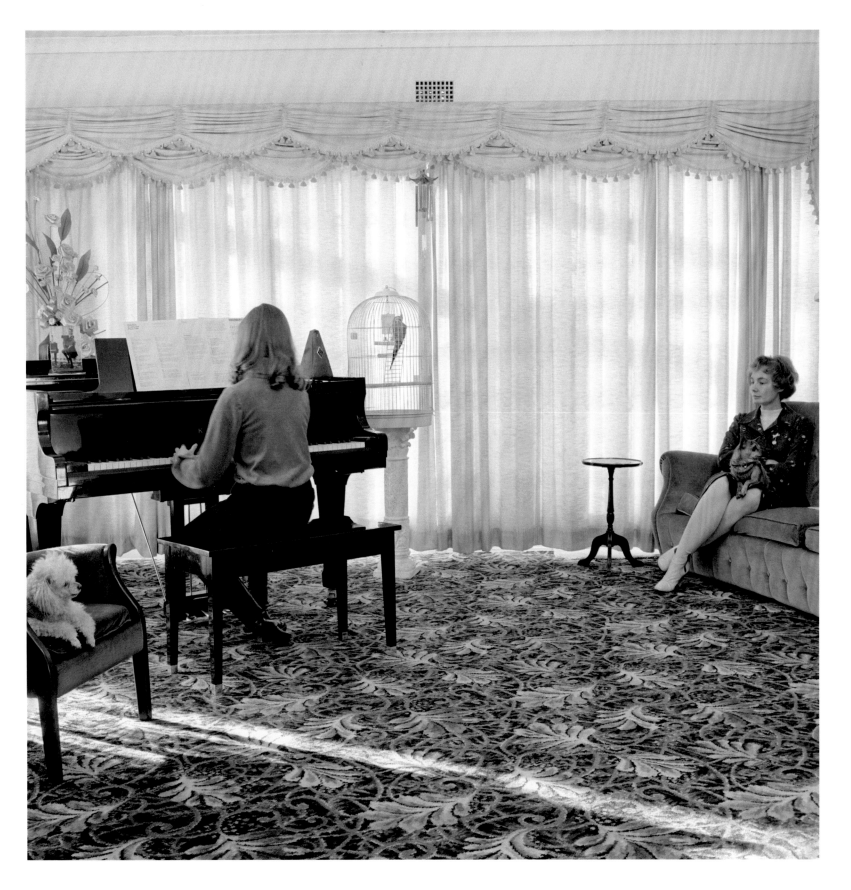

92 A girl and her mother at home, Boksburg,
Transvaal. 22 June 1980

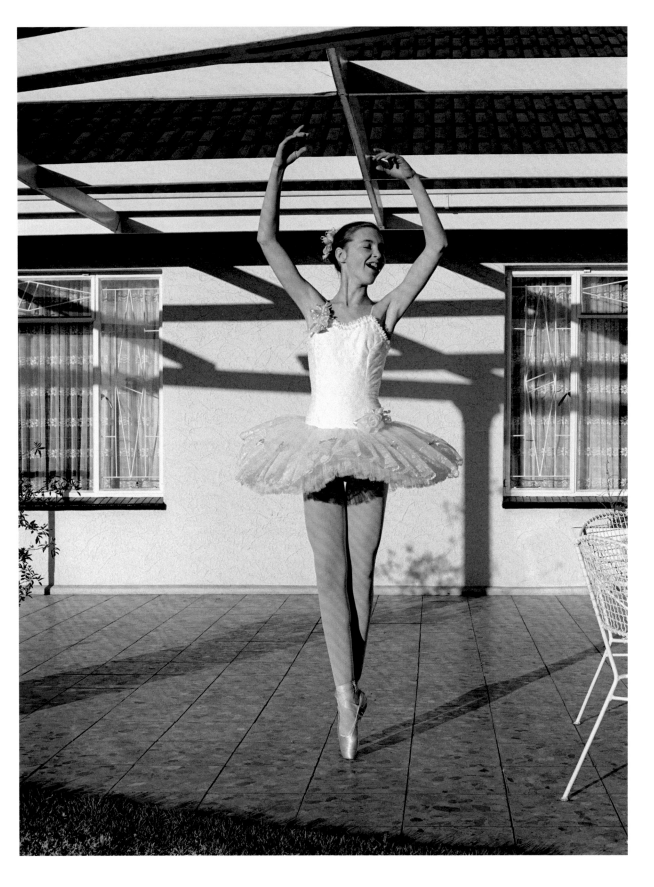

Girl in her new tutu on the stoep, Boksburg,
Transvaal. 22 June 1980

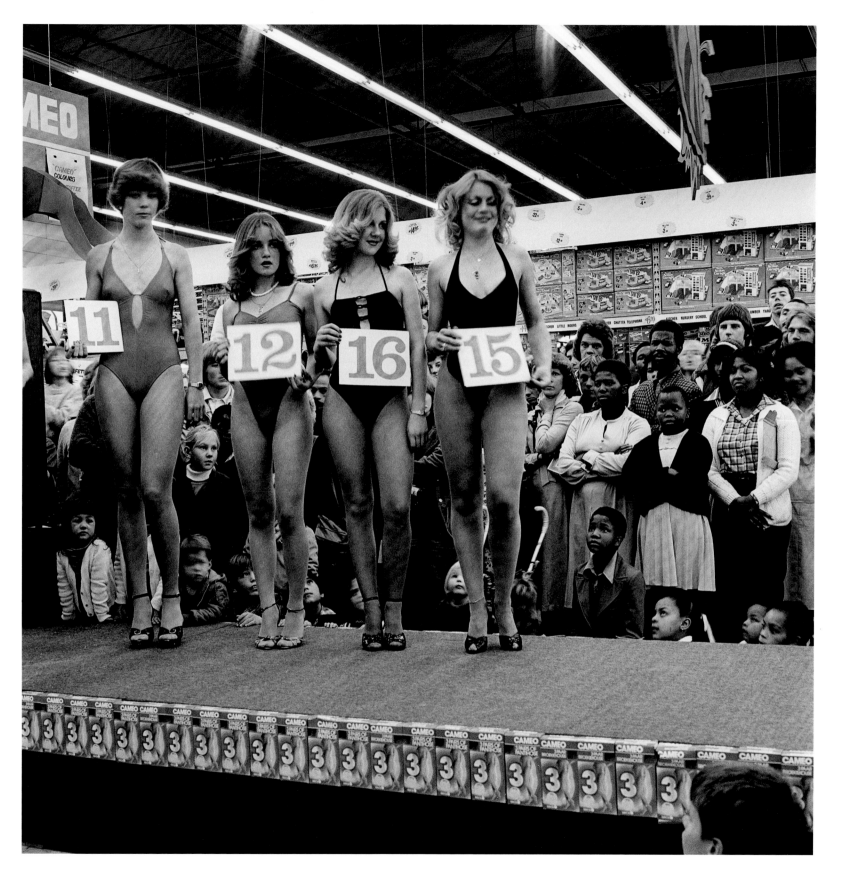

94

Saturday moring at the Hypermarket: Semi-final of the Miss lovely Legs Competition, Boksburg,
Transvaal. 28 June 1980

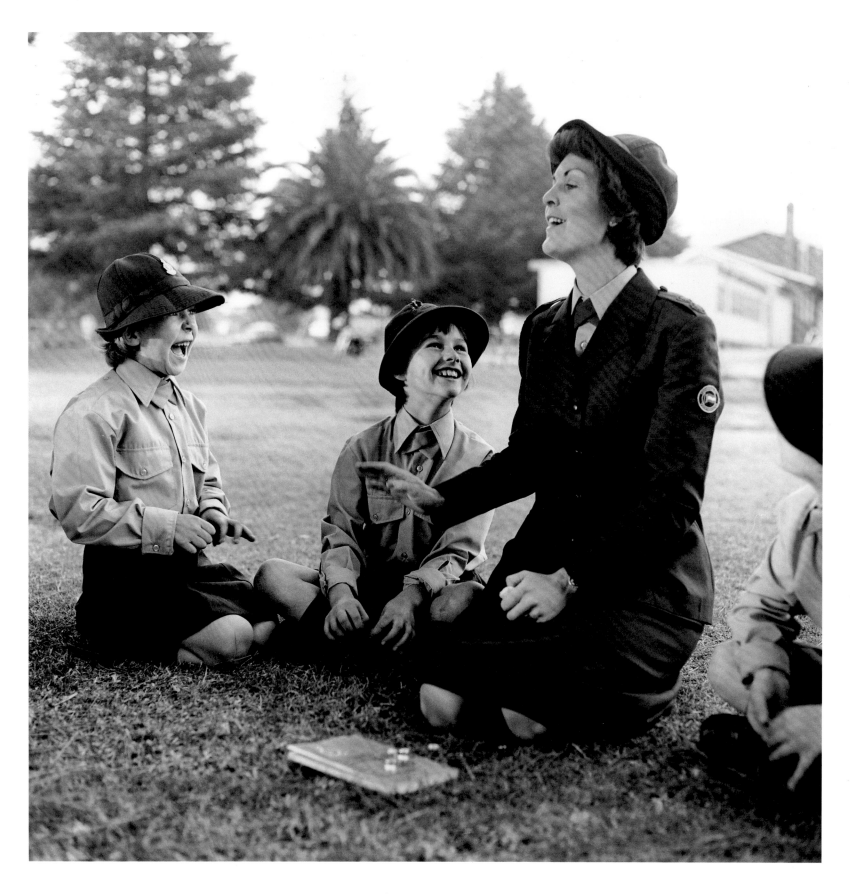

At a meeting of the Voortrekkers in the suburb of Witfield, Boksburg,
Transvaal. June 1980

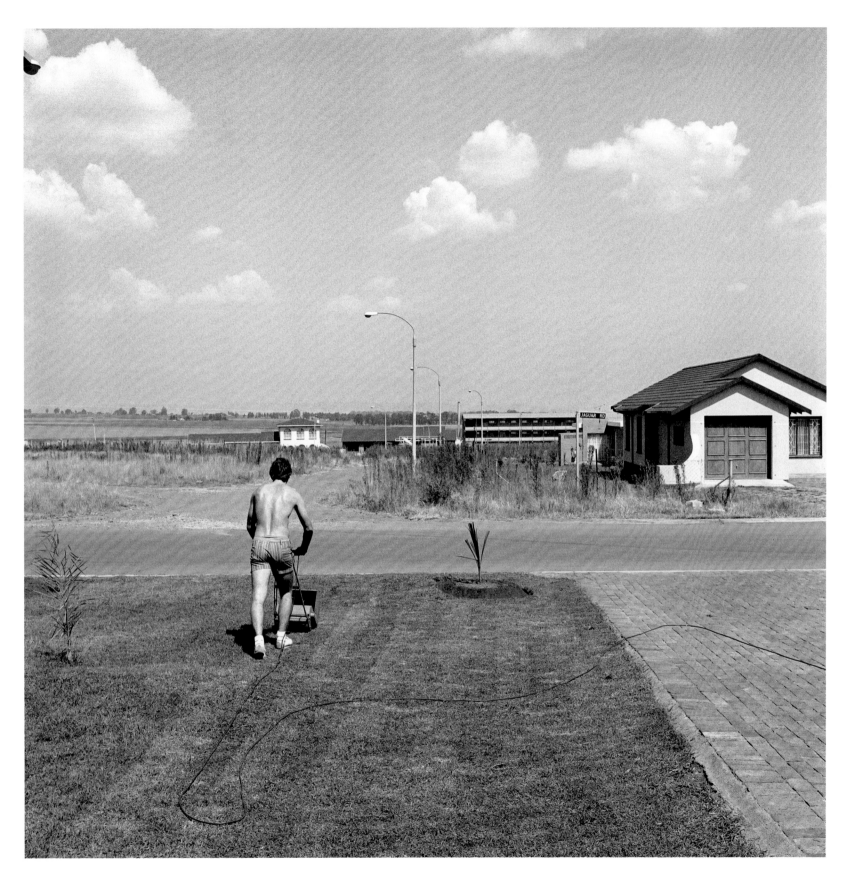

96 Saturday afternoon in Sunward Park, Boksburg,
■ Transvaal. April 1979

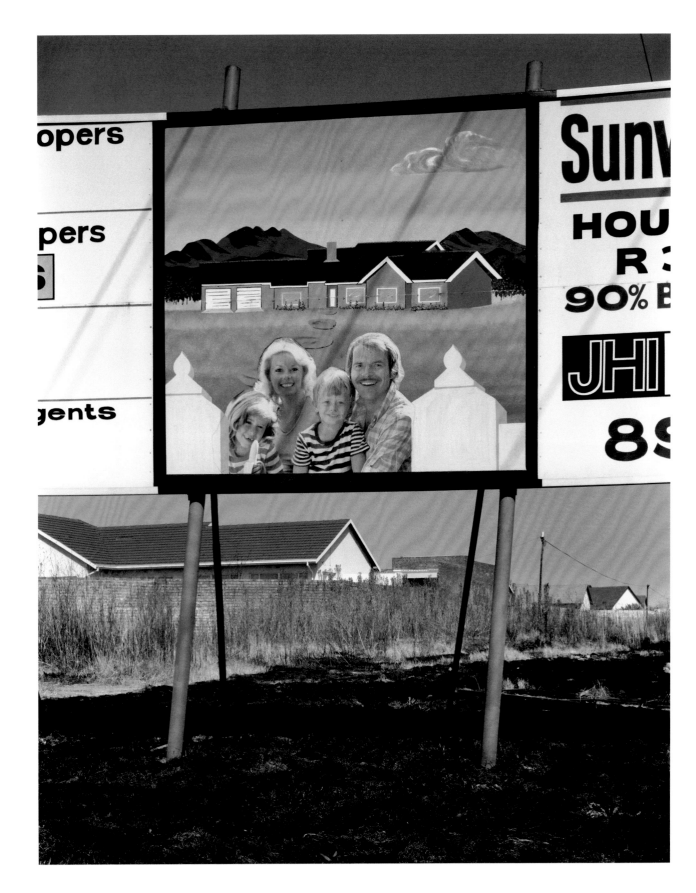

98
■ Domestic workers wait at a suburban shopping centre in a white suburb for the bus that will take them to their homes in the black township of Vosloorus, Boksburg, Transvaal. 1980

During a session of the Junior Town council at the Town Hall, Boksburg, Transvaal. 1980

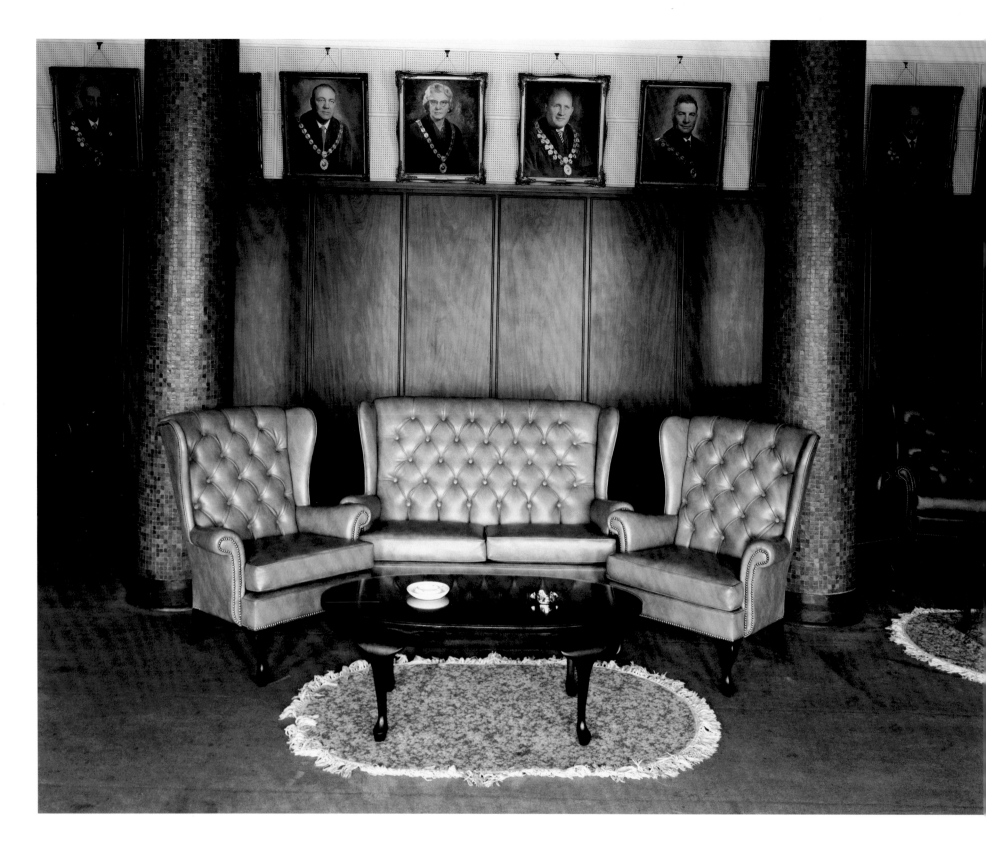

100 The Mayor's Parlour at the Town Hall, Boksburg,
▬ Transvaal. 12 June 1980

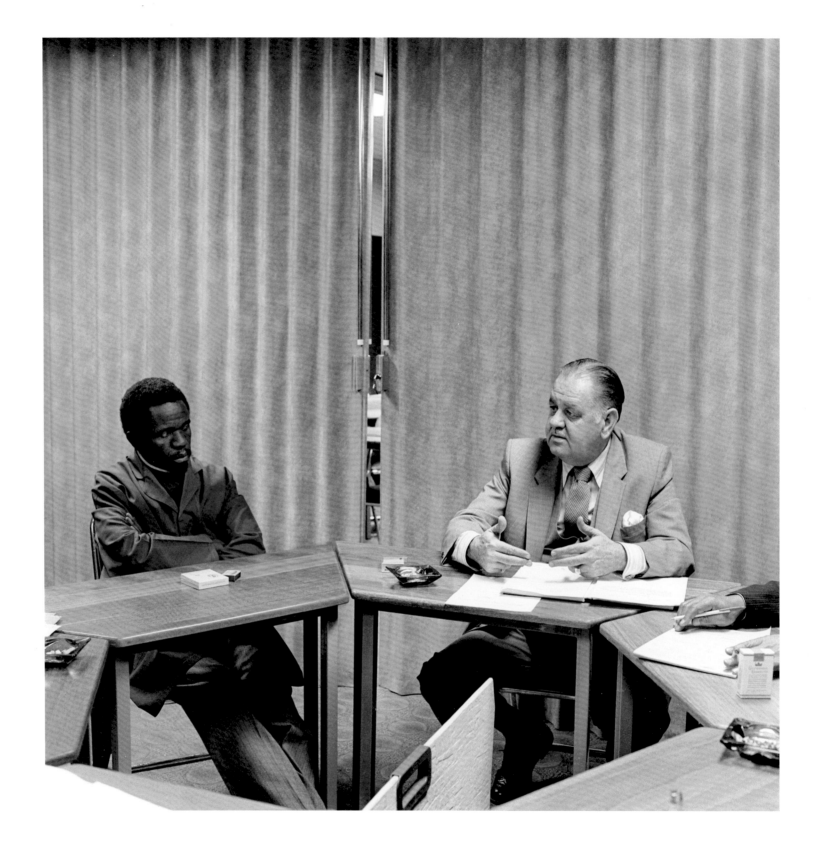

Meeting of the worker-management Liaison Committee of the Colgate-Palmolive Company, Boksburg, Transvaal. 10 July 1980

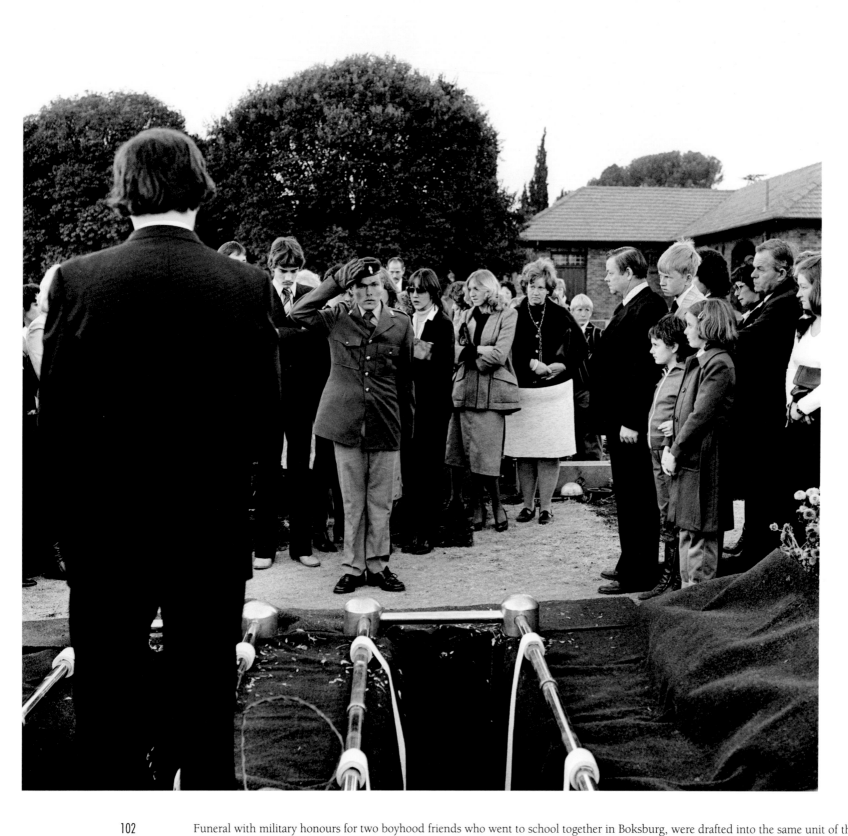

102 Funeral with military honours for two boyhood friends who went to school together in Boksburg, were drafted into the same unit of the South African Army, and were killed in the same action against SWAPO insurgents on the Namibia-Anglola border, Boksburg, Transvaal. 1980

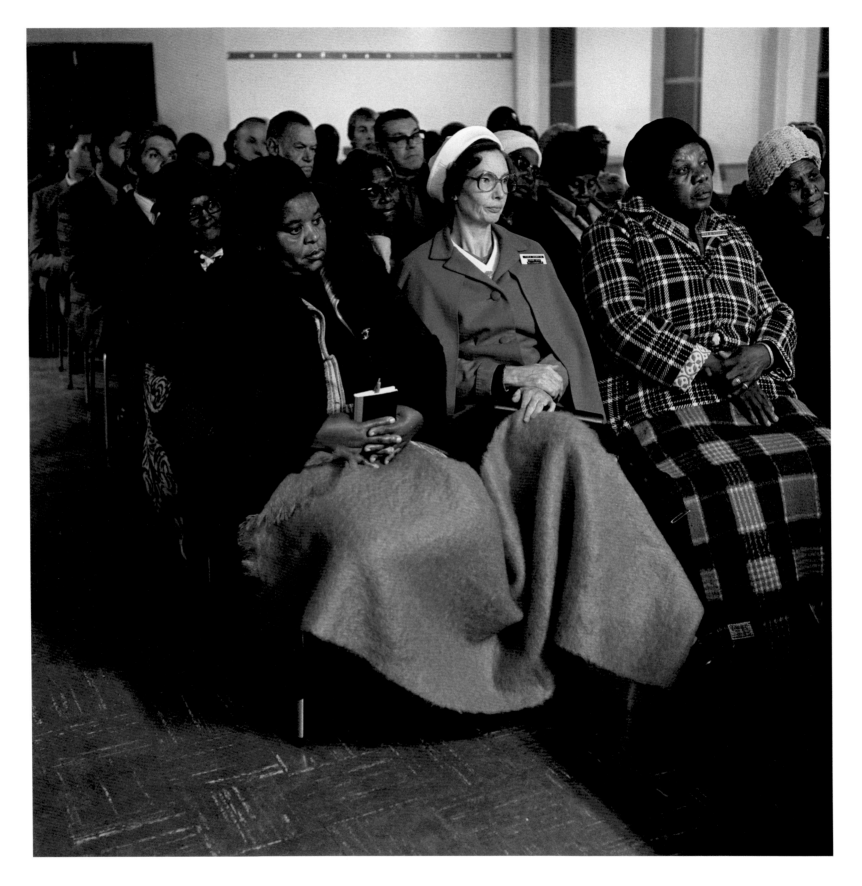

Members of the Methodist Church meet to discuss ways of reducing racial, cultural and class barriers which divide them, Daveyton, Transvaal. 3 July 1980

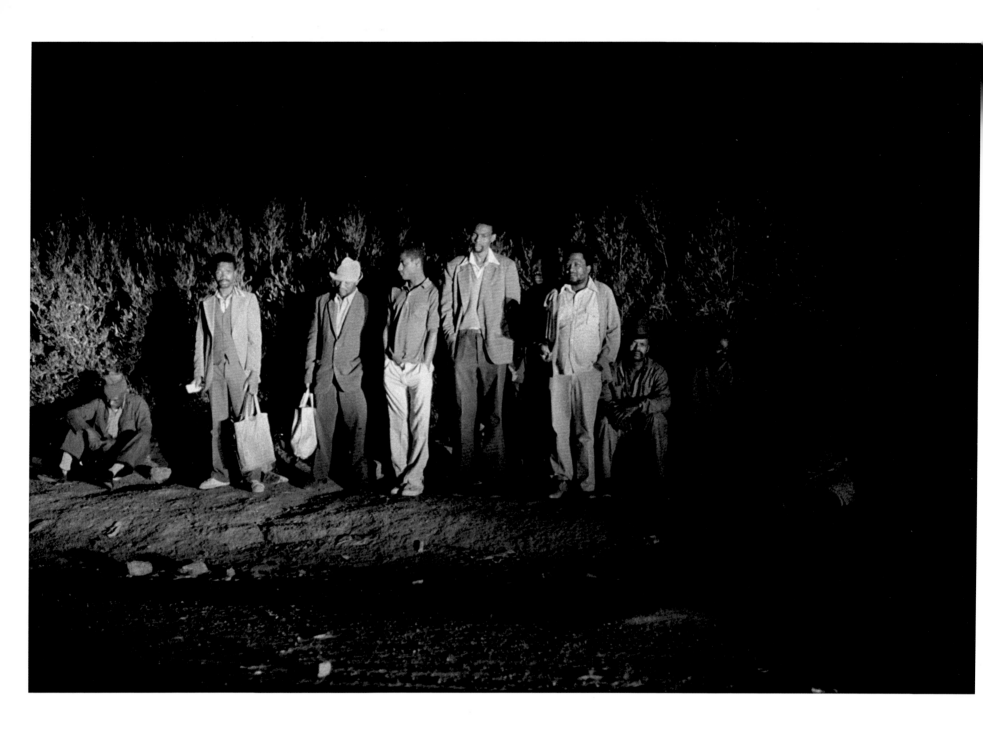

The Transported of KwaNdebele a book published
in 1989 by Aperture and Duke, New York

GOING TO WORK: The apartheid dream required the geographical separation of the
races. To this end millions of Black people were required to live in ethnic 'homelands' or
Bantustans most of which were remote from centres of employment. Here at 2:40 a.m. a
line has formed in the bush of KwaNdebele for the first bus of the day to Pretoria, about
160 kilometres and 3 ¼ hours away. There, many will make a further journey by bus,
train or taxi to be at work by 7:00 a.m. They will make the reverse journey after work.
Some will therefore travel up to eight hours per day. Mathysloop, KwaNdebele, 1984

GOING TO WORK: 2:45 a.m. the first bus of the day pulls in at Mathysloop on the Boekenhouthoek-Marabastad route from KwaNdebele to Pretoria

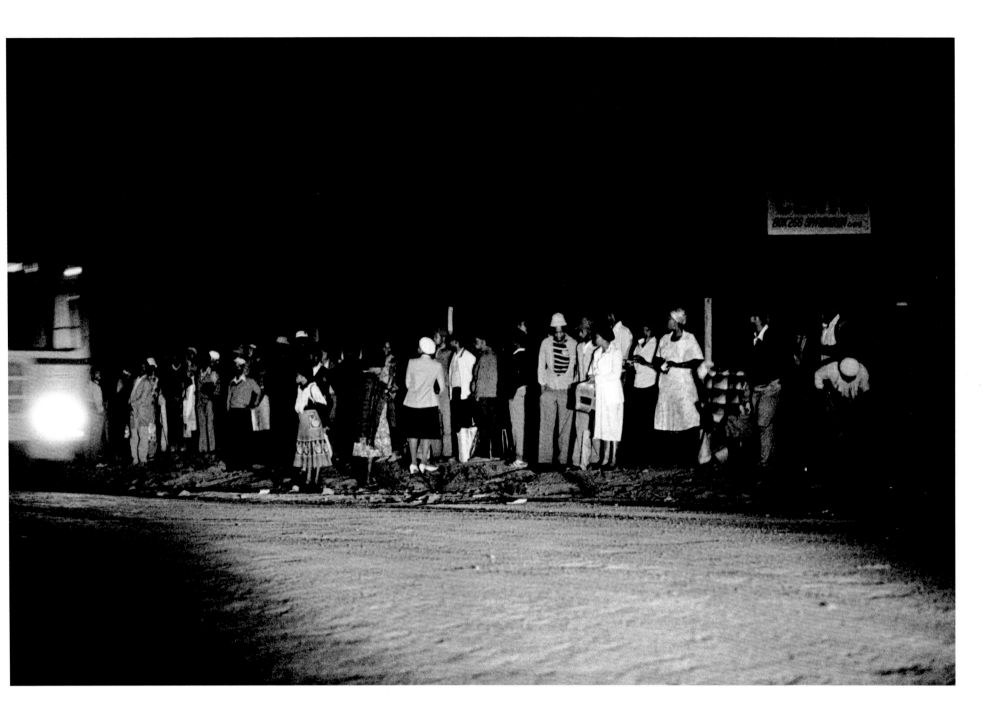

GOING TO WORK: Standing room only now, on the Wolwekraal-Marabastad bus, which is licensed to carry 62 sitting and 29 standing passengers. 1983

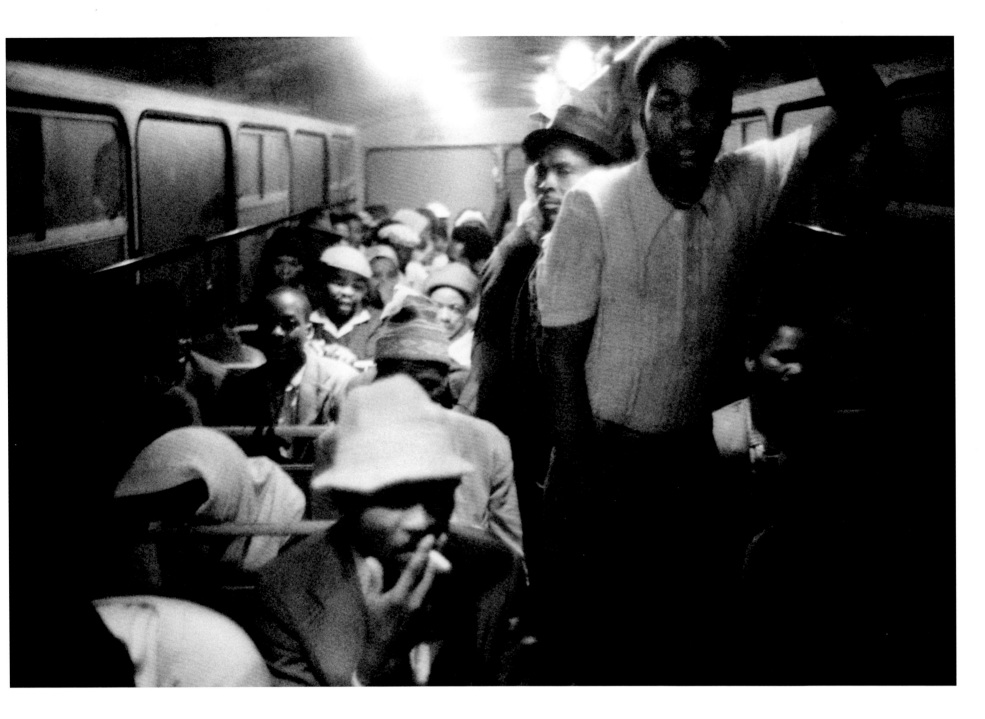

GOING TO WORK: Wolwekraal-Marabastad bus at about 4 a.m. More than an hour and a half still to go. 1983

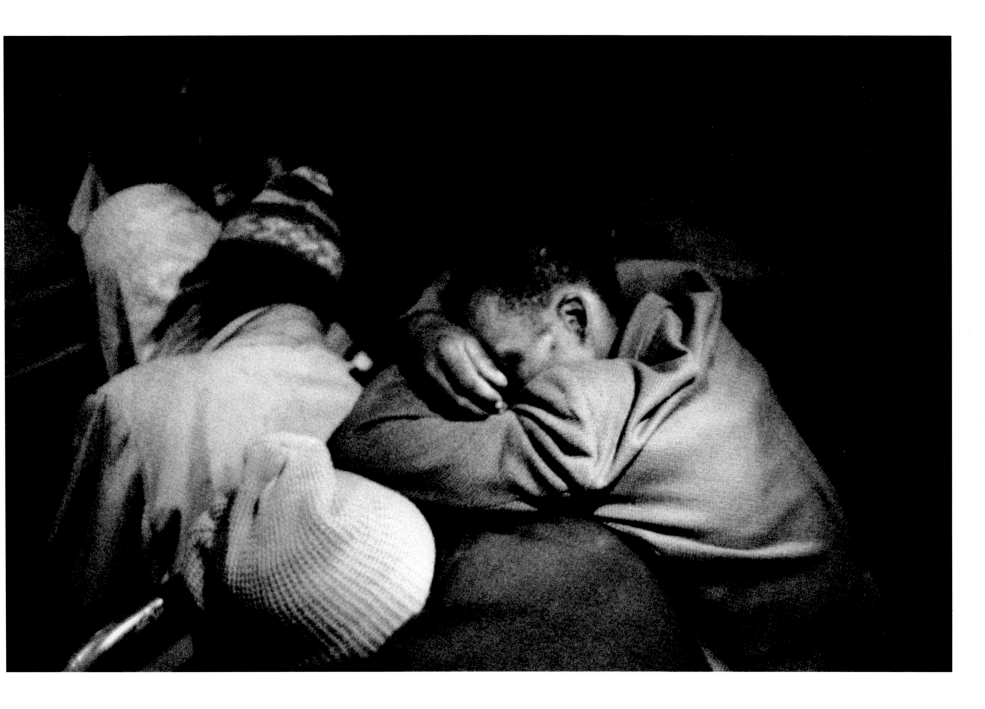

GOING TO WORK: 5:40 a.m. having arrived at Marabastad in Pretoria, people from KwaNdebele now queue for onward connections to their place of work. Some will travel for another hour. 1983

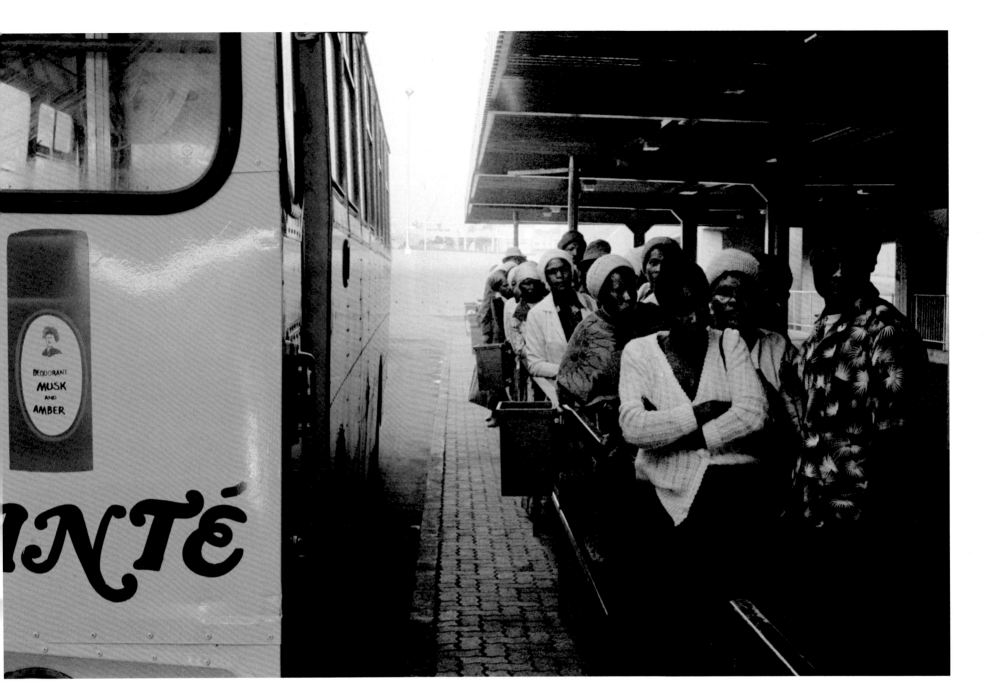

Travellers from KwaNdebele buying weekly season tickets at the PUTCO bus depot in Marabastad, Pretoria. 1983

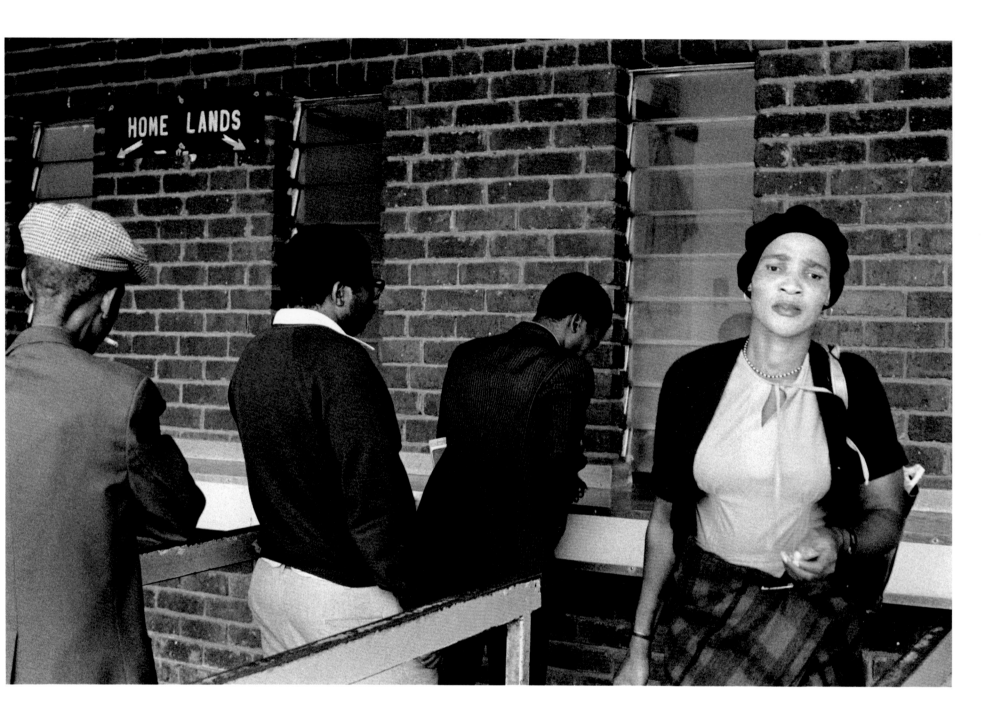

GOING HOME: about 8:30 p.m. about an hour still to go on the Marabastad-Waterval bus. 1984

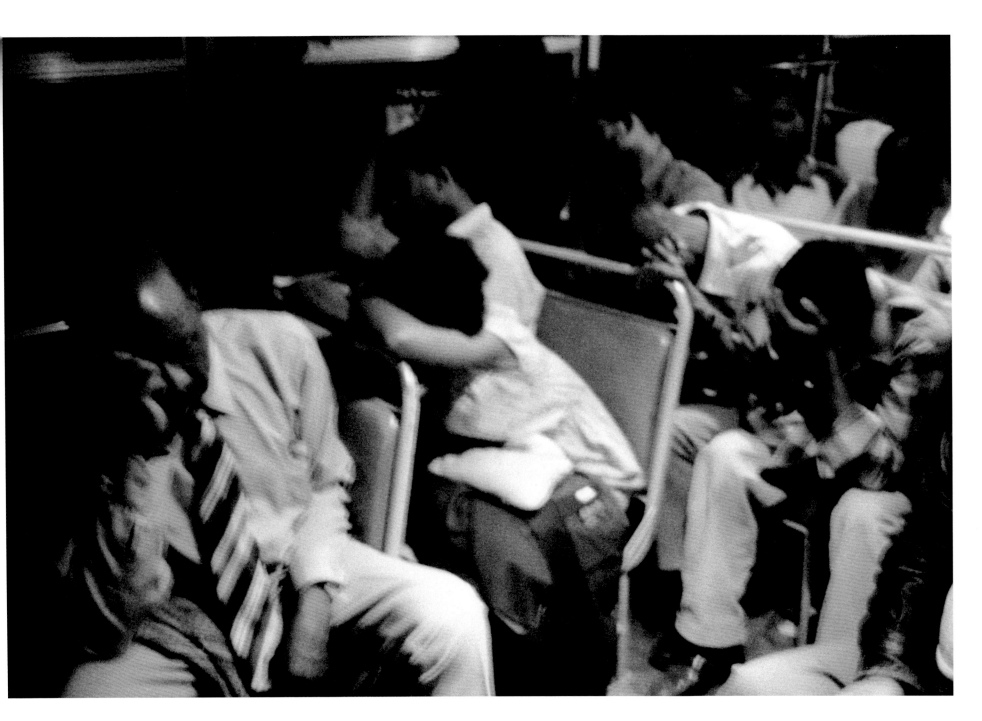

GOING HOME: Some on this bus will reach home at between 9:30 and 10 p.m and rise again the next morning at between 2:00 and 3:00 a.m. 1984

Note in 2006: The cycle still continues.

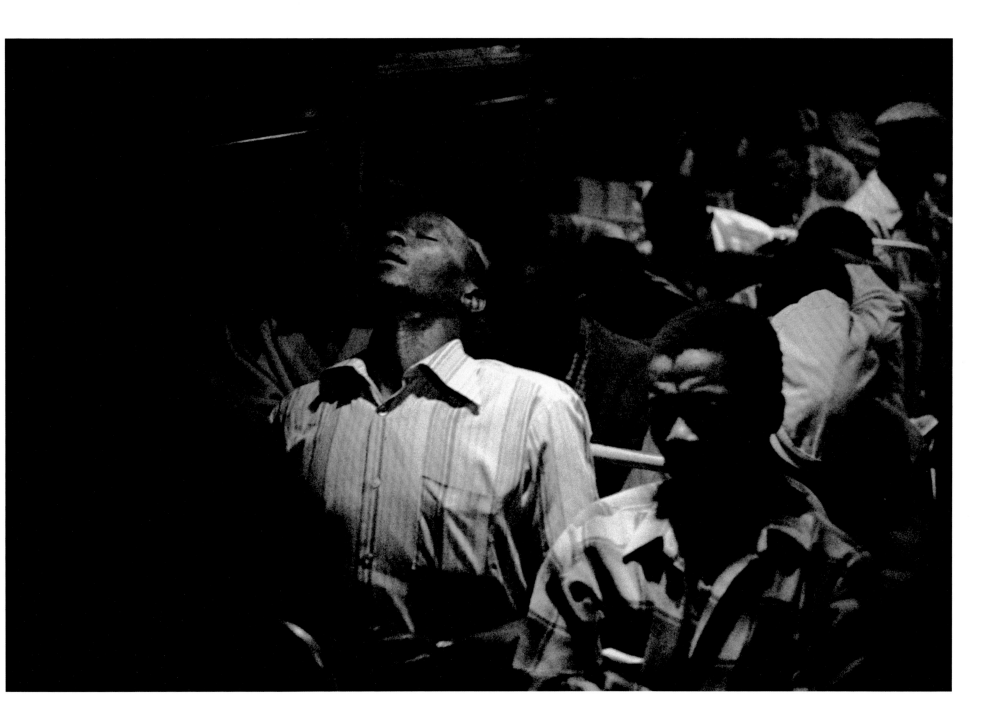

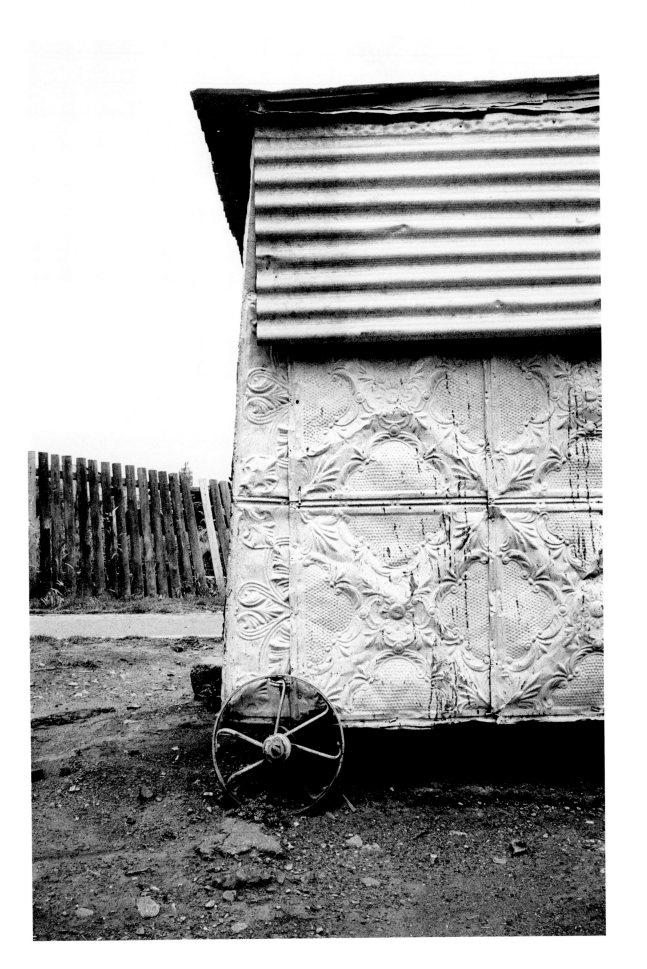

PHOTOGRAPHS FROM

South Africa the Structure of Things Then a book
published in 1998 by the Oxford University Press,
Cape Town and Monacelli, New York

Café-de-Move-On, Braamfontein,
Johannesburg. November 1964

Suburban garden and Table Mountain, Bloubergstrand,
Cape Town. 9 January 1986

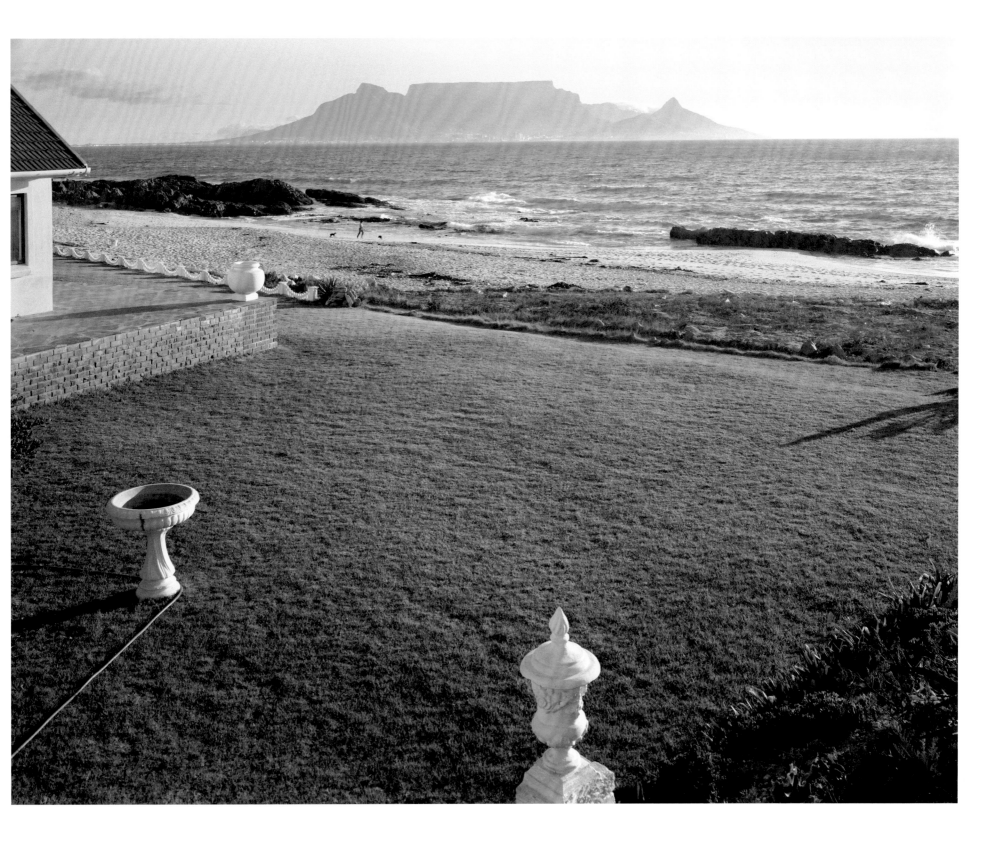

Mother and child in their home after the destruction of its shelter by officials of the Western Cape Development Board, in pursuance of apartheid regulations prohibiting Africans from the Western Cape, Crossroads, Cape Town. 11 October 1984

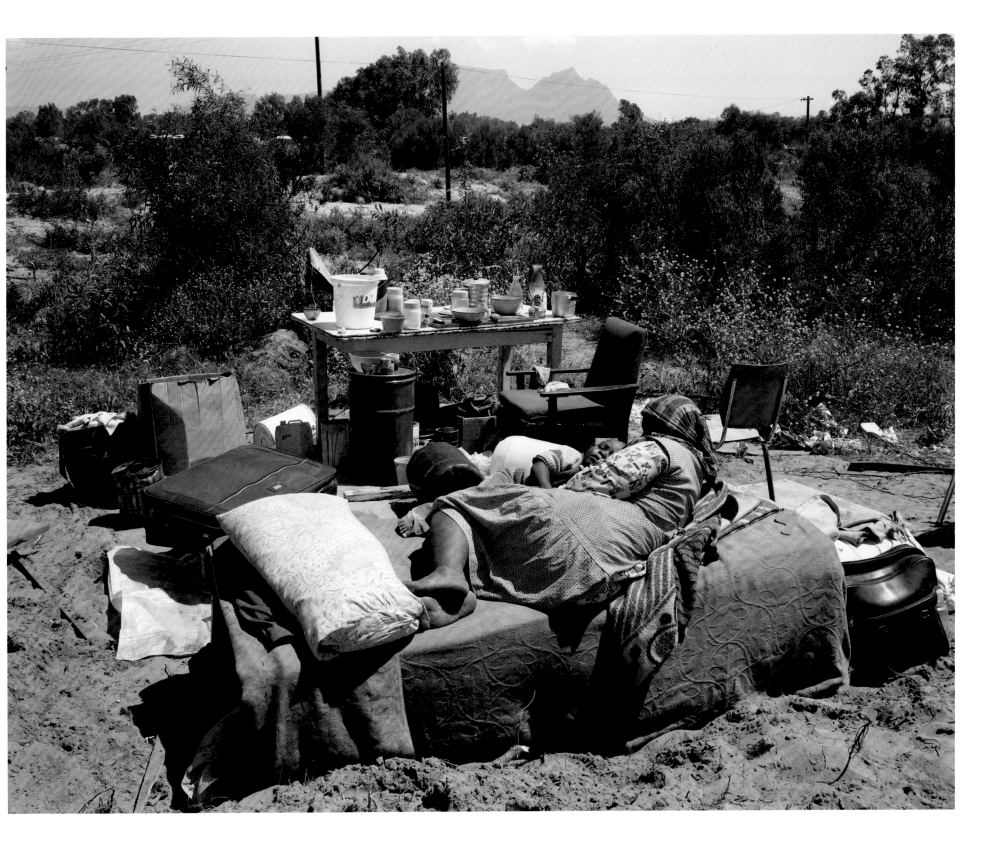

The destruction of District Six after its declaration as a Group Area for whites and the
forced removal of its coloured inhabitiants,
Cape Town. 5 May 1982

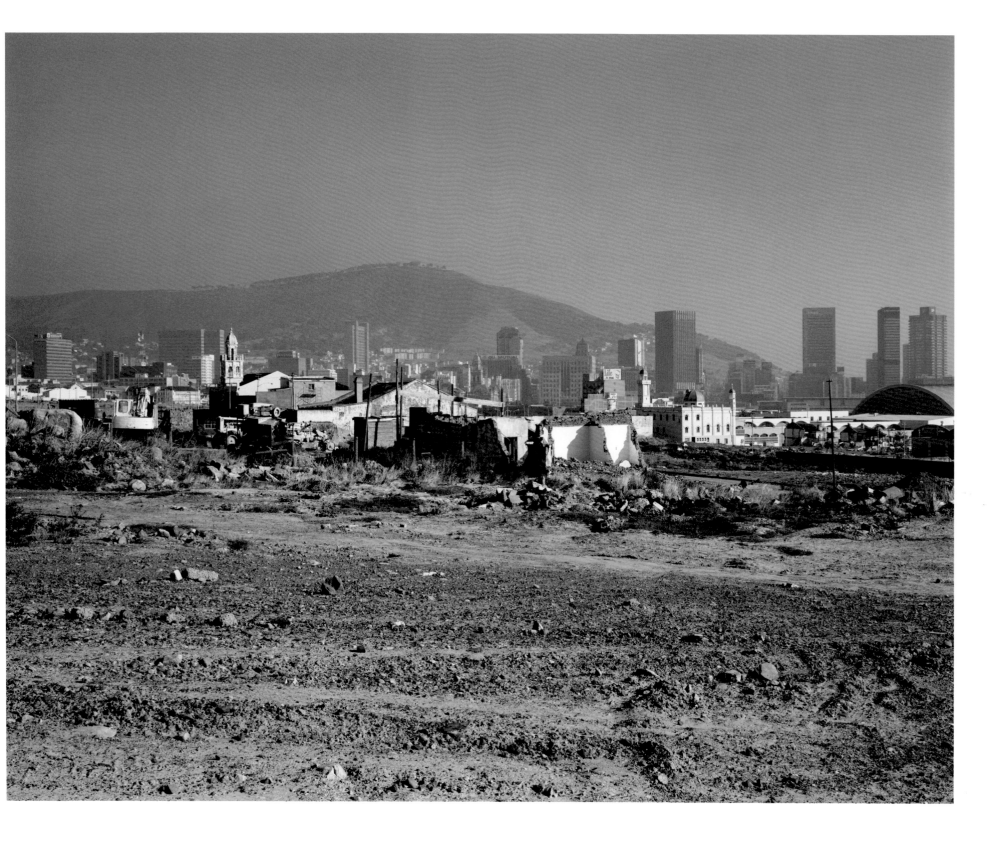

Racially segregated beaches and the boundary between them, Strand,
Cape Province. 16 April 1983

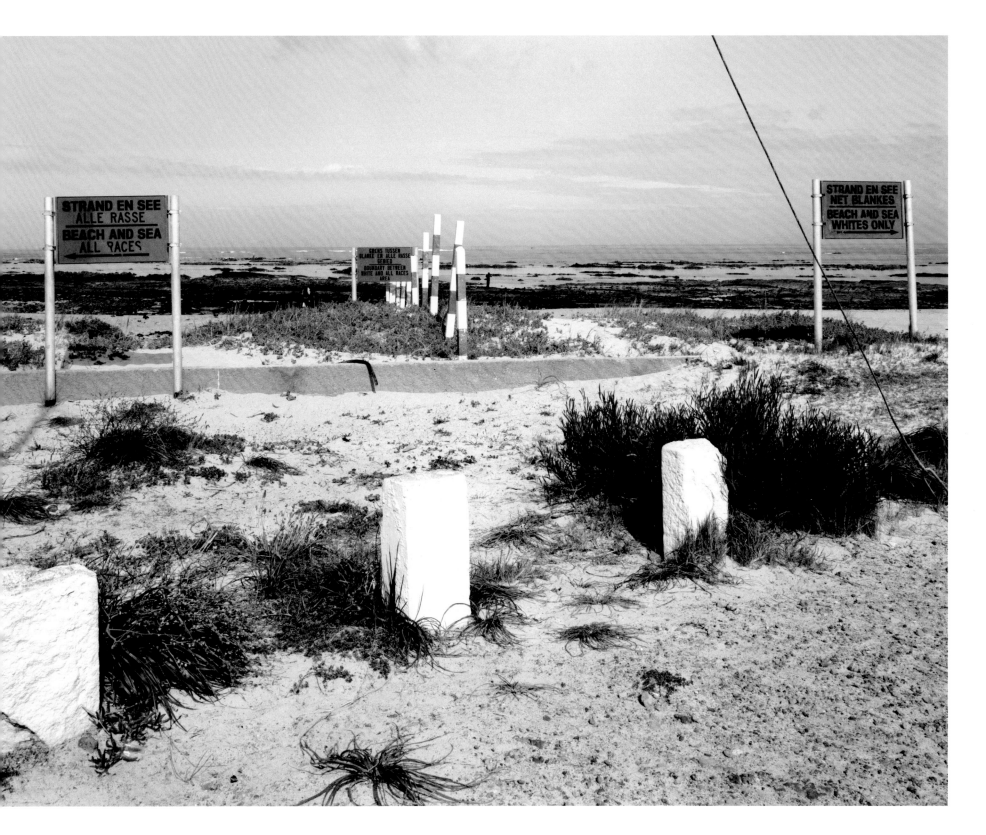

Speculative development by a property developer in putatively 'authentic Cape Dutch' style,
Agatha, Tzaneen, Transvaal. 10 April 1989

Luke Kgatitsoe at his house, bulldozed in February 1984 by the government after the forced removal of the people of Magopa, a black-owned farm, which had been declared a 'black spot', Ventersdorp district, Transvaal. 21 October 1986

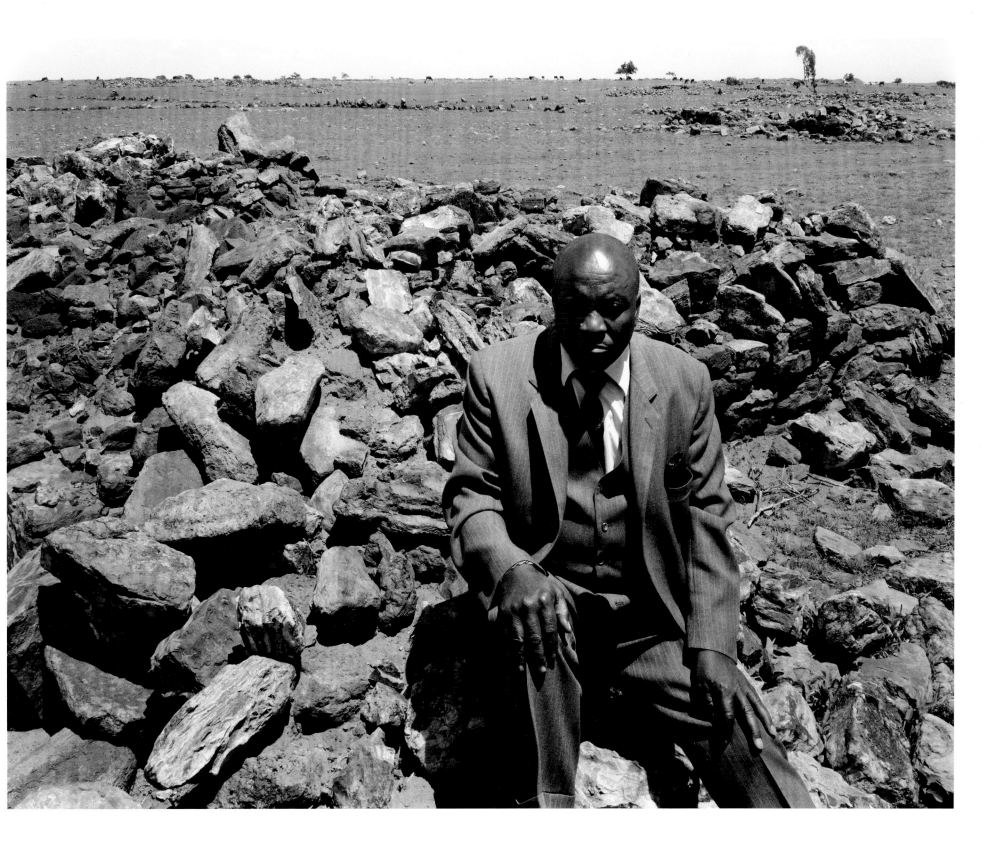

Memorial to those killed in the 'Langa Massacre', 21 March 1985, and to others who
died in the struggle against apartheid; vandalized in 1987 by black vigilantes funded
by Military Intelligence, Kwanabuhle Cemetery, Uitenhage,
Cape Province. 15 September 1990

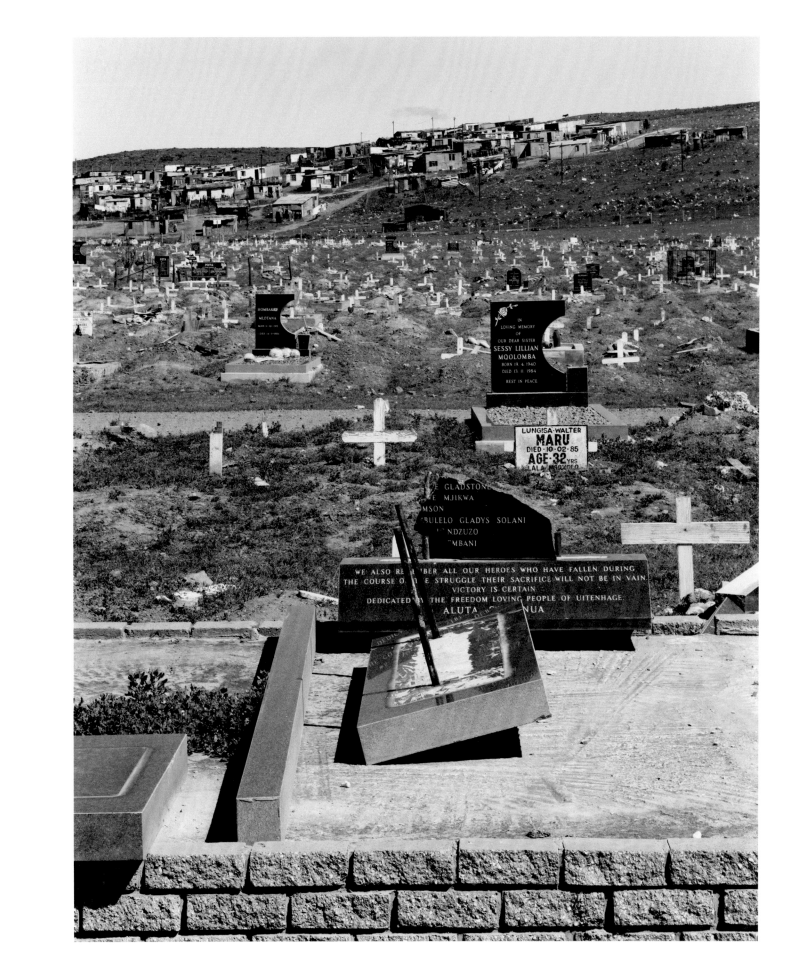

Sunday afternoon during the time of resistance against removal to Letlhabile Resettlement Camp, Oukasie, Brits, Transvaal. 30 November 1986

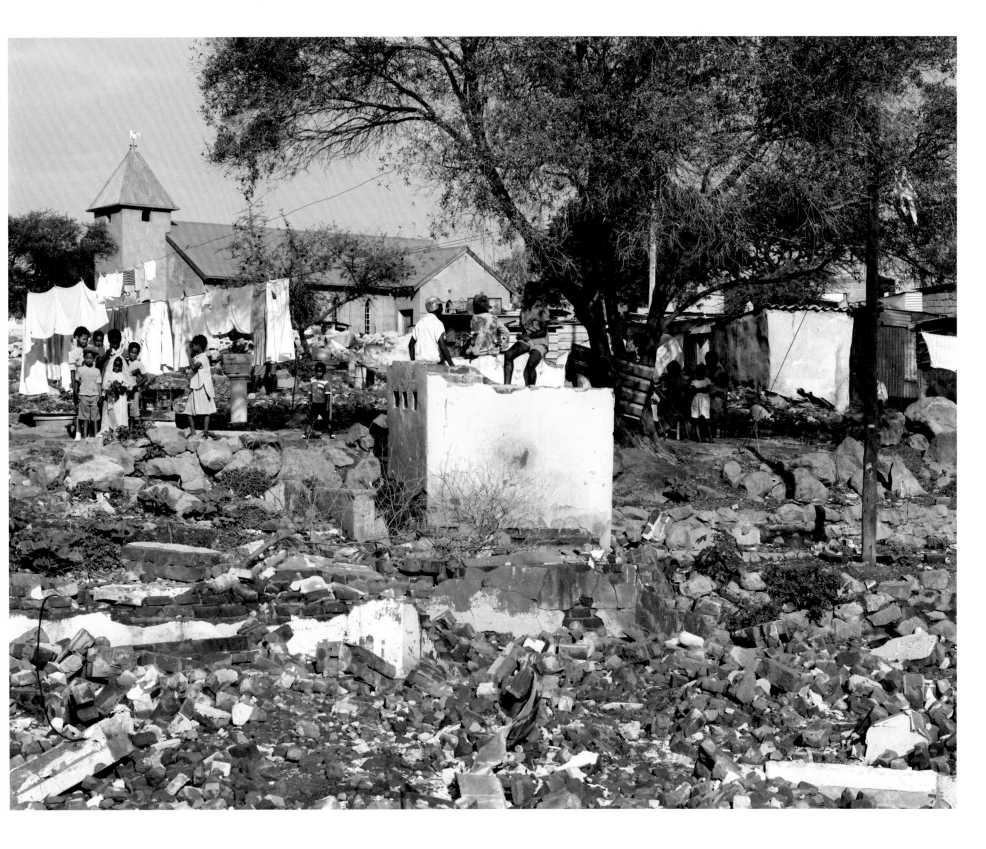

Hassimia Shahib's butchery before the start of forced removal of Indians and demolition of their homes and businesses under the Group Areas Act, Pageview, Johannesburg. April 1976

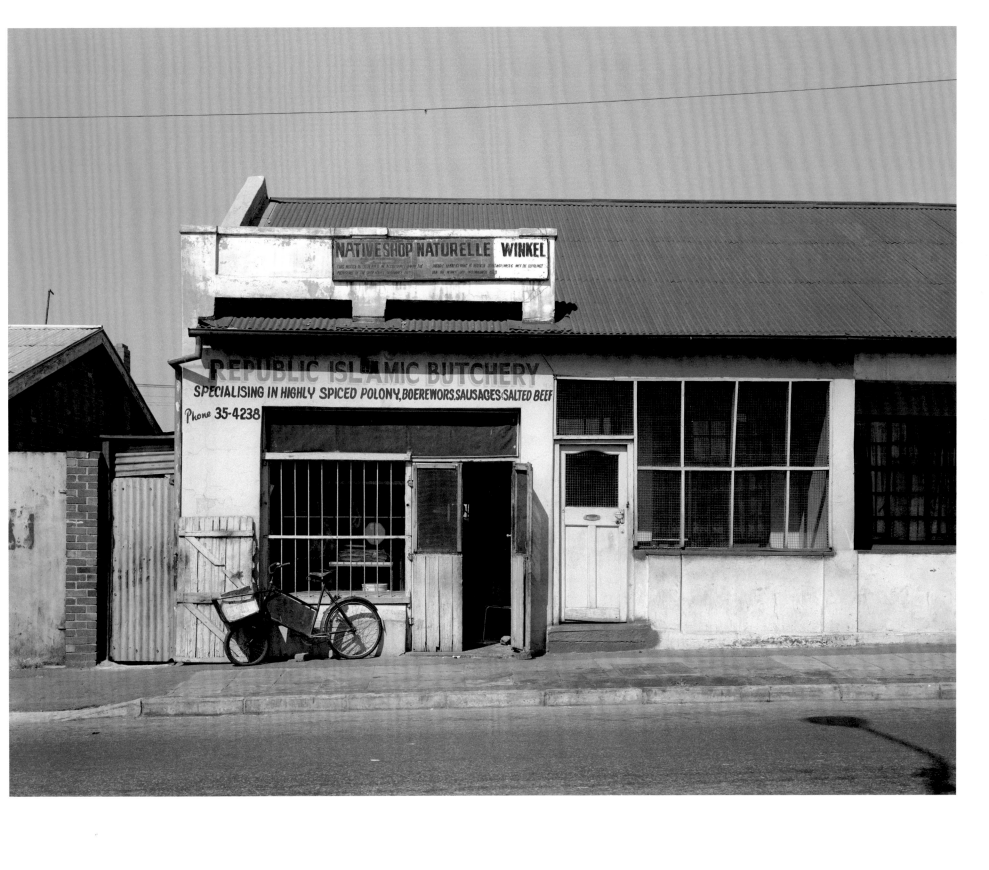

The Docrats' bedroom before the forced removal of Indians and the destruction of their homes under the Group Areas Act, Pageview, Johannesburg. 1976

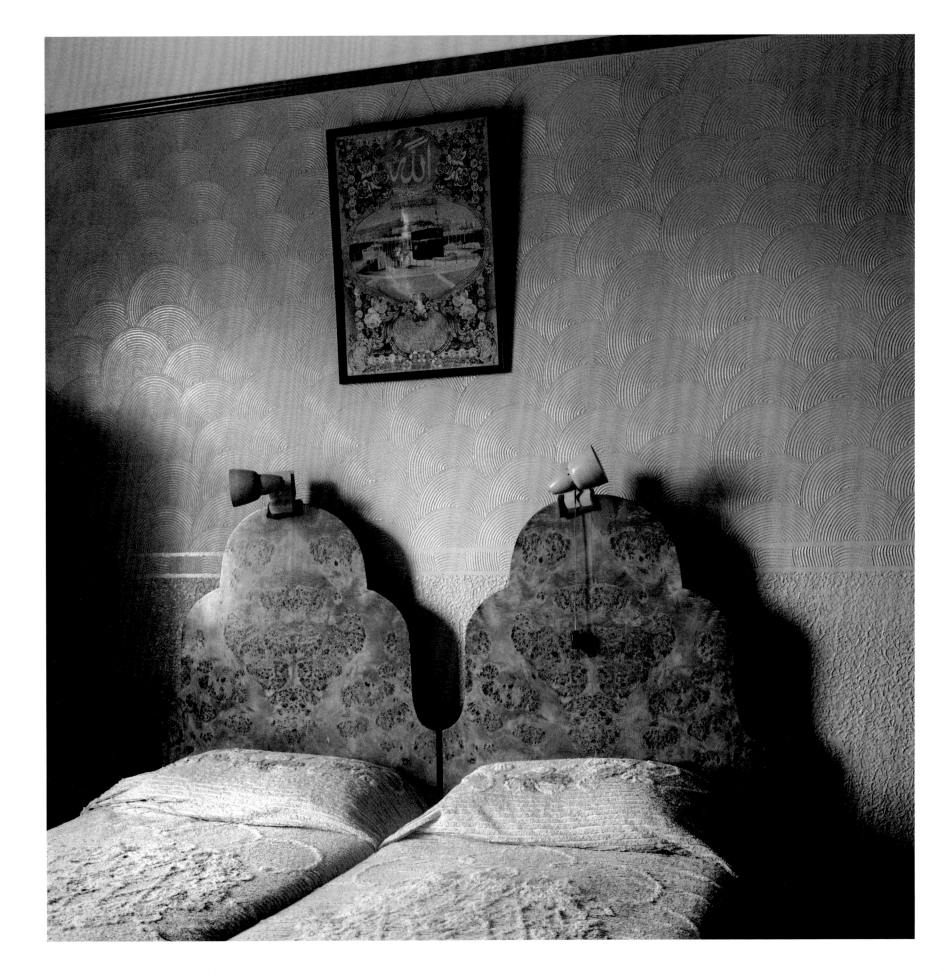

Hassimia Sahib's butchery during his resistance to removal, after the destruction of part of his building, and after the erection of housing for whites under the Group Areas Act, Pageview, Johannesburg. 8 March 1986

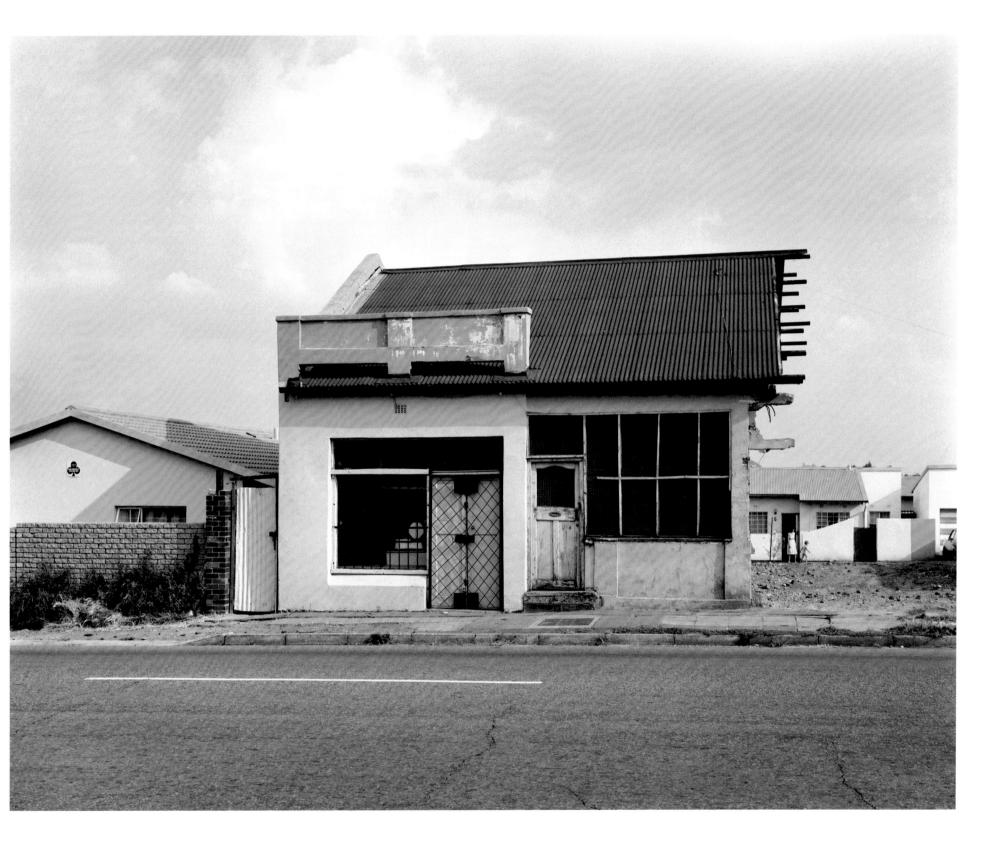

House near Puthaditjhaba,
Qwa Qwa. 1 May 1989

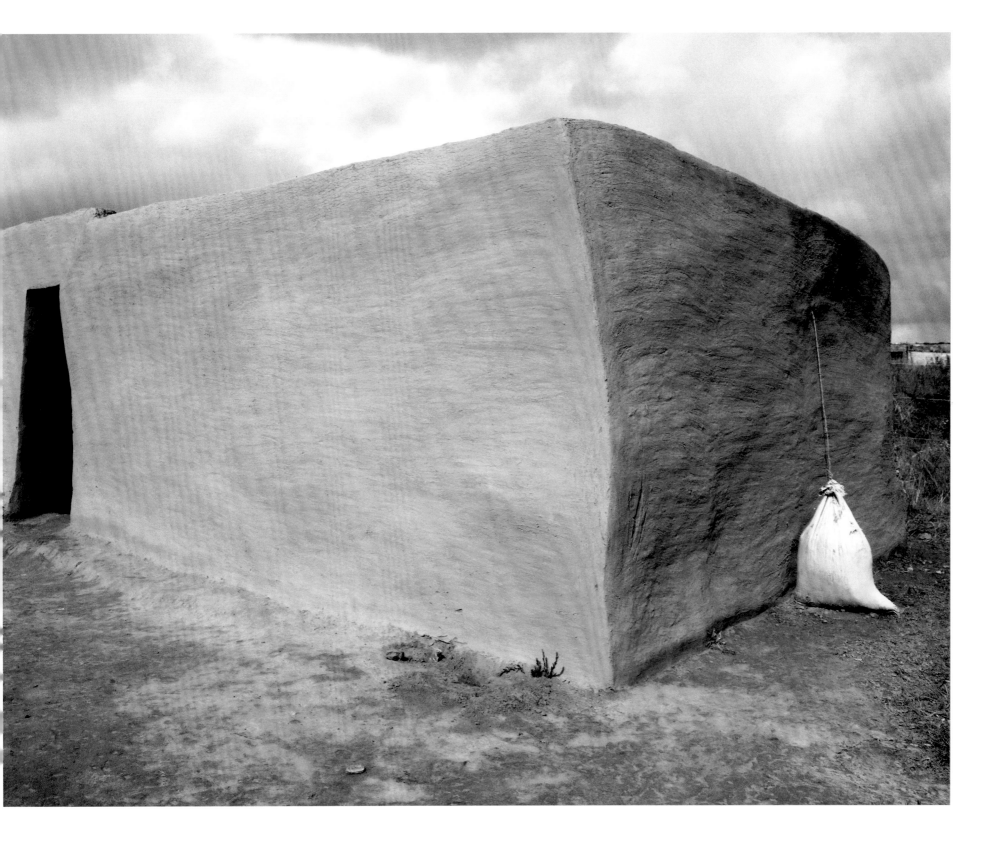

Kite flying near Puthaditjhaba,
Qwa Qwa. 1 May 1989

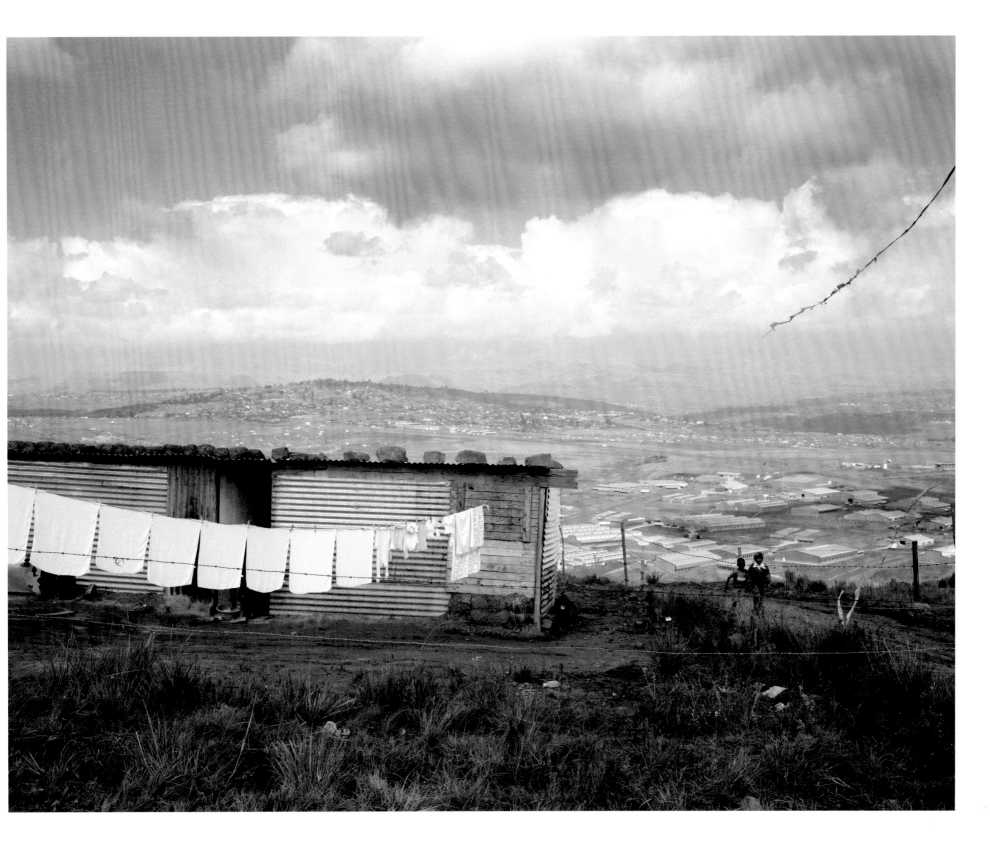

Dutch Reformed Church inaugurated on 31 July 1966, Op-die-Berg, Koue Bokkeveld,
Cape Province. 23 May 1987

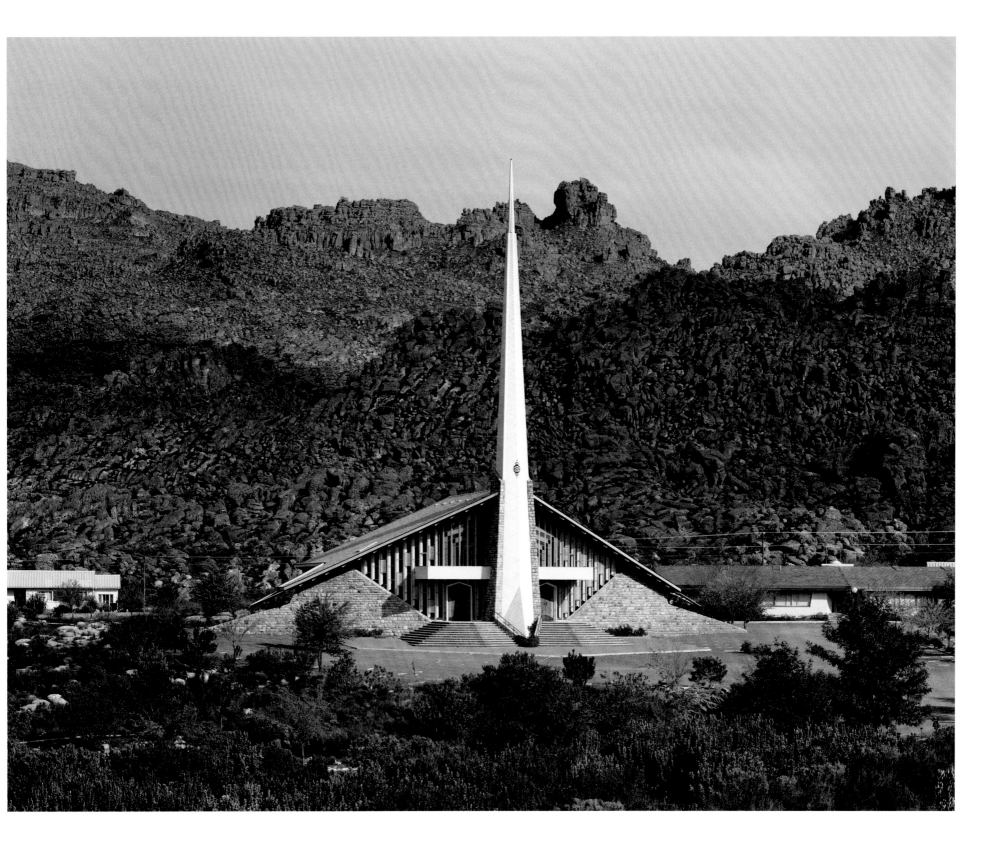

Monument to Voortrekker leader Karel Landman, unveiled on 16 December 1939, De Kol,
Cape Province. 10 April 1993

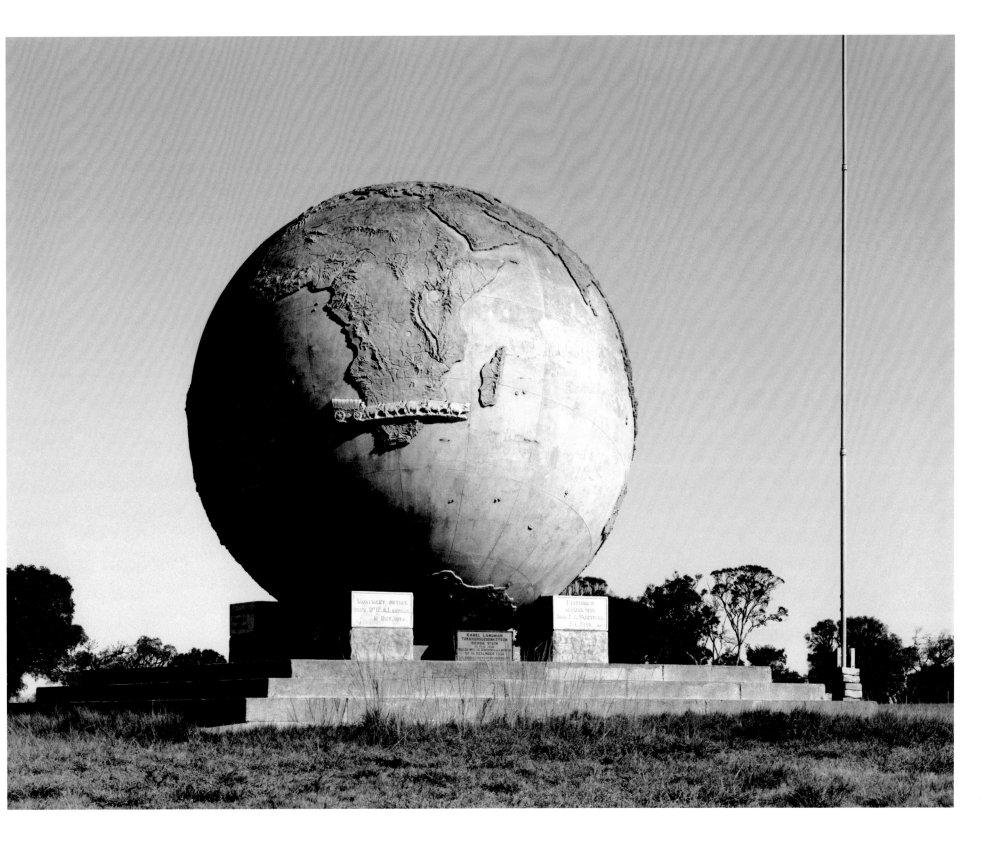

Die Heldeakker, The Heroes' Acre: cemetery for white members of the security forces killed in the 'Total Onslaught', the war against liberation forces in Southern Africa, Ventersdorp, Transvaal. 1 November 1986

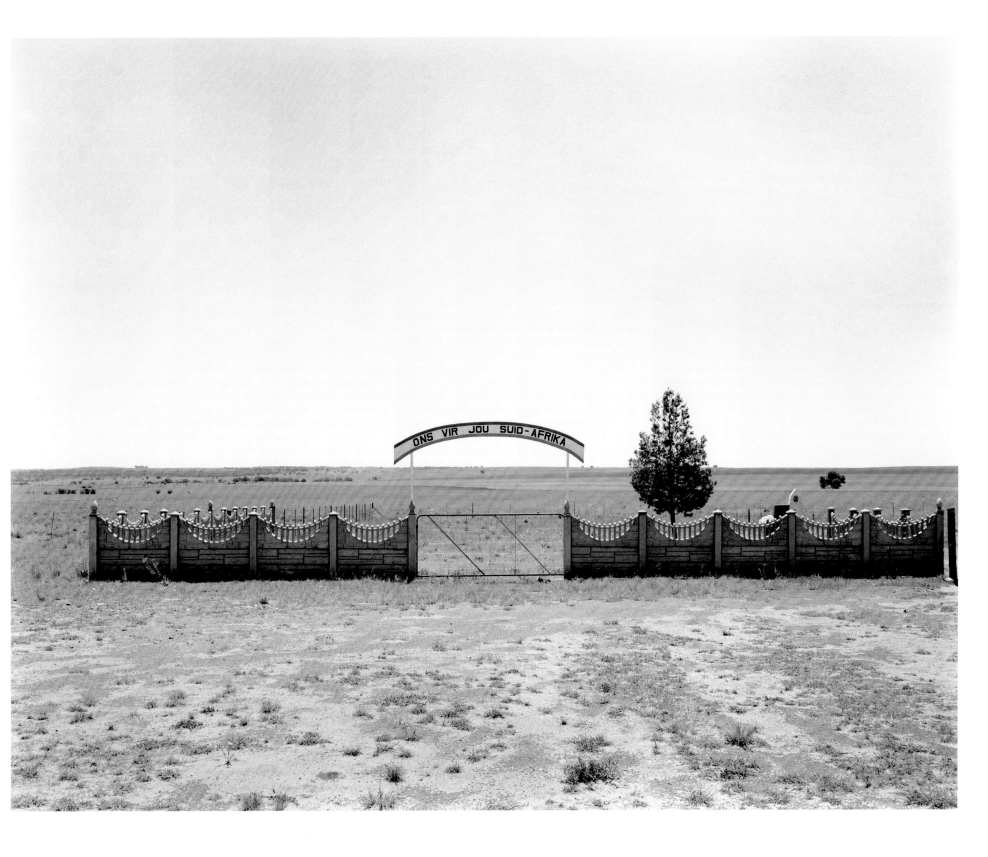

Monument to the Afrikaans language, inaugurated on 10 October 1975, Paarl,
Cape Province. 5 April 1992

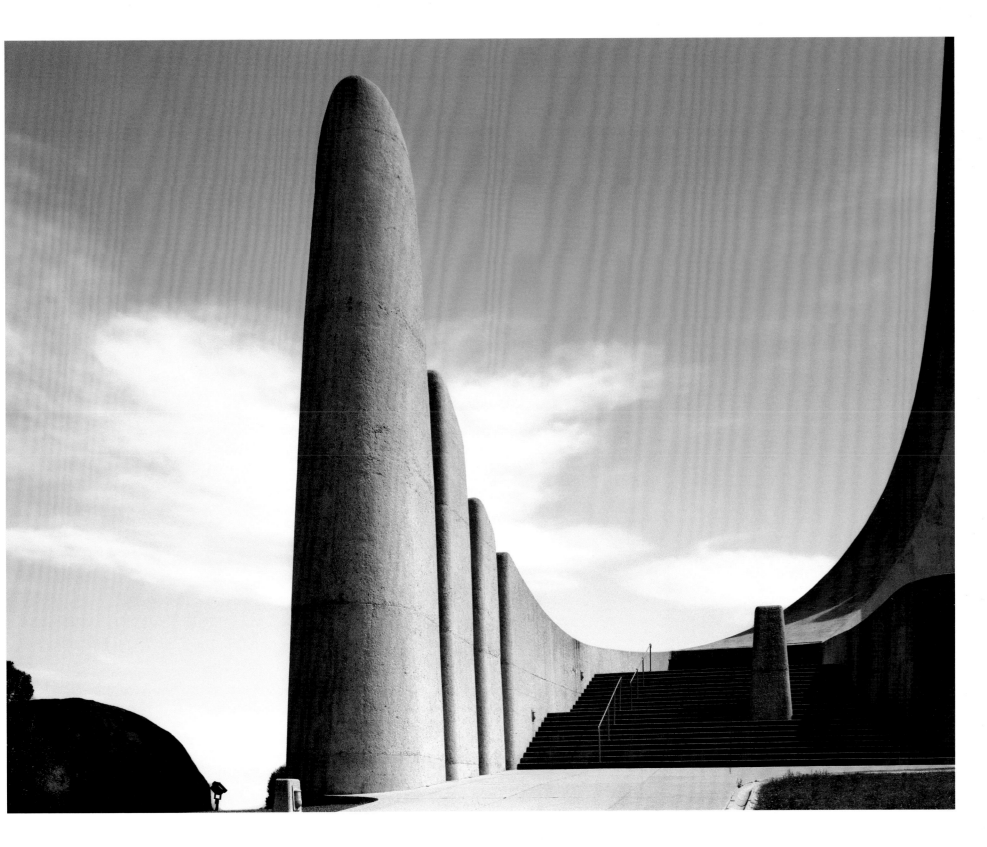

Dutch Reformed Church, Quellerina,
Johannesburg. 3 November 1986

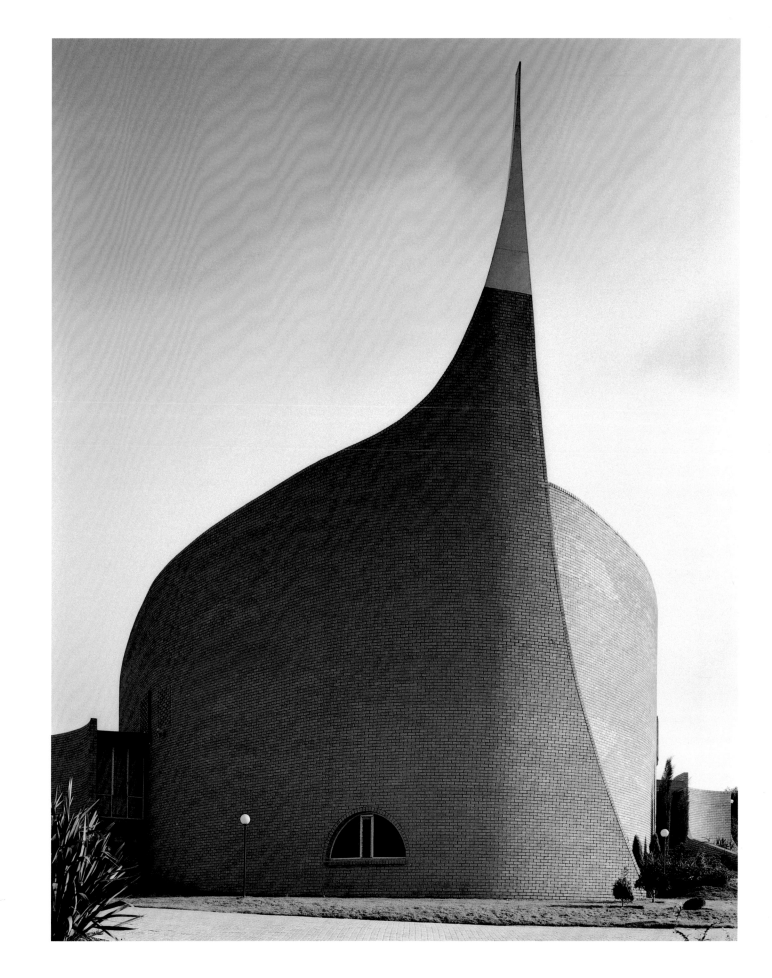

Unemployed men and Krugerpark government housing scheme for lower and middle class whites,
Pretoria, Transvaal. 28 October 1986

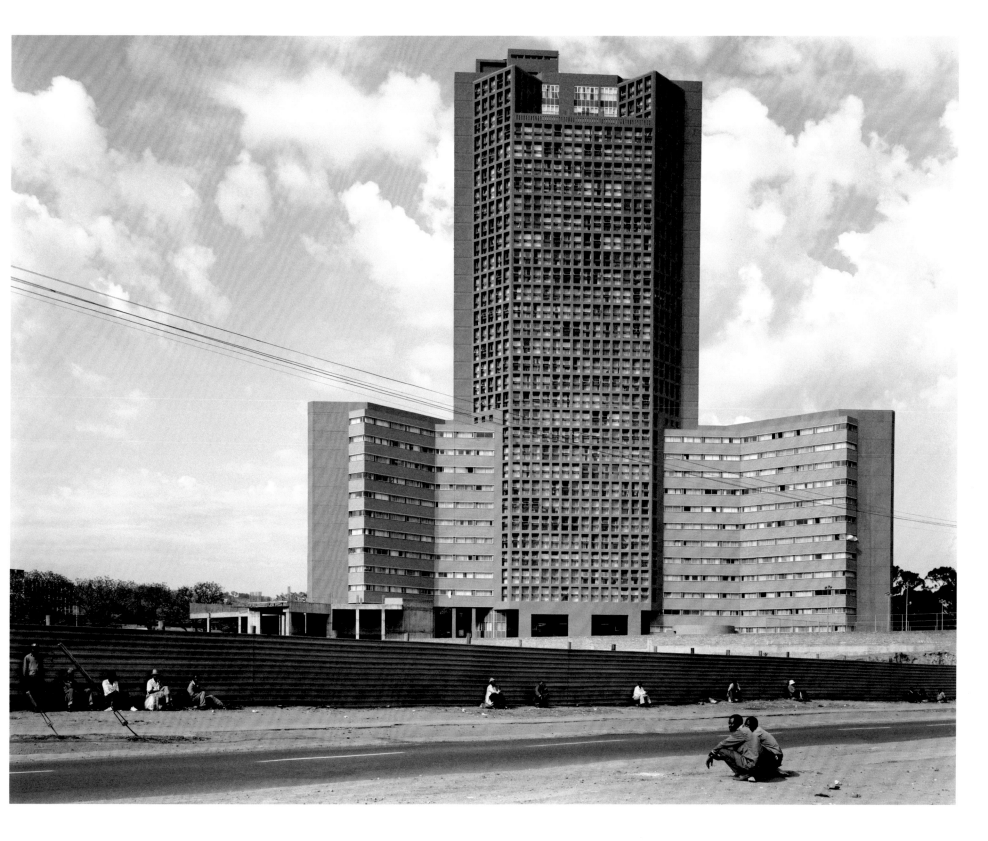

Hostel for African men: the south-east wing, opened on 1 August 1972,
Alexandra Township, Johannesburg. 1 June 1988

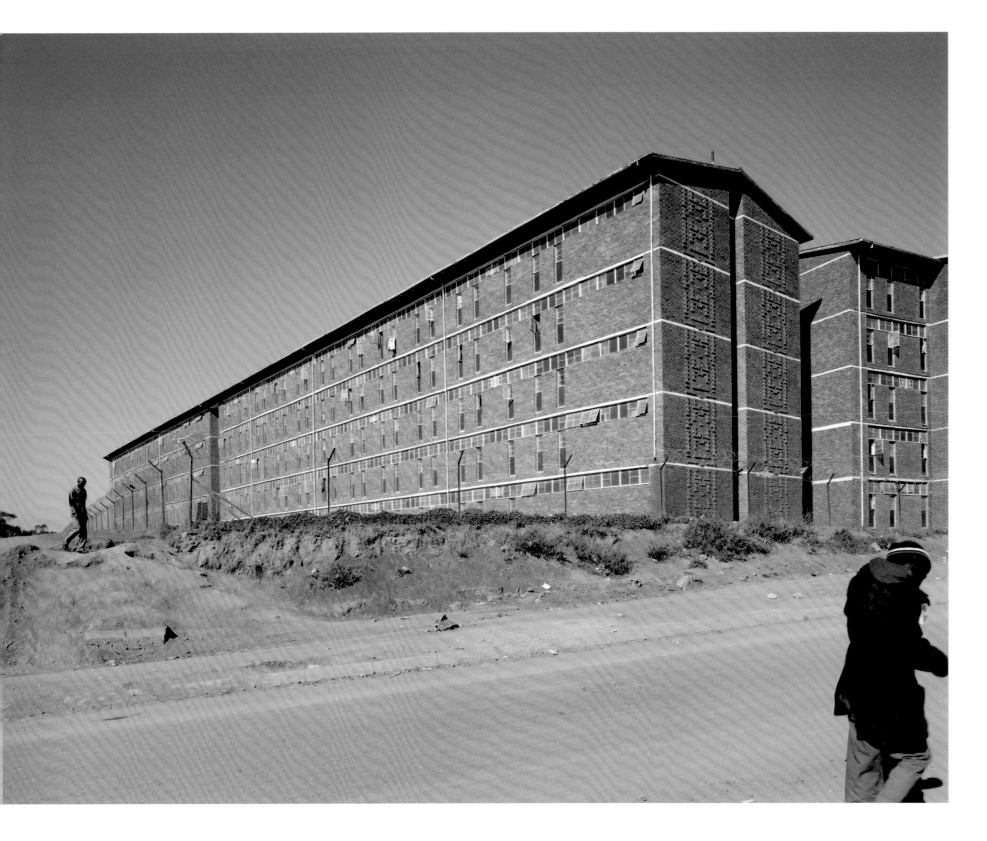

A new shack under construction, Lenasia Extension 9,
Johannesburg. 5 May 1990

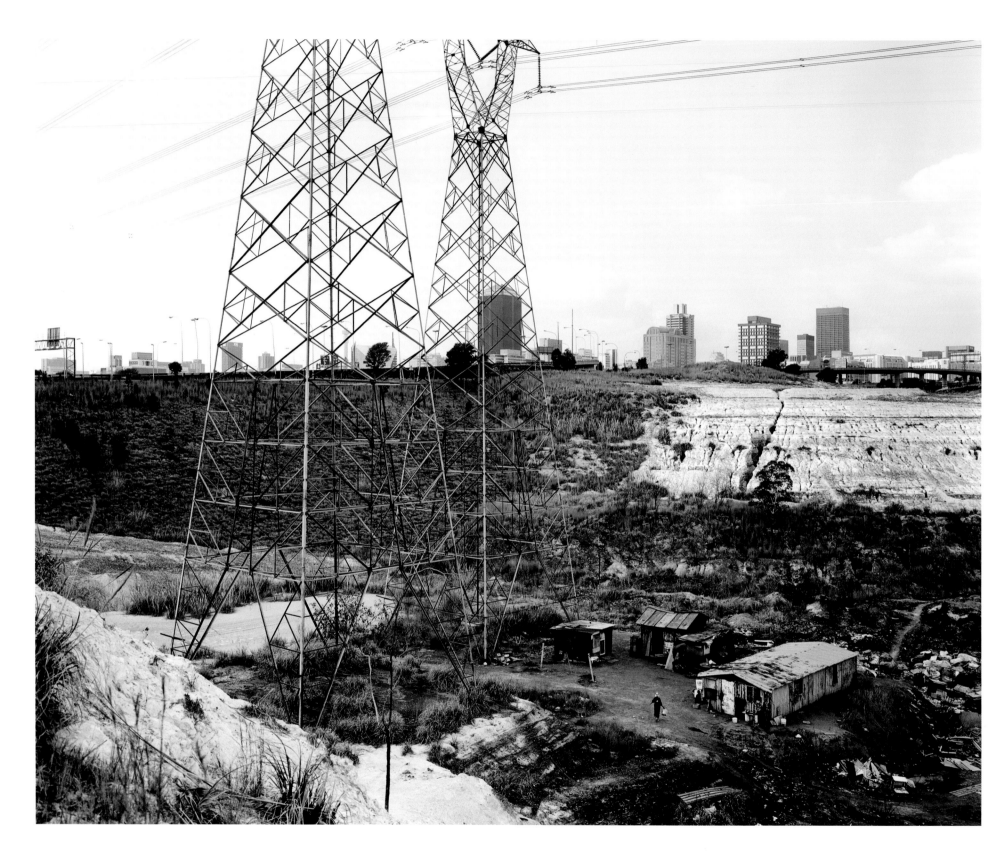

PHOTOGRAPHS FROM

Intersections – Joburg from ongoing photography
some of which was published in a book in 2005
by Prestel, Munich

Johannesburg from the southwest.
12 July 2003

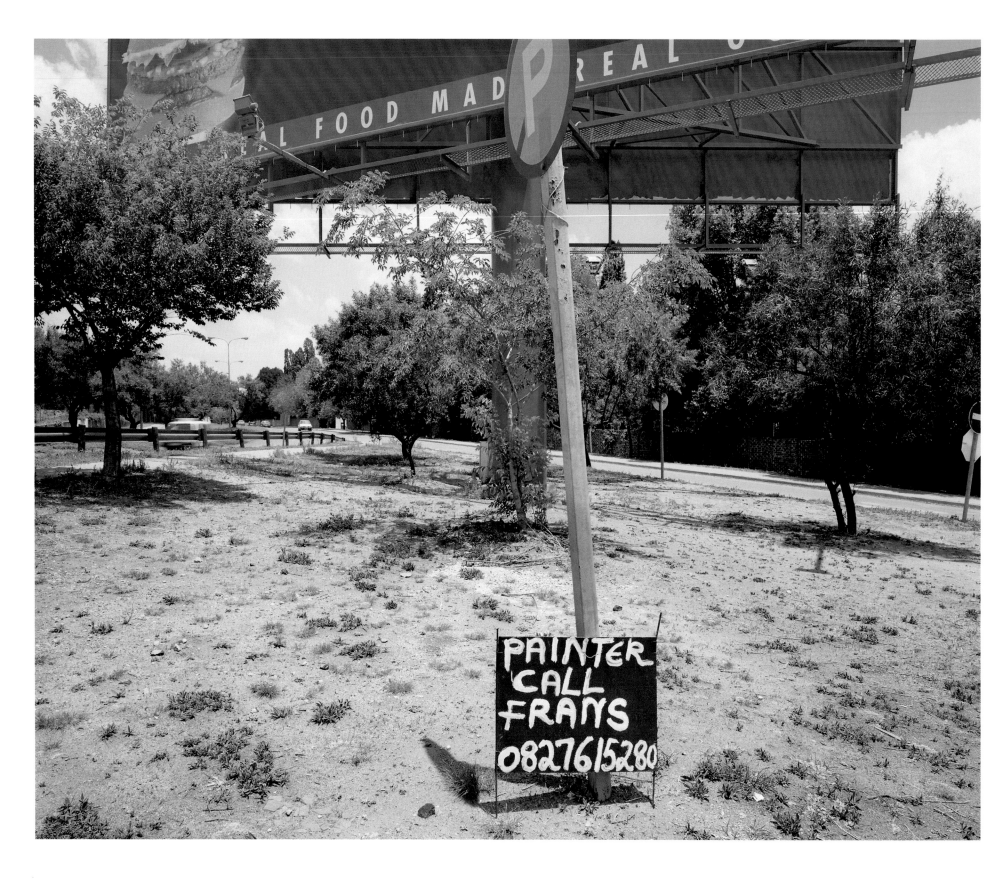

166 Advert by Frans Marakala, painter, at the corner of Rivonia and Federal Roads,
Sandhurst, Johannesburg. 20 November 1999

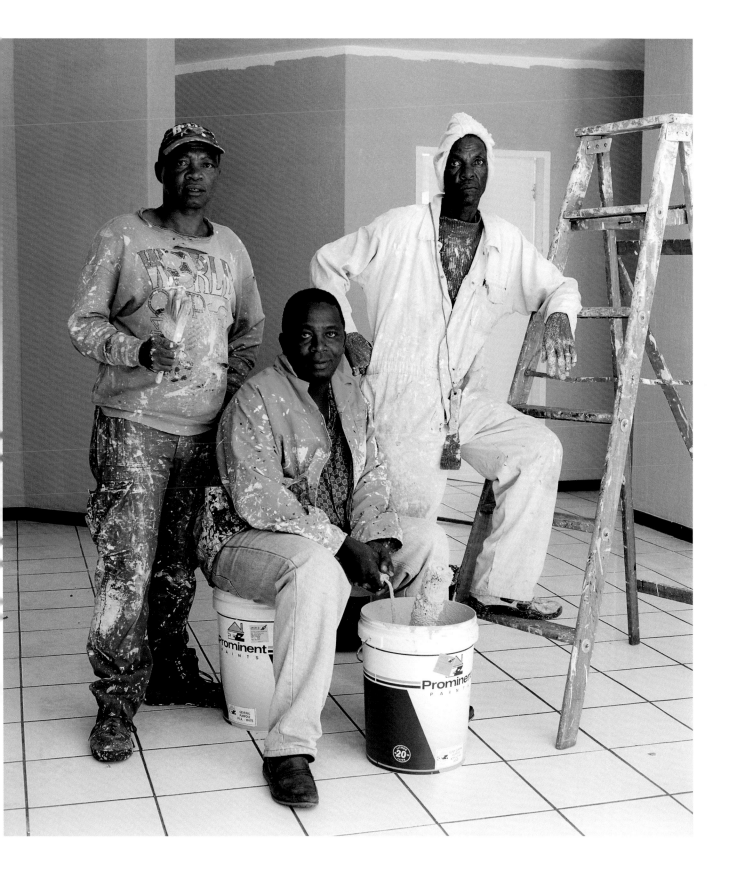

Frans Marakala (centre) with his team, Isiah Molepo and Lucas Kilani, on a job in Hyde Park, Johannesburg. 21 February 2000

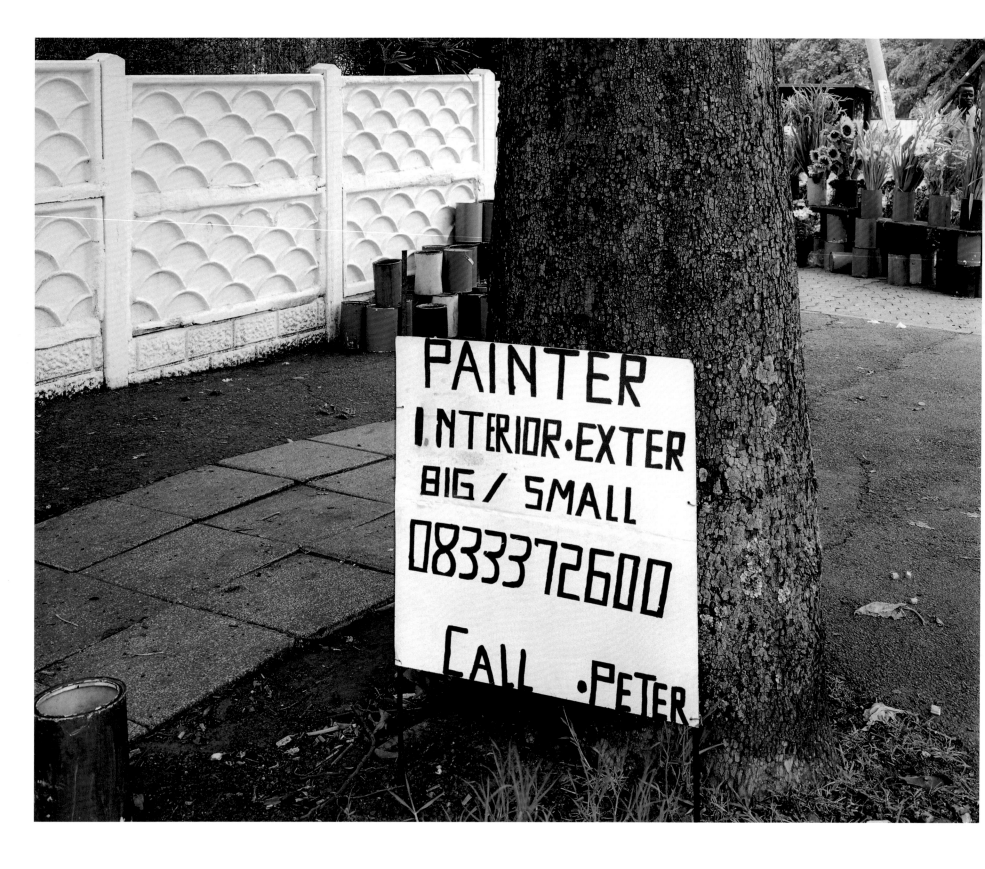

168 Advert by Peter Mogale, painter, at the corner of 11 Avenue and 3 Street Lower Houghton,

Johannesburg. 20 November 1999

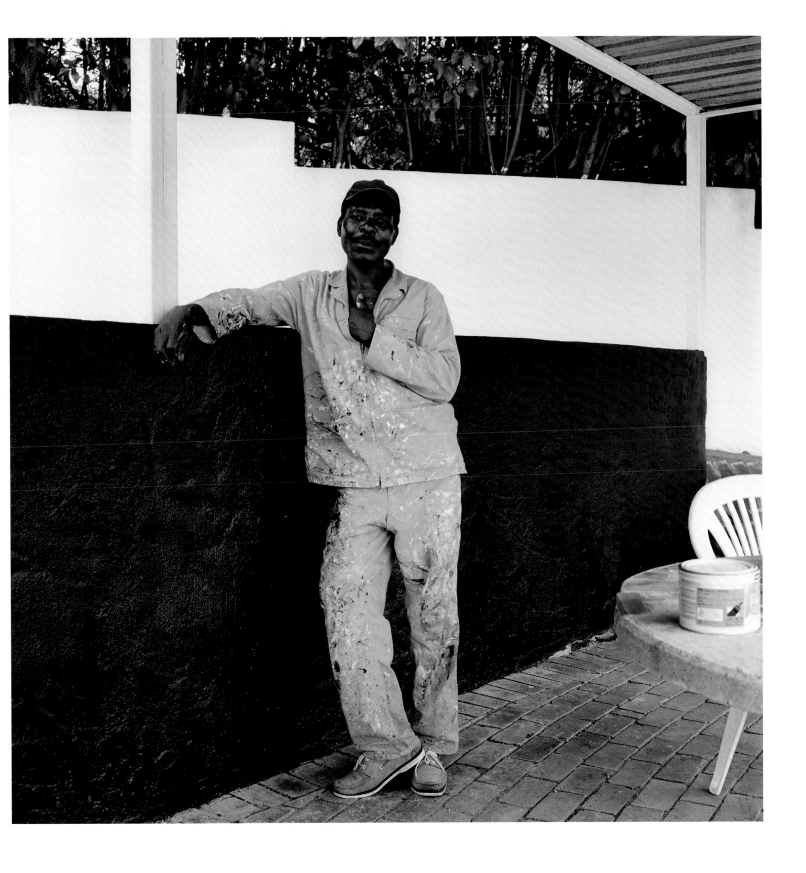

Painter Peter Mogale on a job in Birnam,
Johannesburg. 17 February 2000

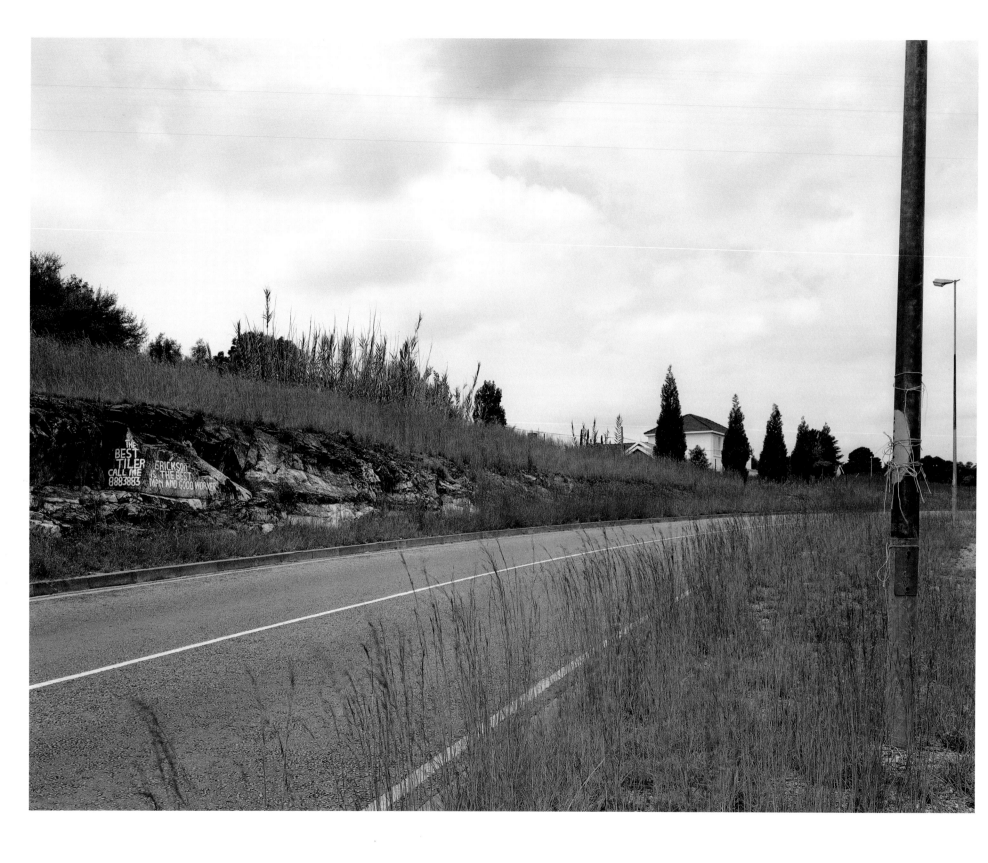

170 Erikson Ngomane's advert, Republic Road,
 Darrenwood. 17 February 2000

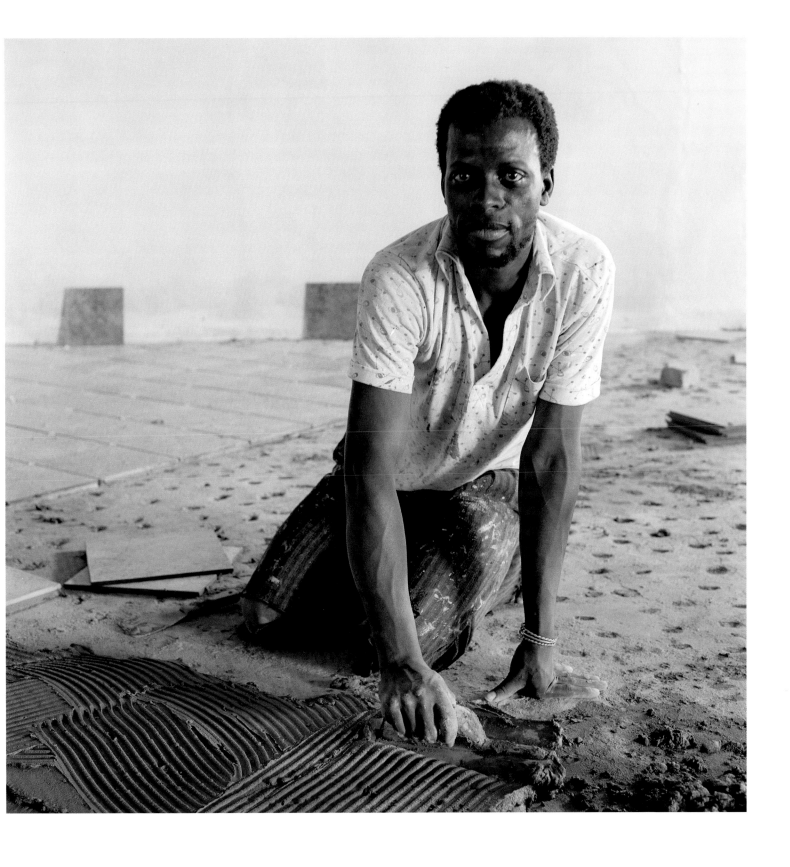

Tiler, Erikson Ngomane,
Linden. 17 February 2000

171

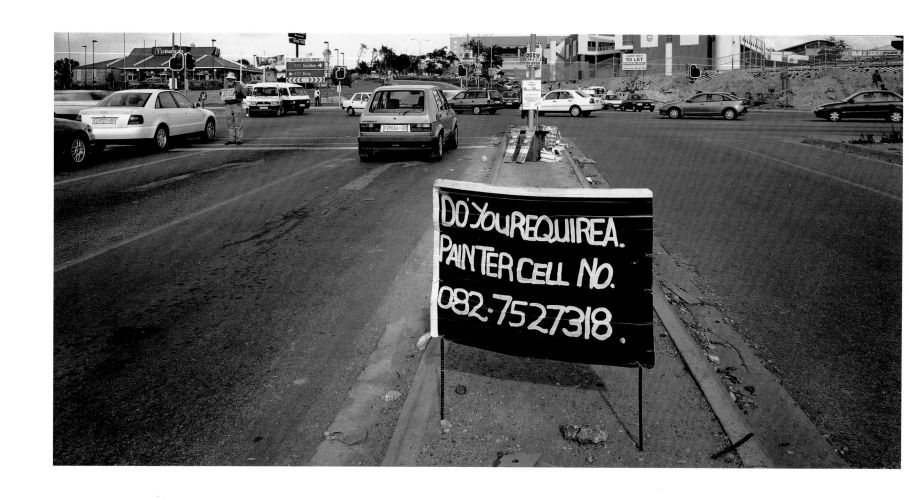

172 Painter, Corrie Jacobs's advert, Fourways,
▬ Johannesburg. 27 November 1999

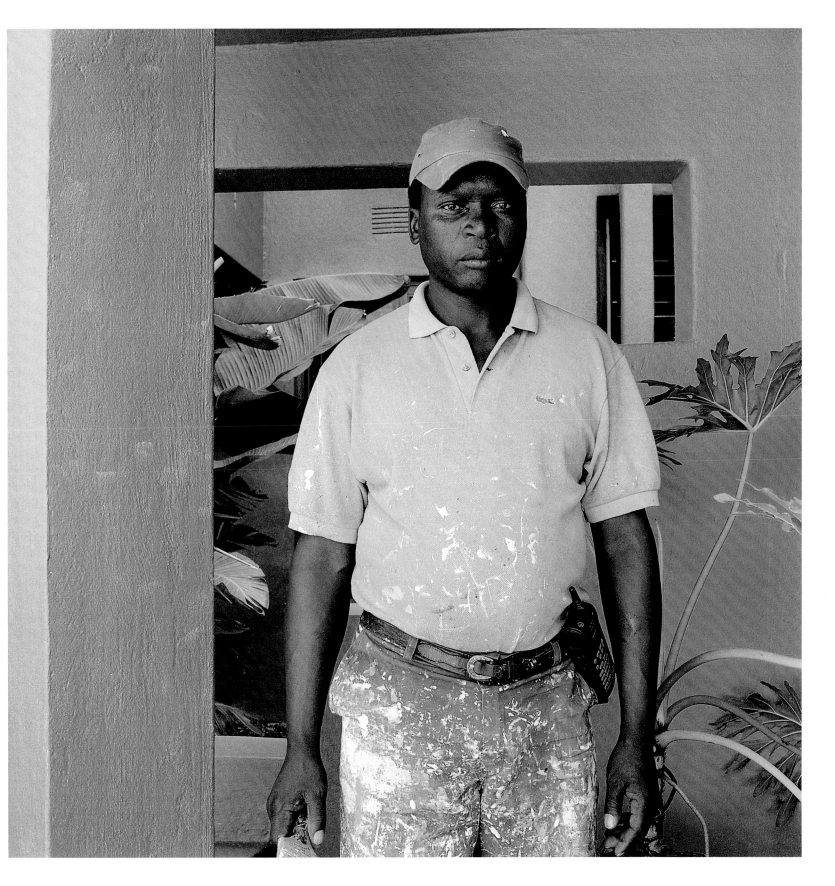

Painter, Corrie Jacobs, Rivonia, Johannesburg . 12 April 2000 173

Brooms for sale, Elm and First Avenue, Edenvale,
Transvaal. 22 November 1999

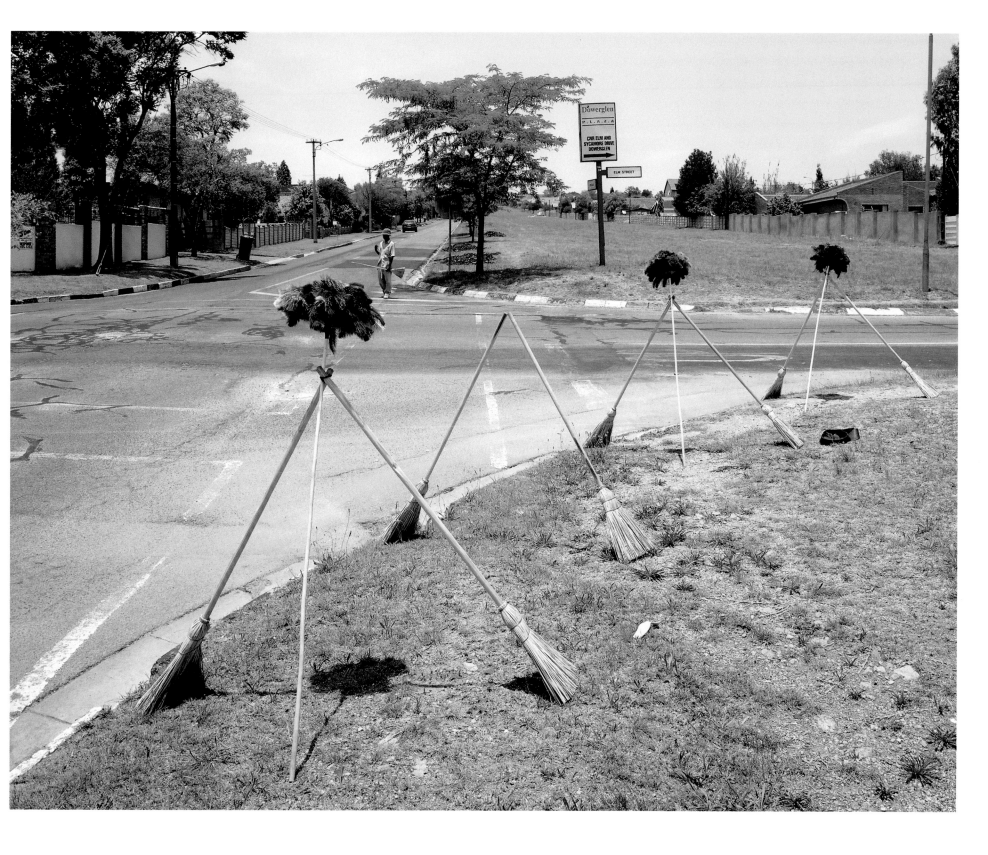

George Nkomo, hawker, Fourways,
Johannesburg. 21 August 2002

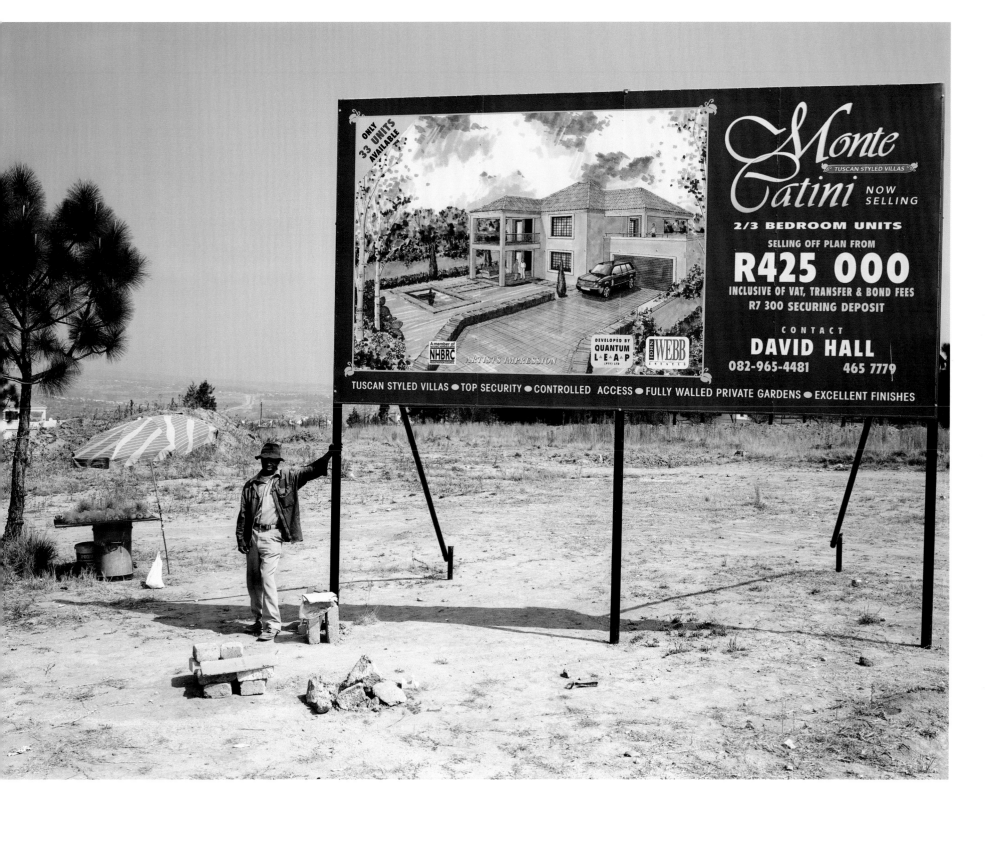

Digging a ditch at the portico to Saranton Private Estate, Fourways,
Johannesburg. 3 April 2002

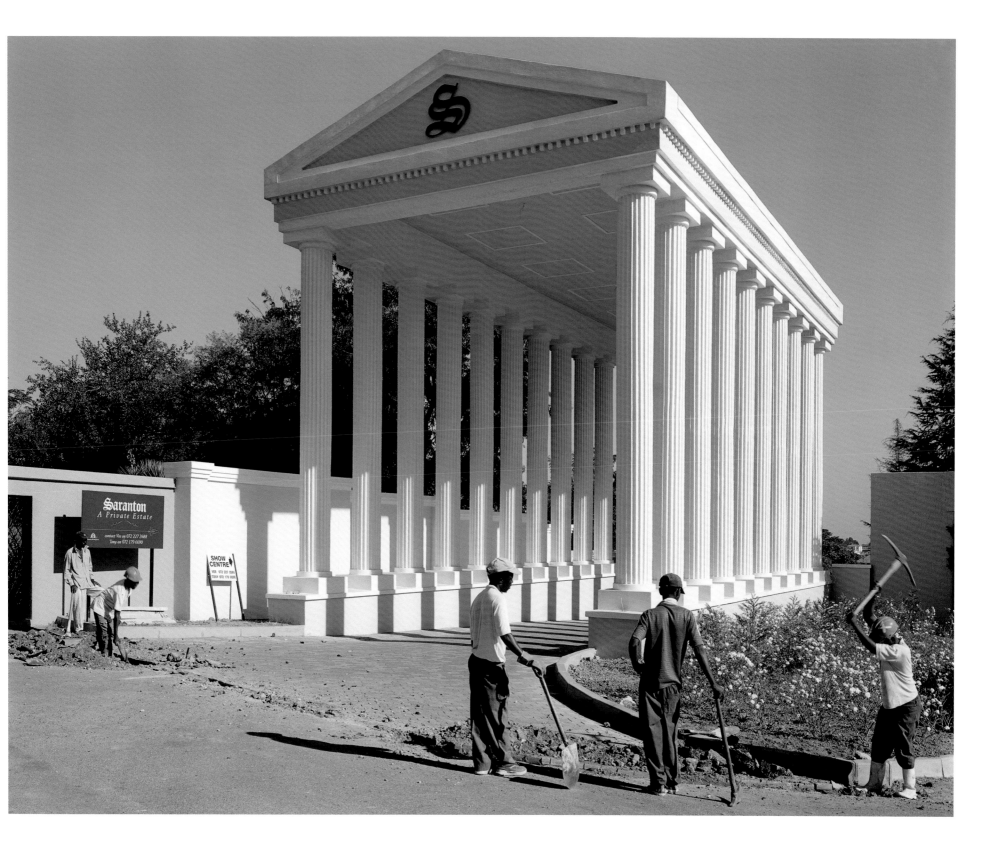

Hawker waiting to serve food to construction workers from the office park, 93 Grayston, Sandton, Johannesburg. 14 November 2001

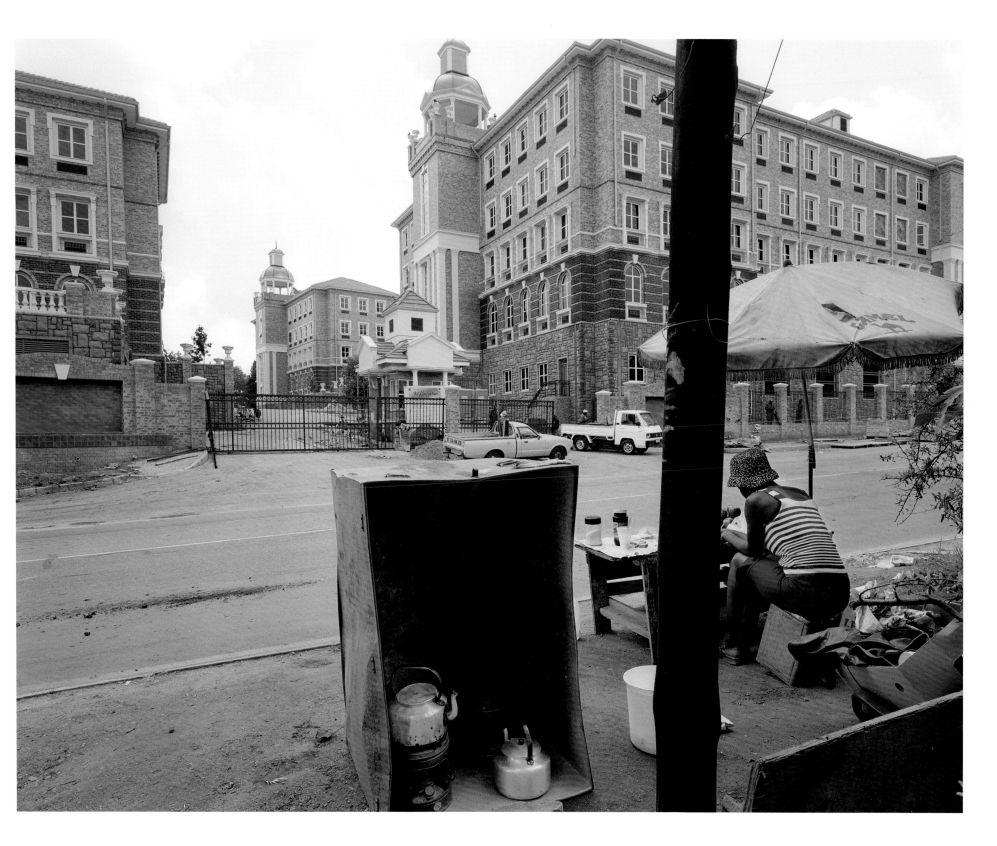

Thuso Ndlovu, hawker, Fourways,
Johannesburg. 28 December 2001

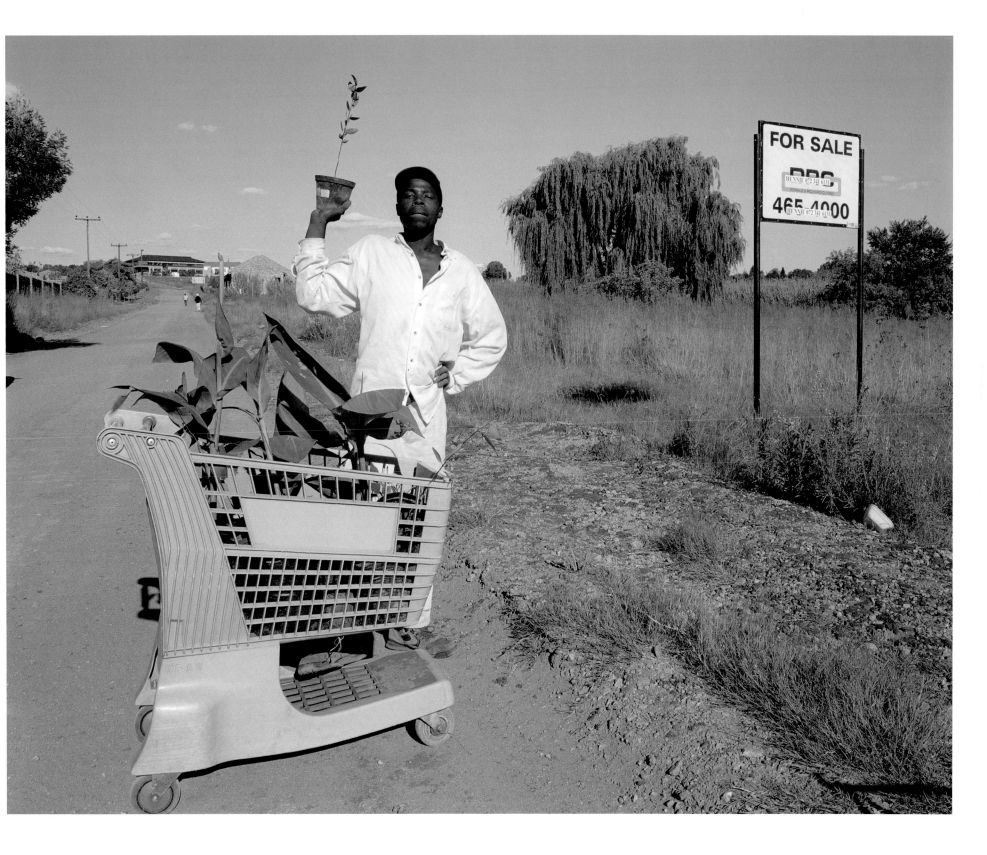

Silencers for sale and fitting, Esselen and Banket Streets, Hillbrow,
Johannesburg. 7 January 2002

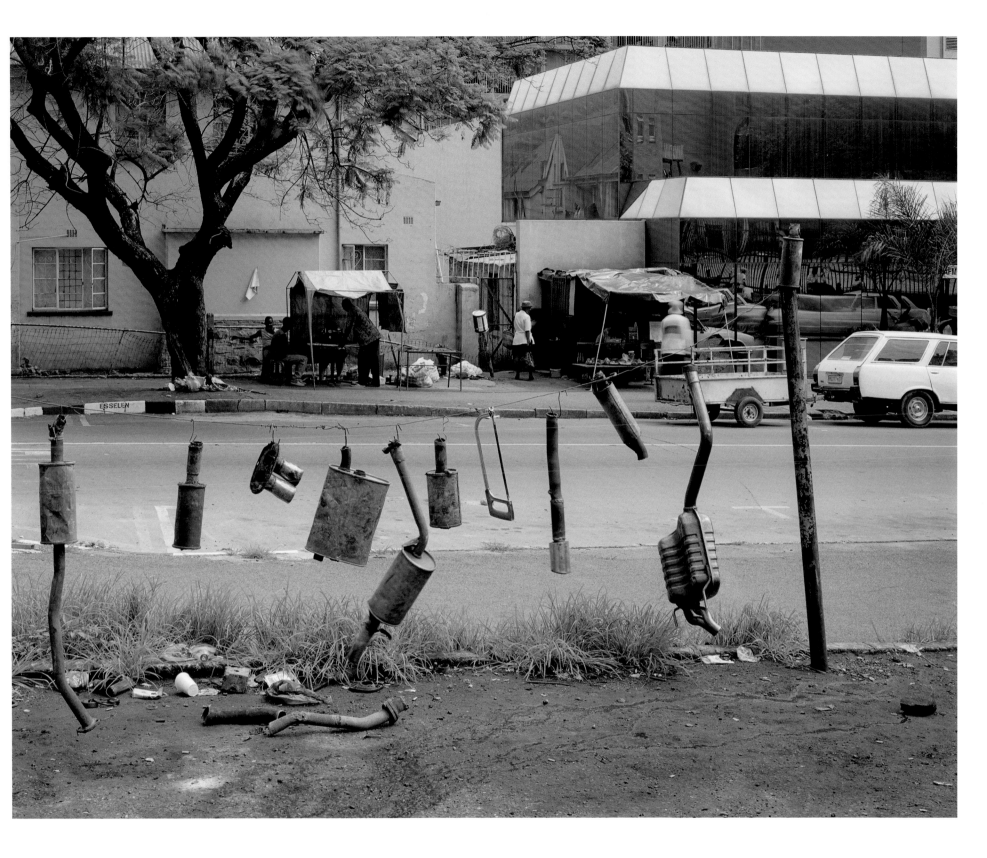

Squatters' shacks, Newtown,
Johannesburg. 1 November 2001

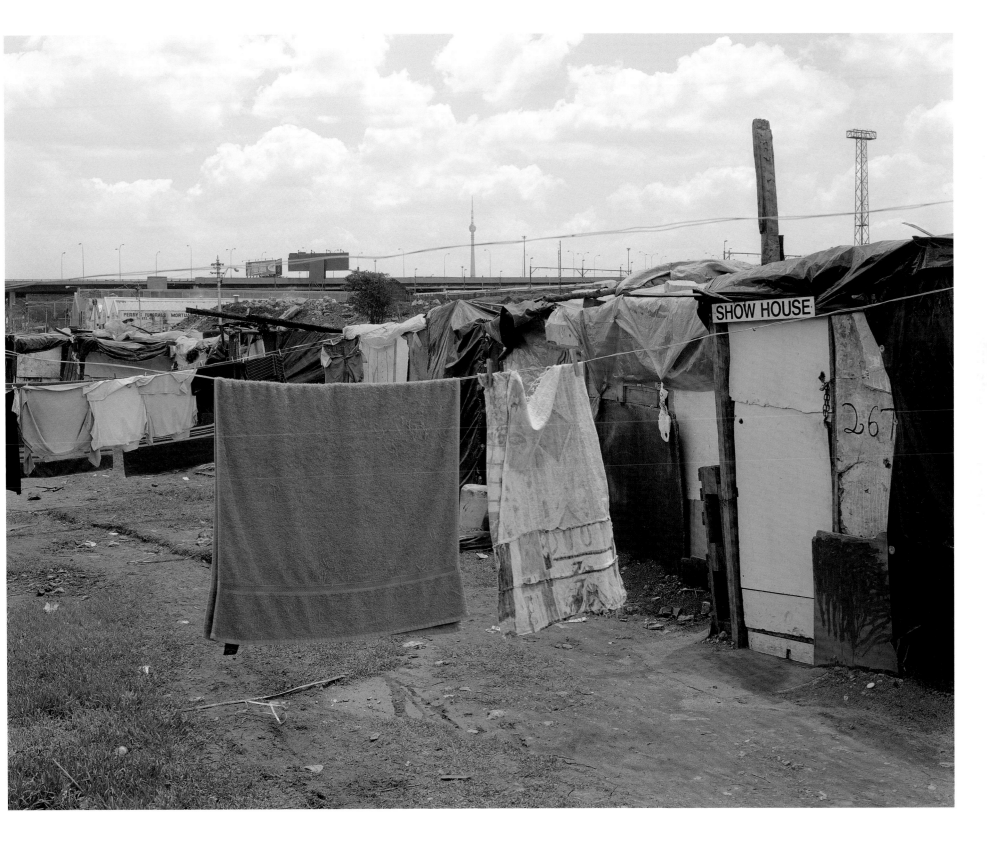

Adverts on the base of the telecommunications tower, Hillbrow,
Johannesburg. 18 January 2002

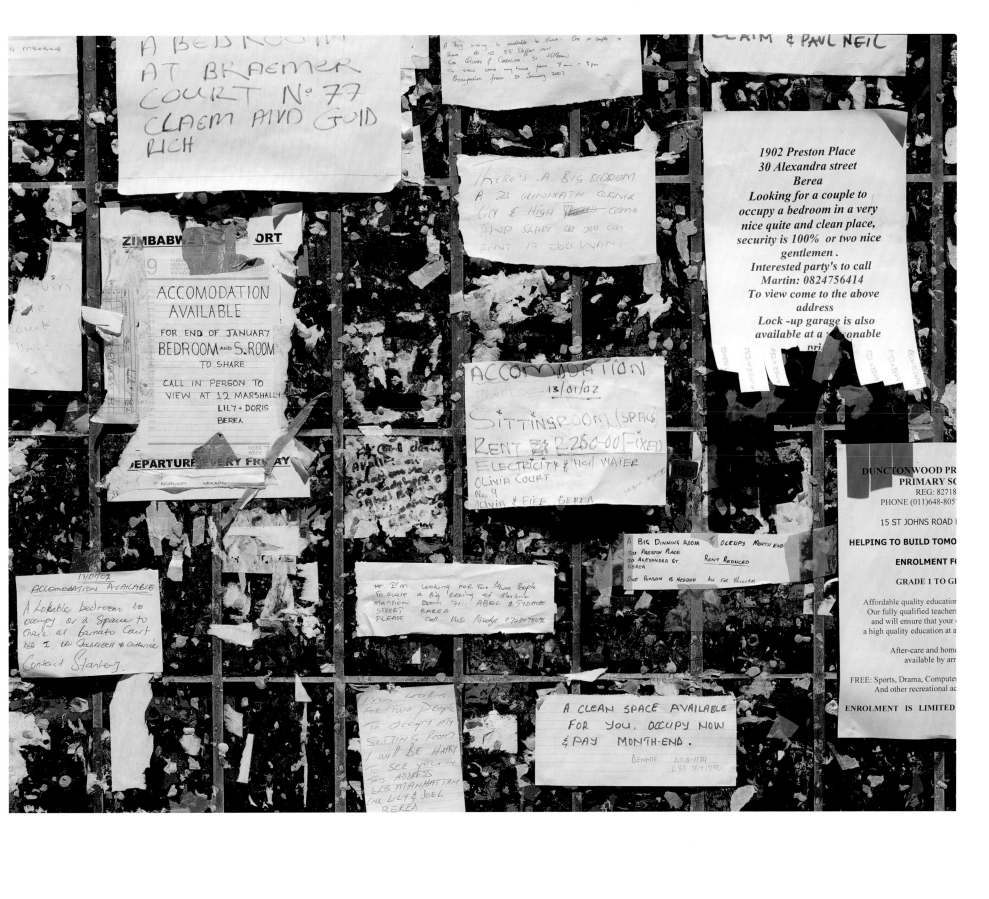

Pavement sale on Jeppe Street,
Johannesburg. 10 August 2002

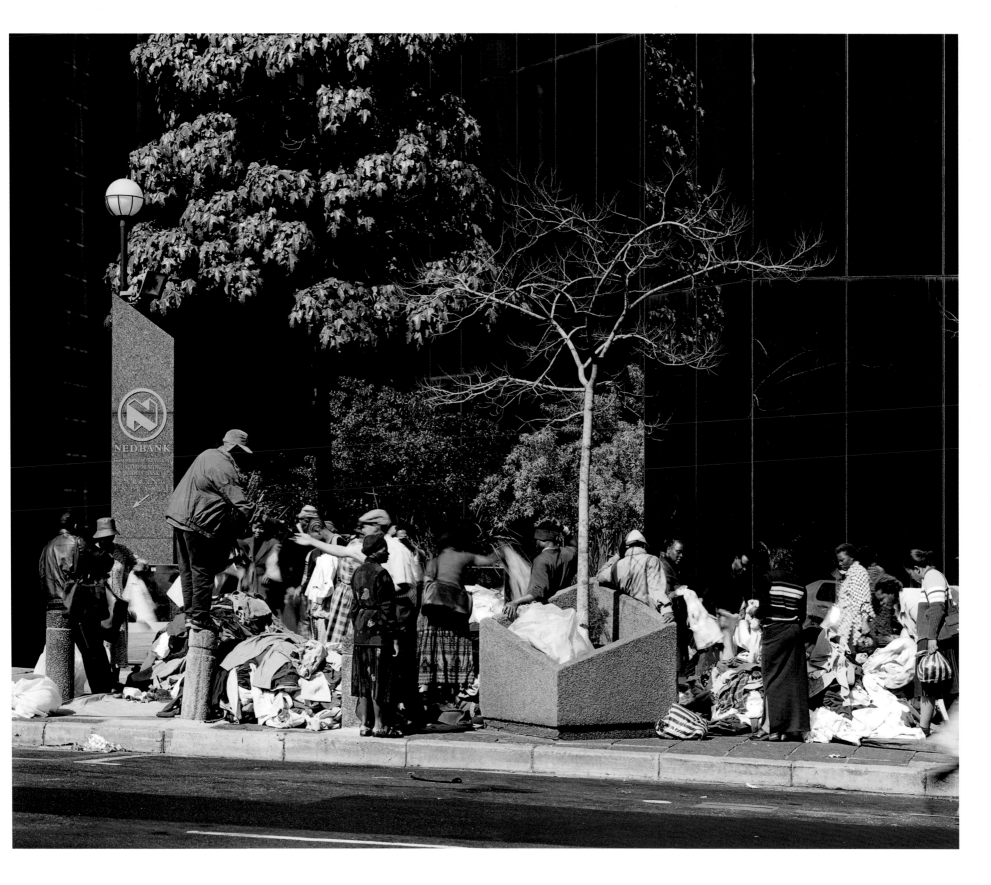

Braiding hair on Bree Street,
Johannesburg. 7 September 2002

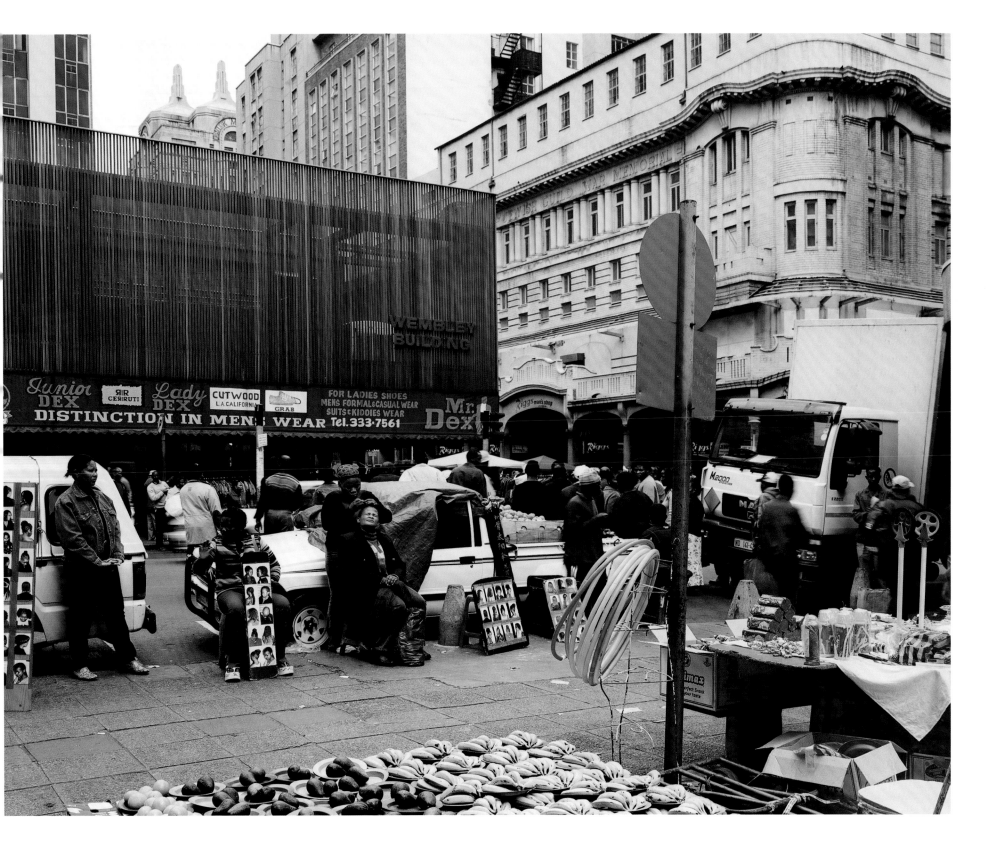

Under the motorway, where the inyangas (traditional healers) sold their muti (medicines),
Farraday, Johannesburg. 10 August 2002

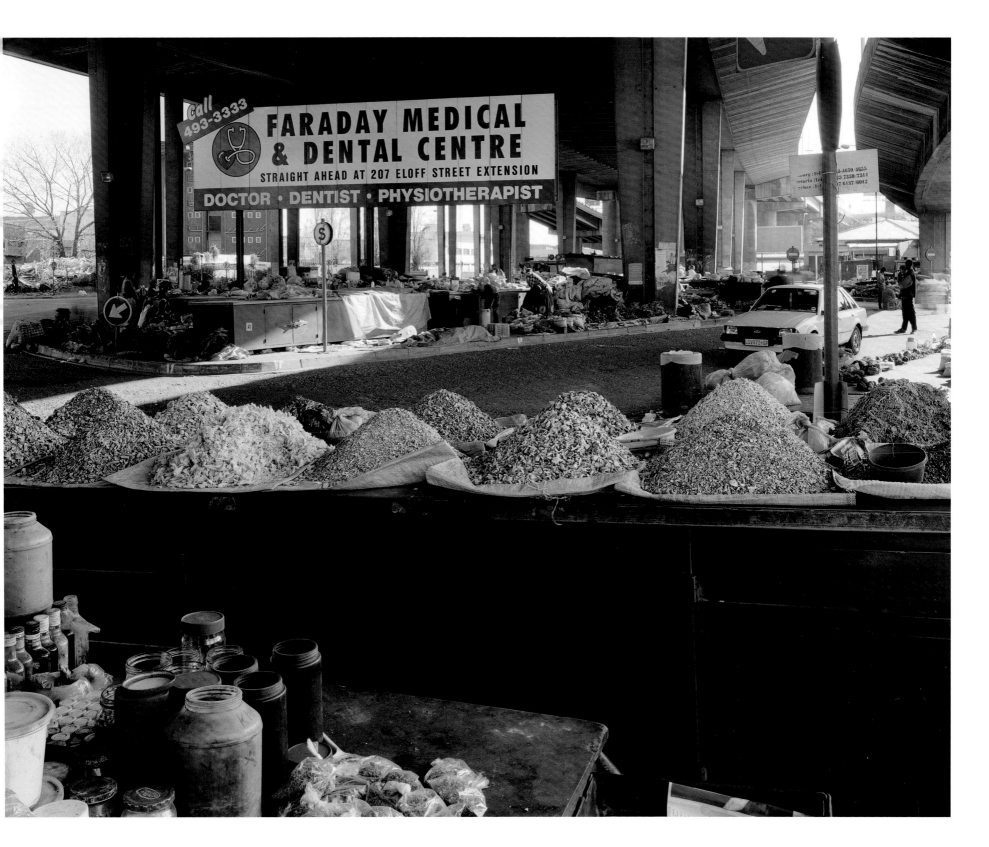

Barbers, Newtown,
Johannesburg. 1 November 2003

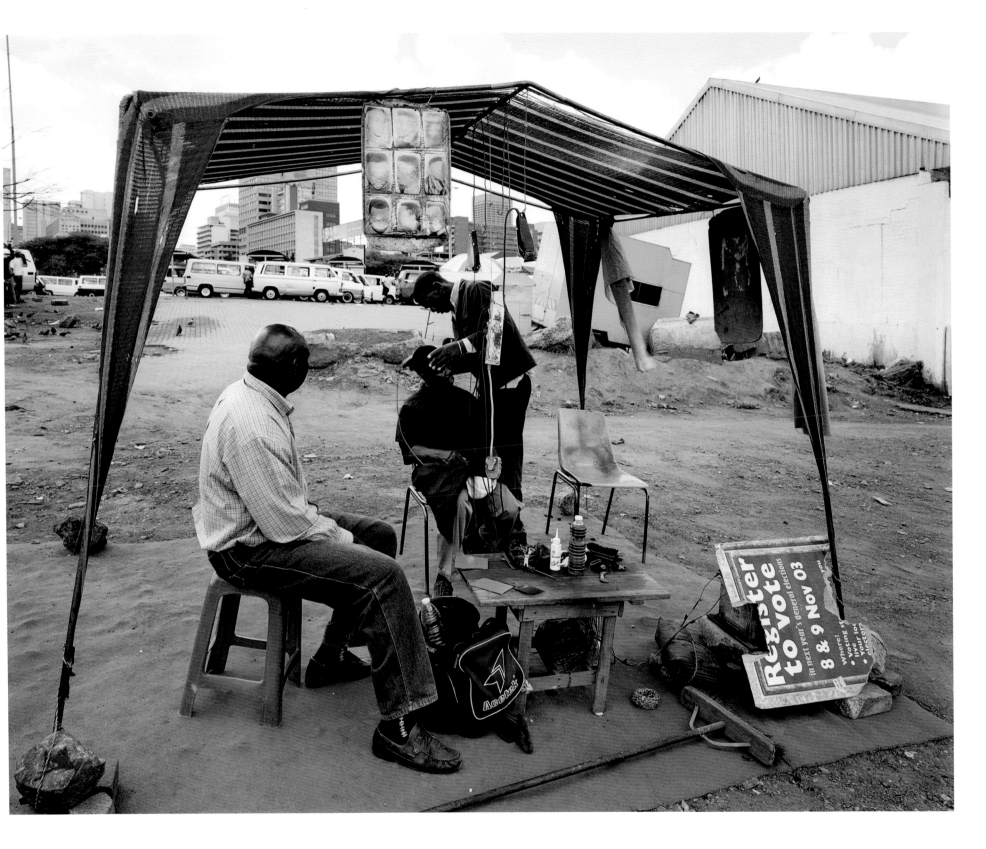

Carved figures for sale, Nicol Drive, Fourways,
Johannesburg. 17 April 2004

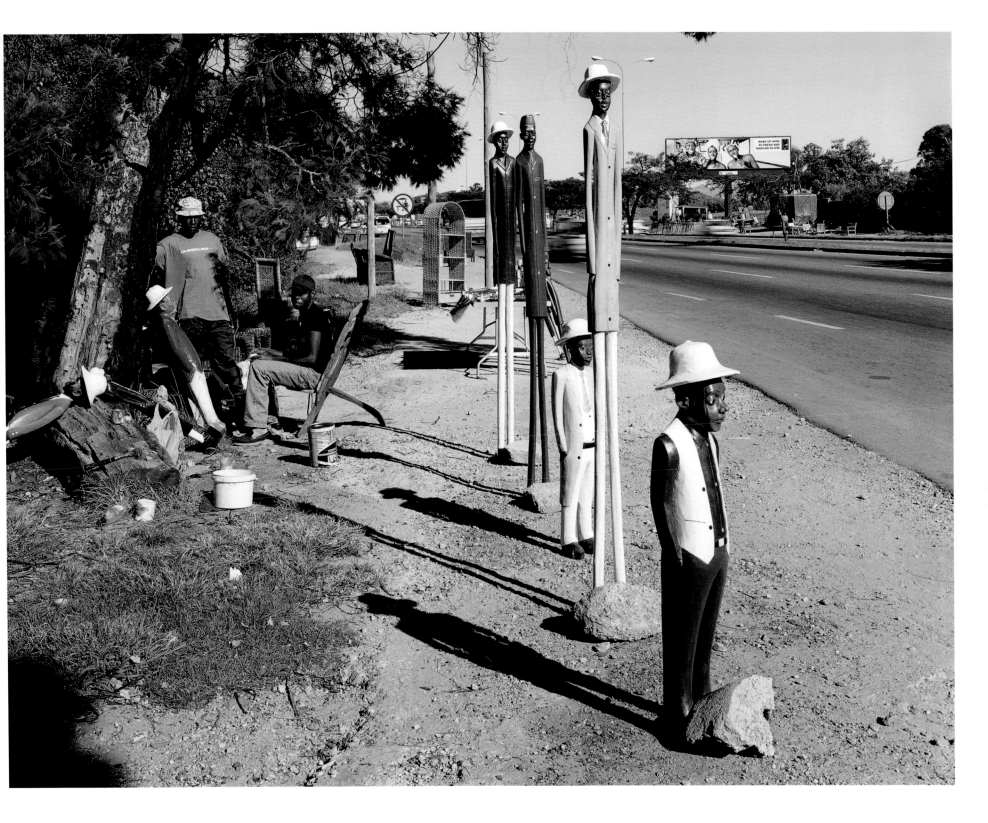

Our summer garden and ADT, Fellside,
Johannesburg. 9 January 2006

Townhouse development, Houghton,
Johannesburg. 8 March 2006

'Hacienda' cluster housing development, Ruimsig, Strubensvalley,
Johannesburg. 27 April 2004.

Galvanised ironware for sale, Ruimsig, Strubensvalley,
Johannesburg. 8 May 2004

Clothes for sale on Freedom Square (now Walter Sisulu Square), Kliptown, Soweto, Johannesburg. 10 December 2003

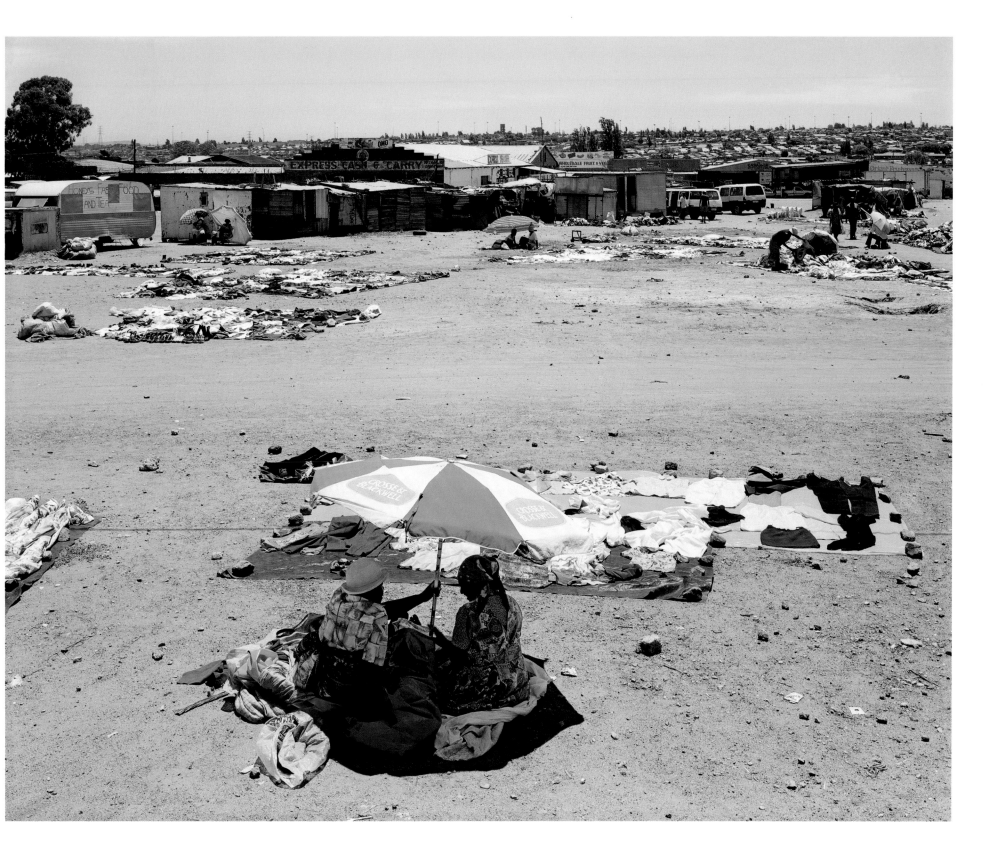

Mother and child, Nelson Mandela Square, Sandton,
Johannesburg. 8 March 2005

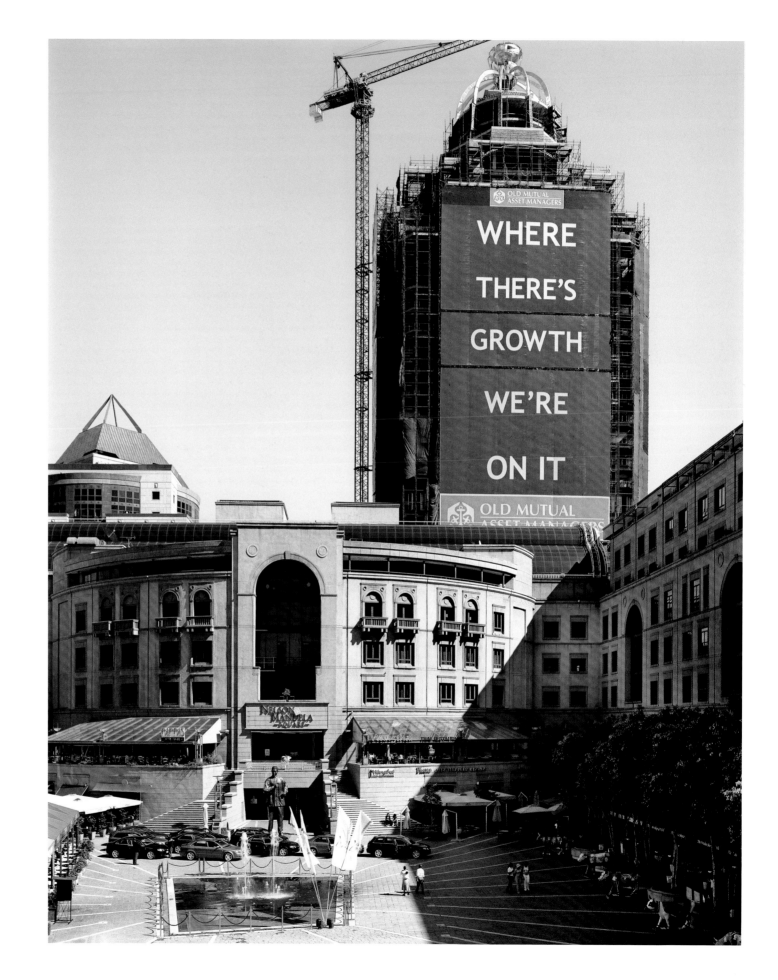

Alexandra Township and Sandton,
Johannesburg. 11 May 2003

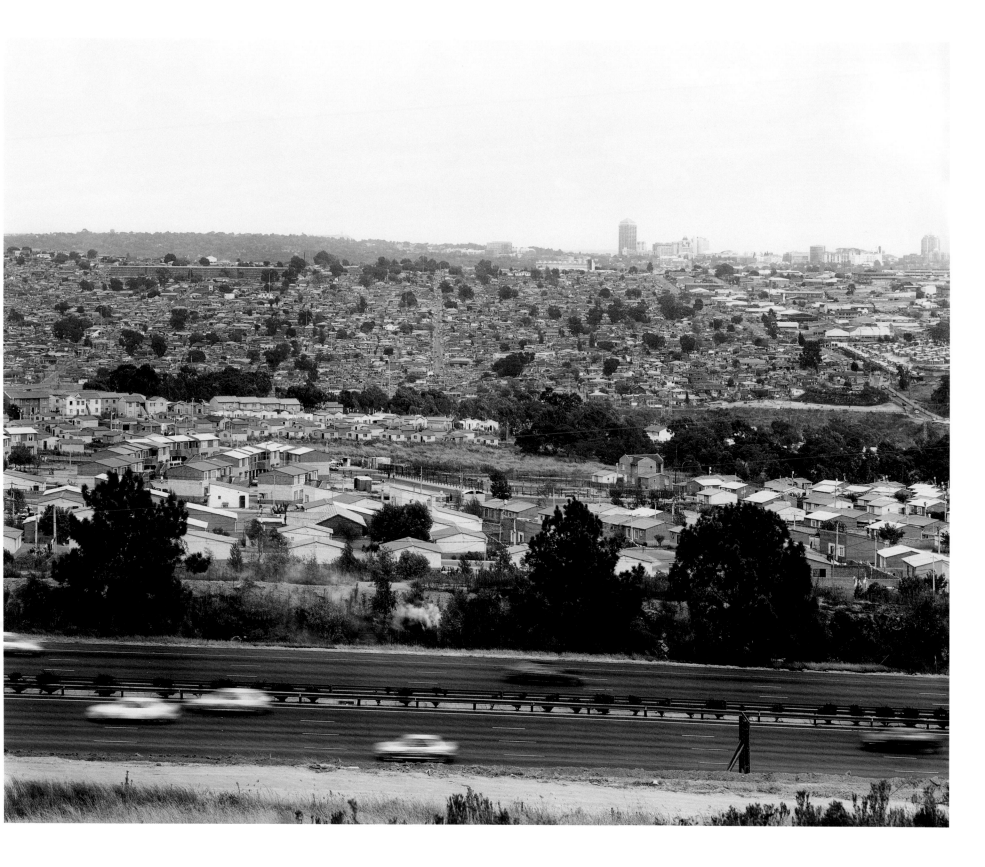

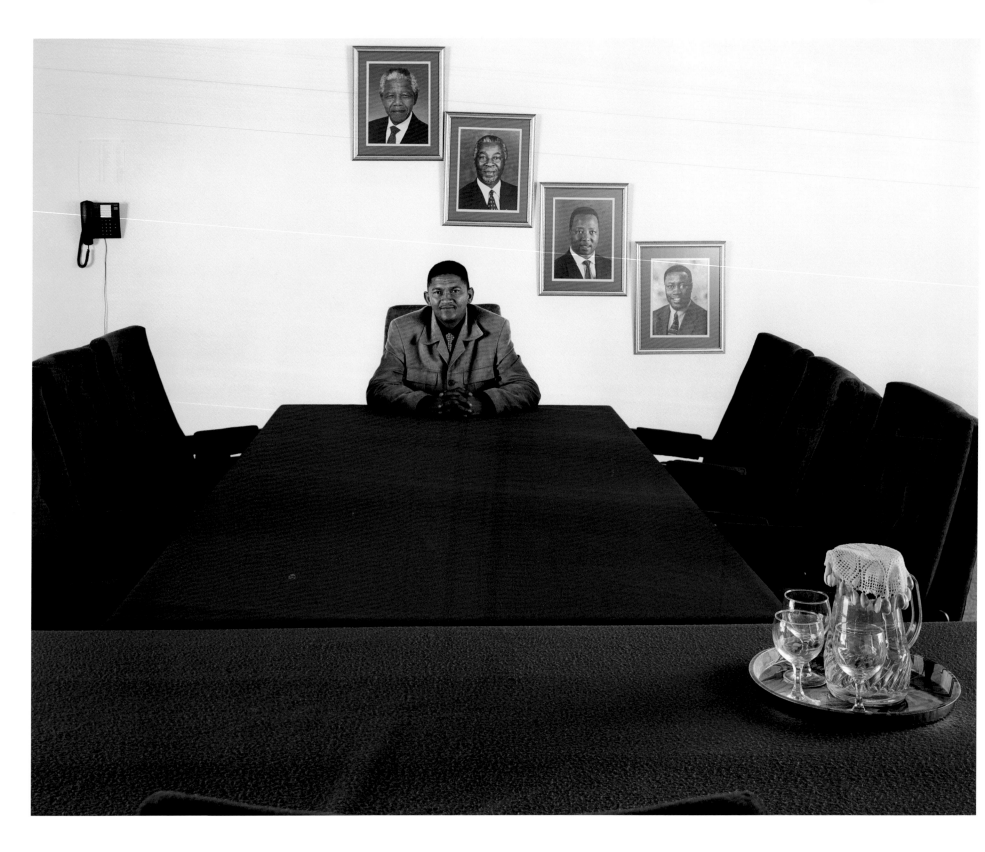

Intersections – Municipal Officials
ongoing photography some of which was
published in a book in 2005 by Prestel, Munich

Martin Klaase, mayor of the Kamiesberg Local Municipality in the council chamber at Garies,
Northern Cape. 28 June 2004

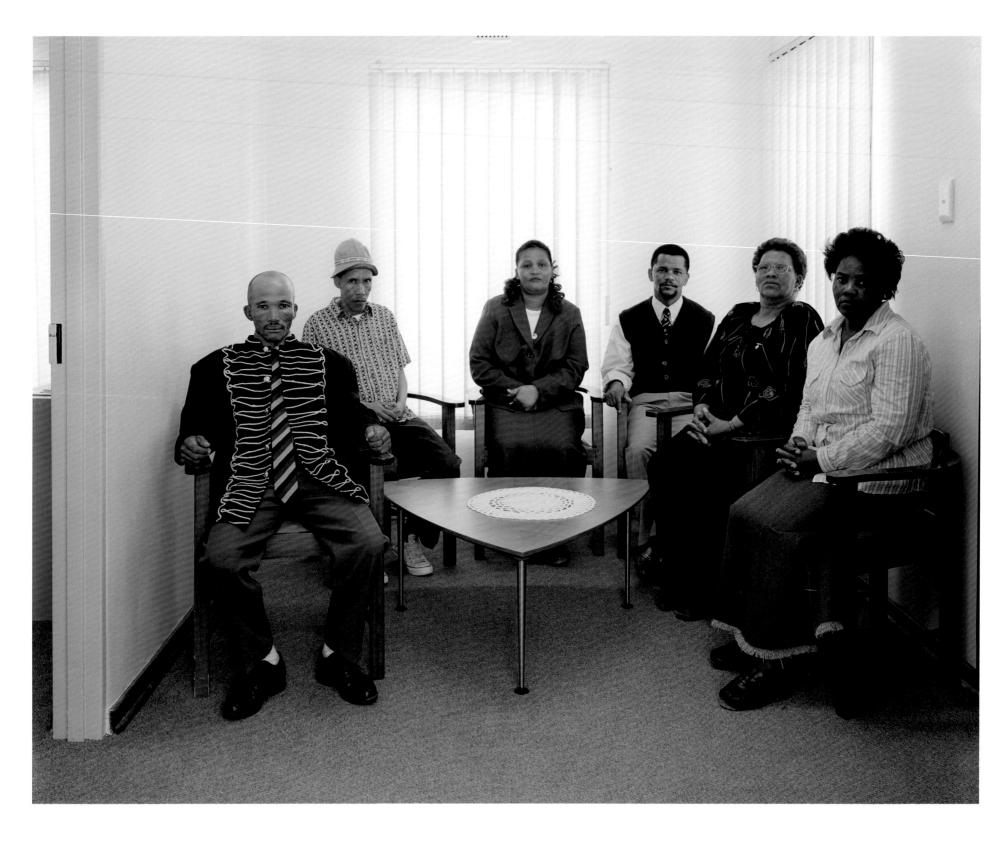

216
█ The council of the Khai-Ma Local Municipality. Left to right: Johannes Swartbooi, Lakus van Rooi, Alexandra Beukes (mayor), Marcellinus Gall, Hedwiga Jaar, Rosina Secondt. Pofadder, Northern Cape. 24 June 2004

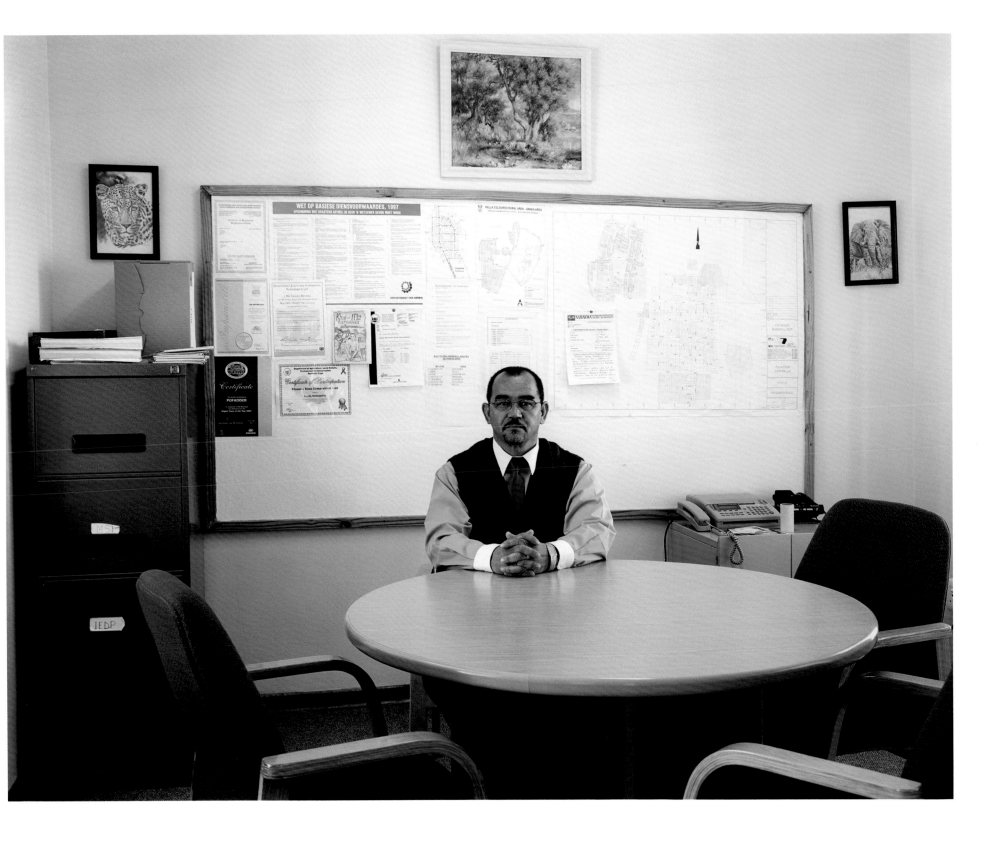

Lesley Beukes, manager of Khai-Ma Local Municipality, in his office, Pofadder,
Northern Cape. 24 June 2004

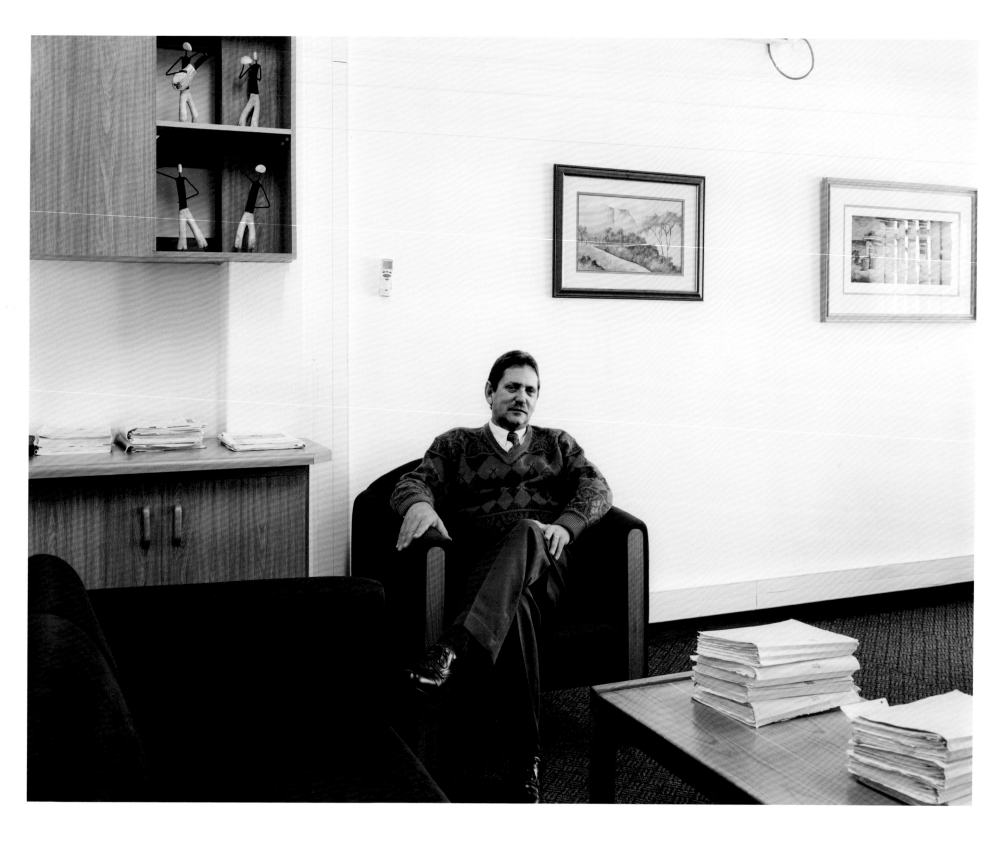

Nico Nel, Manager of the Breede River Winelands Municipality,
Ashton, Western Cape. 22 July 2004

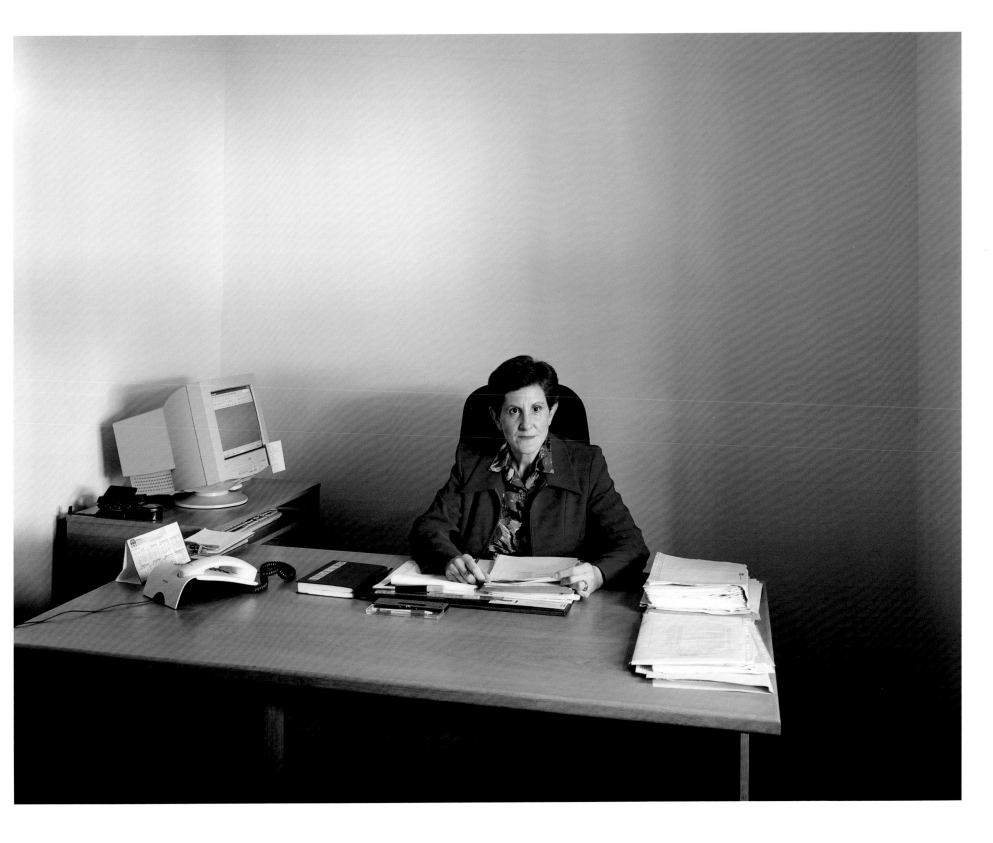

Karin Heydenrych, public relations officer, Breede River/Winelands Local Municipality,
Ashton, Western Cape. 22 July 2004

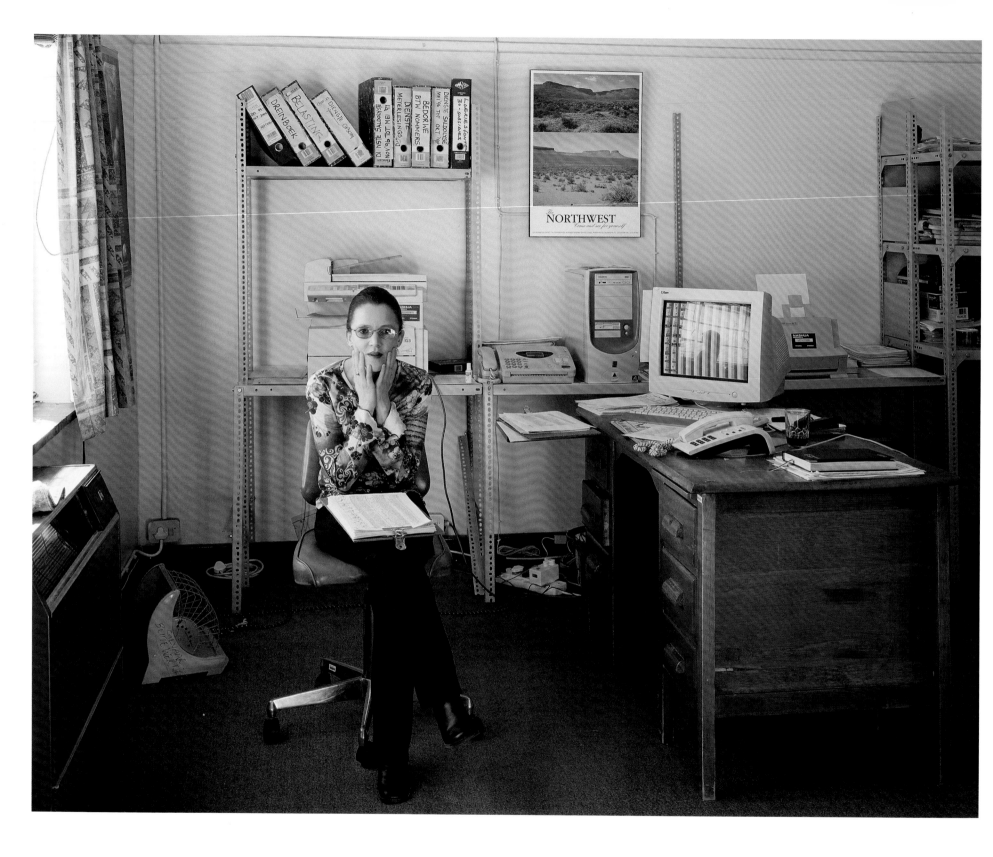

220 ■ Elize Klaaste, Senior Clerk, Hantam Local Municipality,
Loeriesfontein. 25 June 2004

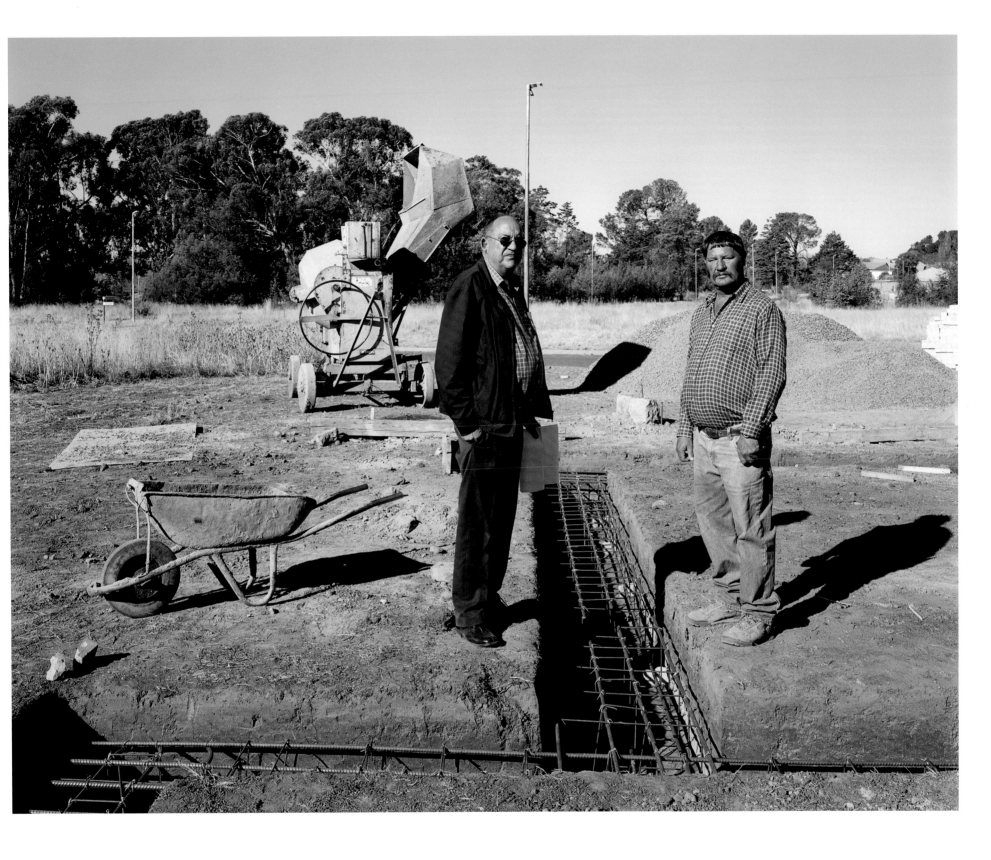

Paul Vos Pool, building and health inspector, Mantsopa Local Municipality and Jan Grobler, bricklayer, Ladybrand, Free State. 16 August 2004

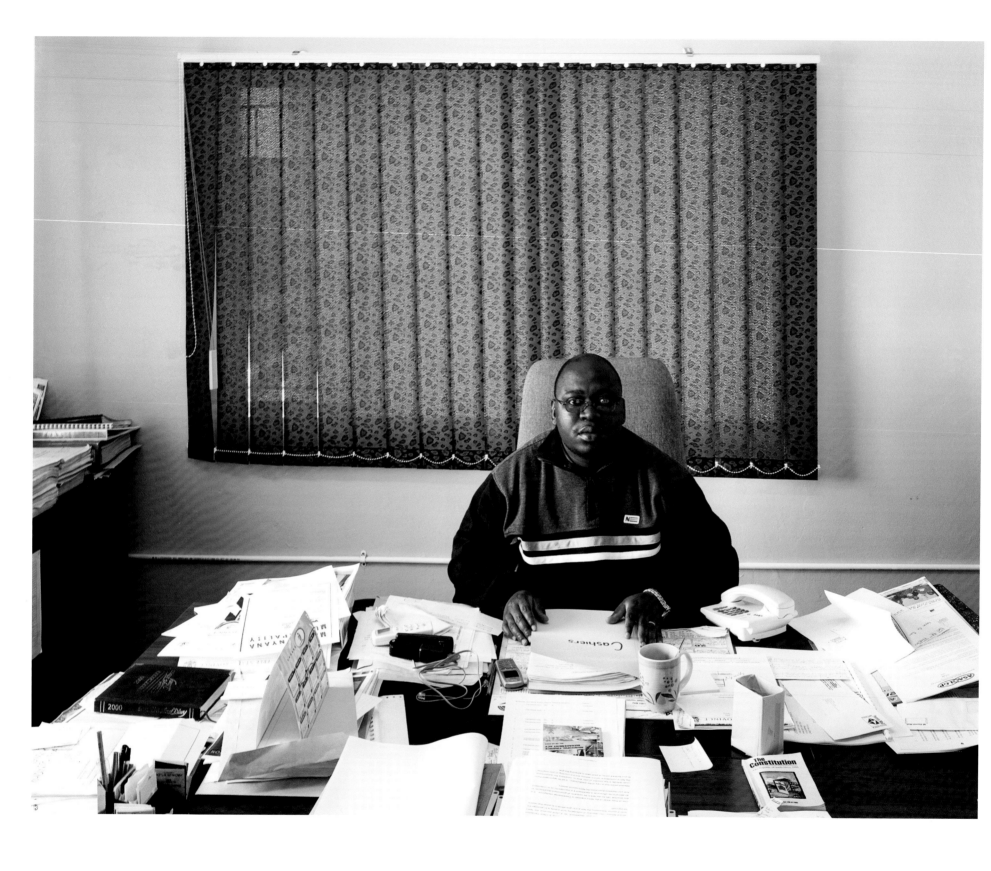

222

M. S. Phera, acting municipal manager, Masilonyana Municipality, Theunissen,
Free State. 11 August 2004

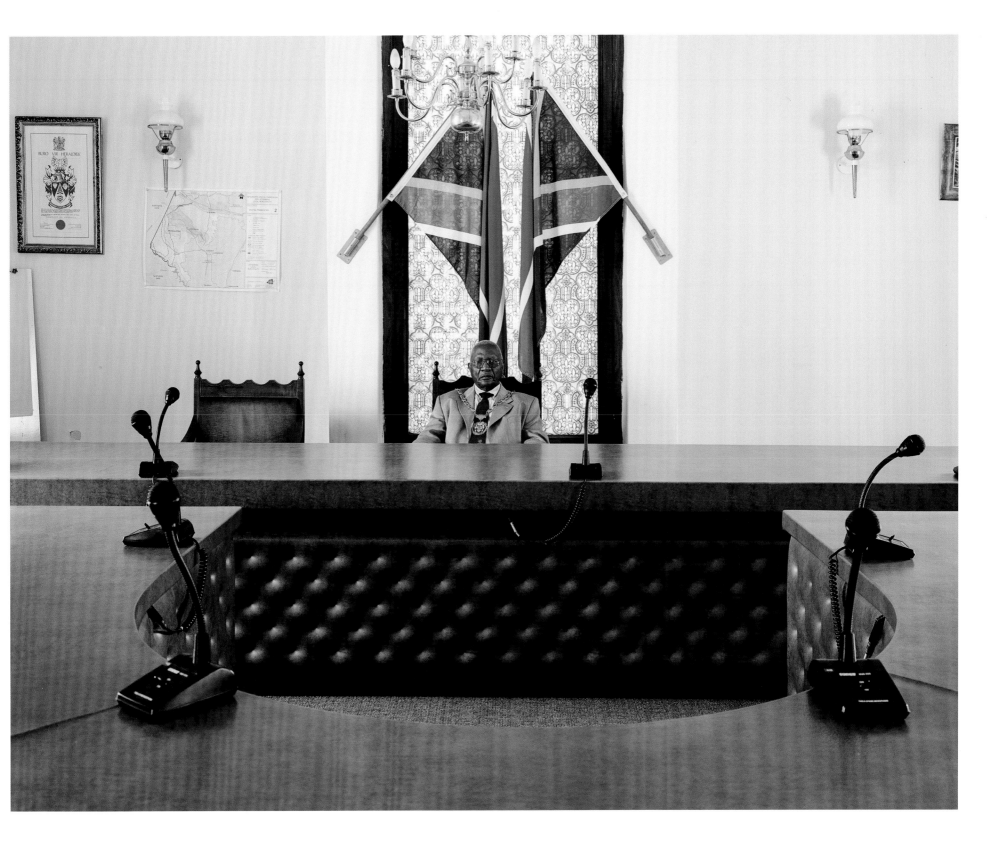

Johannes Rens, mayor, Letsemeng Local Municipality, in the council chamber, Koffiefontein, Free State. 31 August 2004

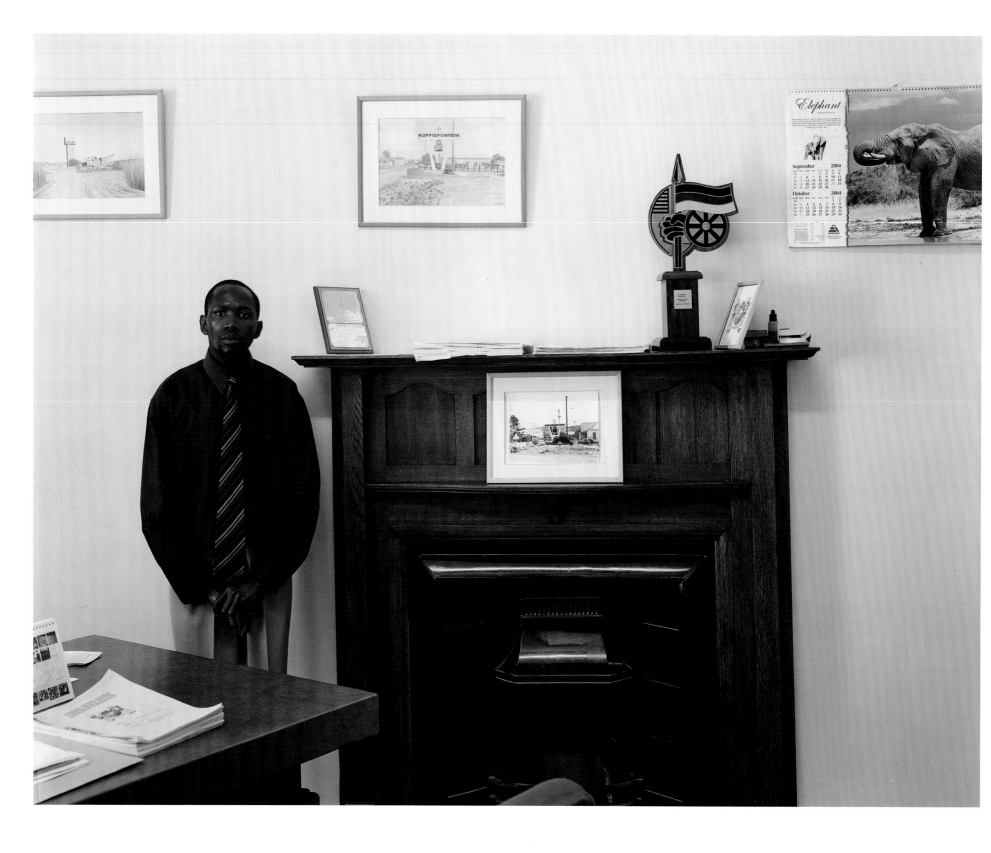

224 Peter Shuping, youth development officer, Letsemeng Local Municipality, in the municipal offices,
Koffiefontein, Free State. 1 September 2004

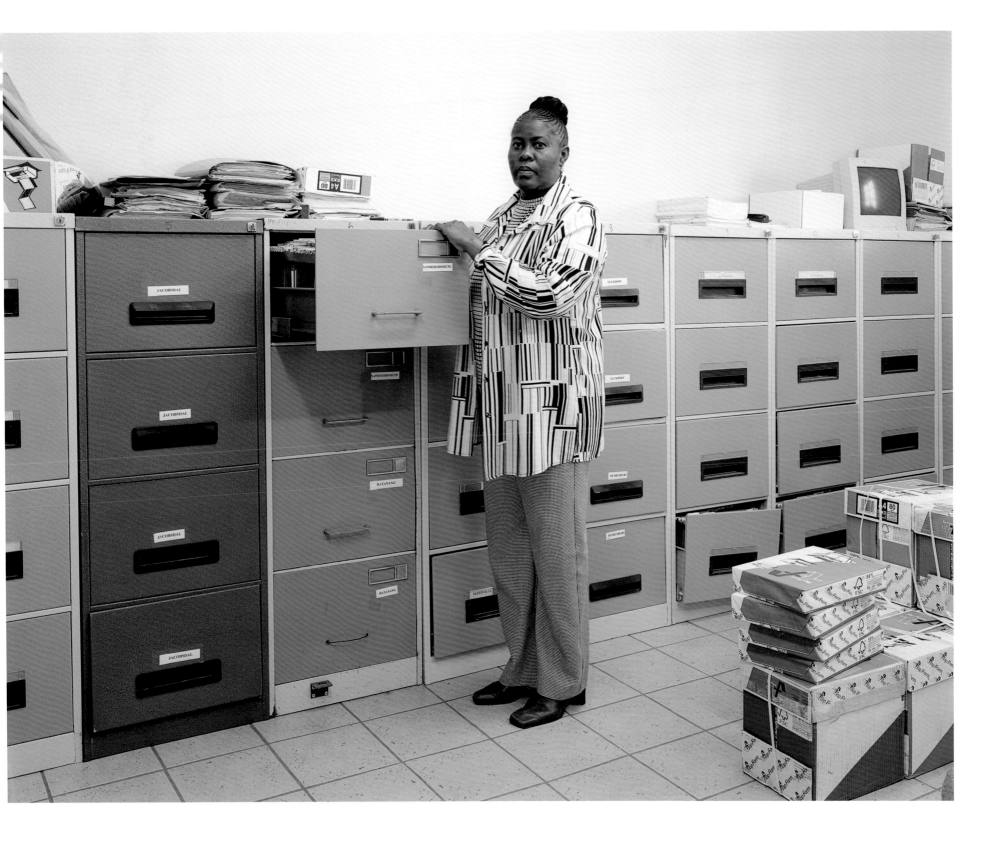

Meisie Wolf, municipal manager, Letsemeng Local Municipality,
Koffiefontein, Free State.. 31 August 2004

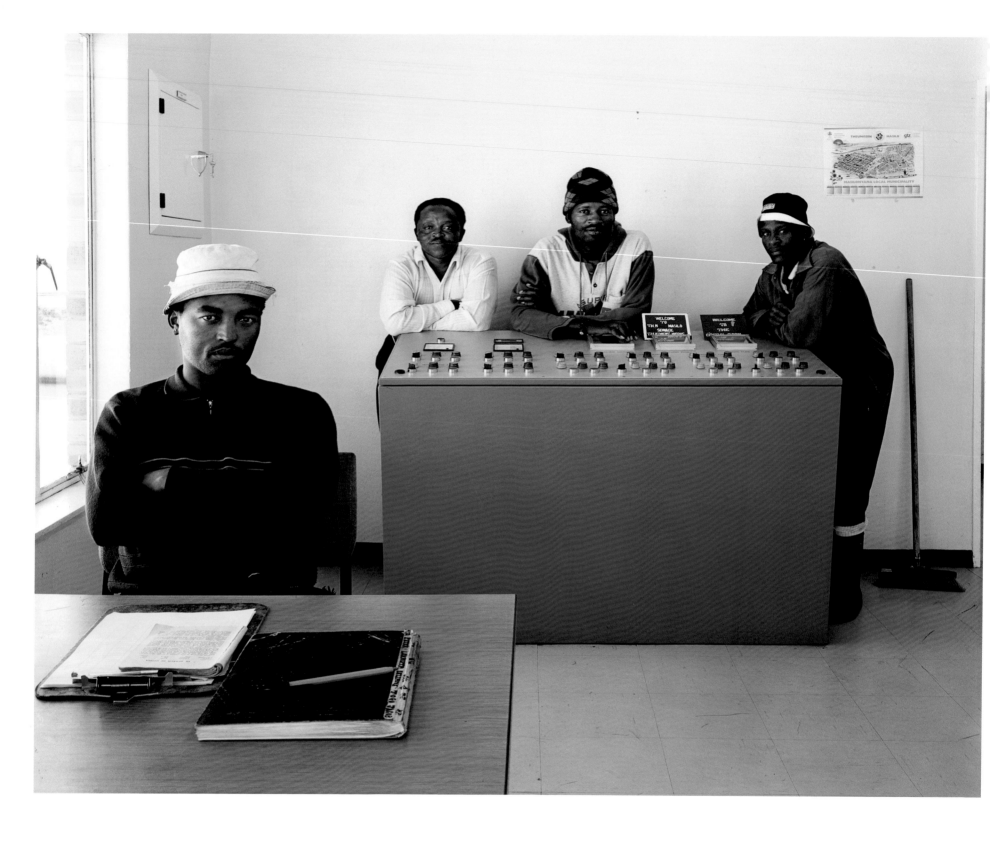

226 Operators of the Theunissen sewage Treatment Plant, Seliane Vincent, Jonas Togo, Piet Jacobs, Albert Lekauta.
Masilonyana Local Municipality, Theunissen, Free State. 12 August 2004v

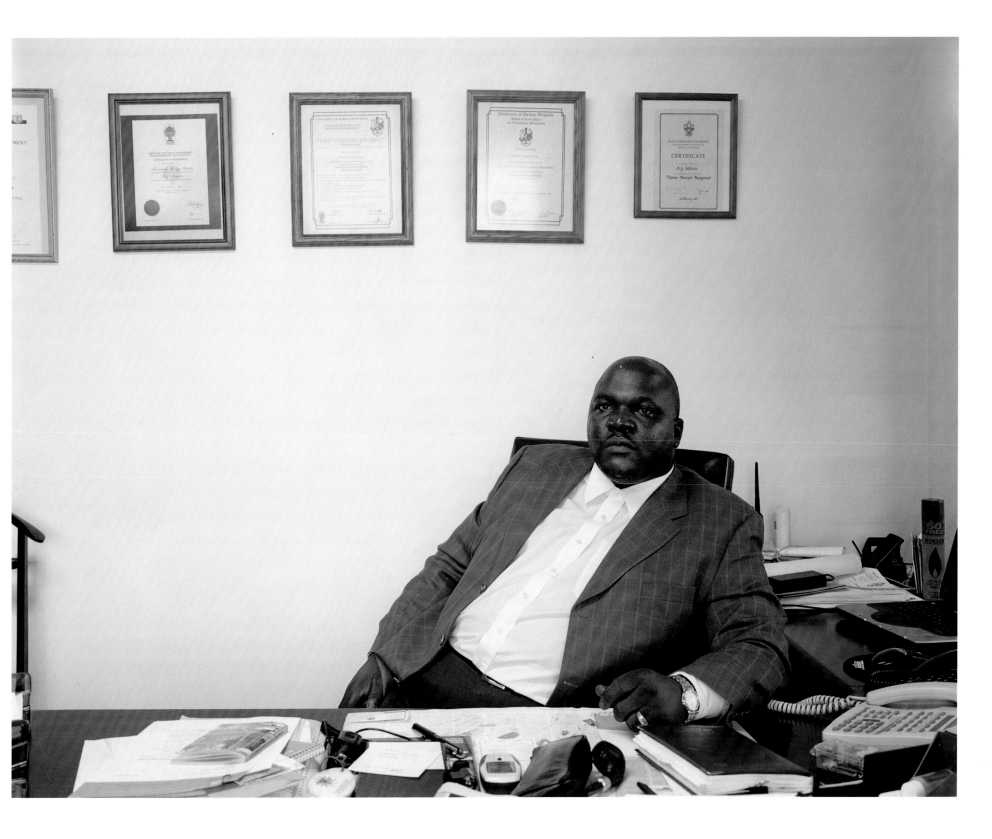

George Seitisho, manager of the Plettenberg Bay Local Municipality.
Plettenberg Bay, Western Cape. 8 October 2004

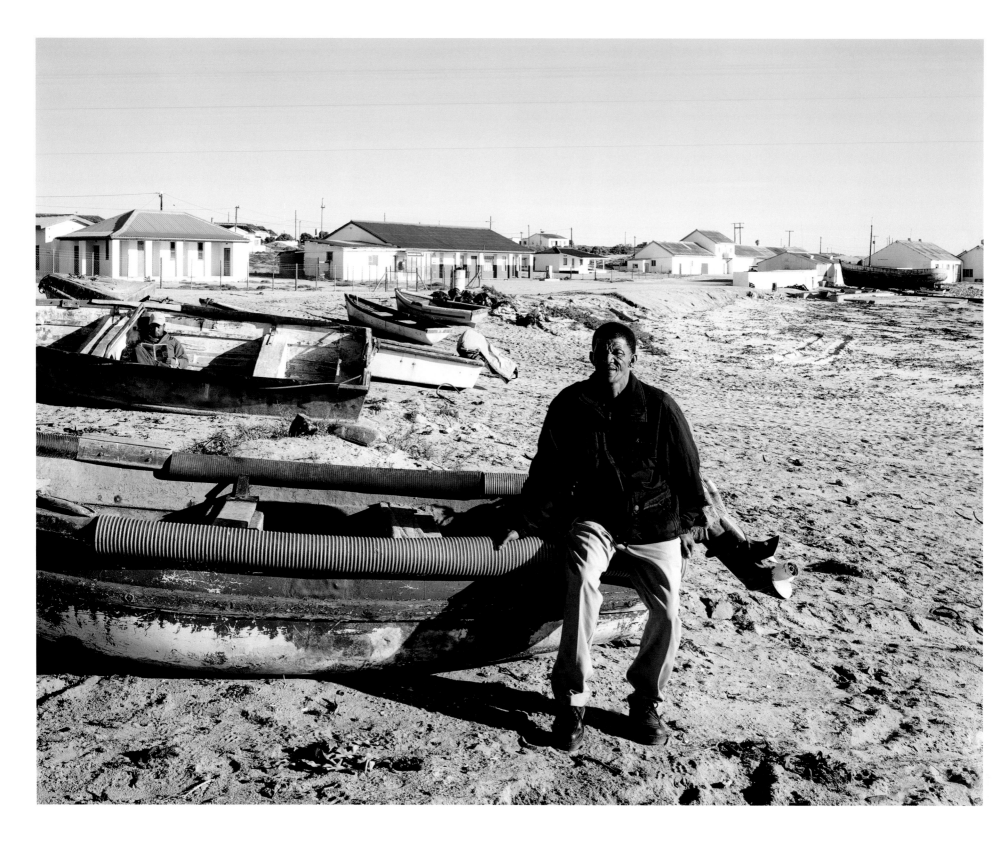

228 Piet Sochop, municipal councillor for ward 1, Kamiesberg Local Municipality, Hondeklipbaai,
Northern Cape. 28 June 2004

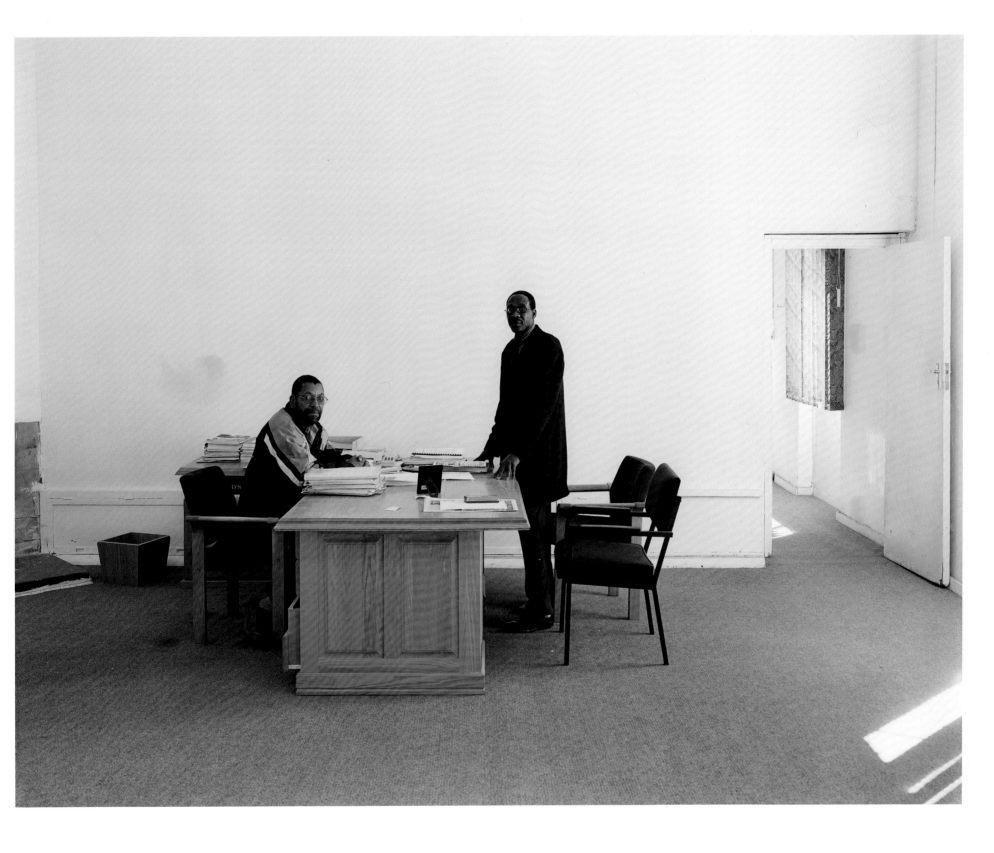

Willem Mathee, acting mayor and Dan Molangoanyane, speaker of Mantsopa Local Municipality in Mathee's office, Ladybrand, Free State. 16 August 2004

A CHRONOLOGY

alex dodd

1930s

Born in Randfontein, South Africa, in 1930, the third son of Eli Goldblatt and Olga Light, both of whom came to South Africa as children with their parents, to escape the persecution of the Lithuanian Jewish communities in the 1890s

'Unlike many of the other Jewish immigrants, my parents both spoke English pretty well. But when they wanted to speak between themselves and not be understood, they spoke Yiddish.

'When my grandfather died in 1910, my father had to go into the family business, a general dealer's store called Brown & Goldblatt, which he eventually turned into a men's outfitting shop. It was, of its kind, one of the best on the Reef. His customer base was extraordinarily mixed. While concession store traders specialised in goods that the mineworkers bought, Basotho blankets and that kind of thing, he went in for the top end of that trade. Miners would come all the way from the East Rand to buy his rugs, imported from Ireland. He took a very personal interest in his customers. In the early days, before the Second World War and shortly after it, there weren't many high-quality clothing manufacturers in South Africa, so the best suits and jackets came from England – Simpsons, Sumrie... He would measure a customer for a suit and send off an order by post to Simpsons in London. The magistrate needed something cool, but he had to be smartly dressed, so he would fit him with a washable linen suit from Hong Kong.

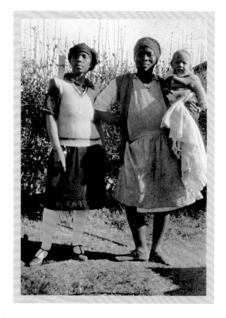

An unidentified woman and Martha Mopeloa holding David Goldblatt. Martha looked after David throughout his childhood and became a lifelong friend. She lives in Randfontein. 9 September 1931 [Photographer unknown]

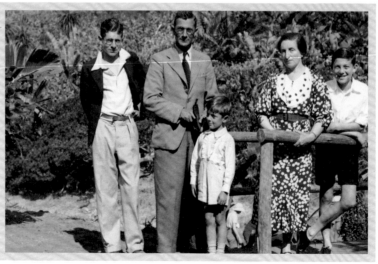

Eli and Olga Goldblatt with their sons Nick, Dan and David (centre), on holiday at Uvongo, Natal, circa 1936 [Photographer unknown]

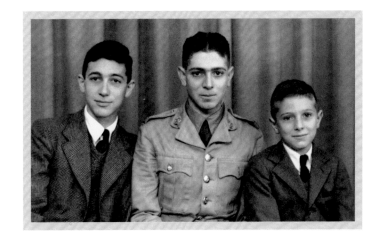

Dan, Nick and David Goldblatt, Randfontein, circa 1940 [Photographer unknown]

'My father was a perfectionist, but never in a confrontational way. If a man came in and needed new clothes or shoes, it was absolutely *verboten* to ask him what size he was. You had to know what size would be right for him, which meant you had to measure him, try it on to see. You didn't rely on people saying, 'this feels good' when you knew it didn't look right. You had to find the right thing. That was an absolute in our shop. You had to know your business.

'My mother worked as a typist in a clothing company and that's possibly how they met.

1940s
Attended primary school at Ursuline Convent, Randfontein

'When I reached Standard Six, I was sent off to boarding school at Pretoria Boys High. It was a disaster. Coming from the protected beneficent ambience of the Ursuline Convent, I was thrown into a hothouse of bullying and racism. It was pretty common for a big boy to call me, a junior, "You fucking little bloody Jew" – that sort of thing. It was a violent place and I just couldn't take it. My brother, Nick, who was then in the air force, visited me and could see that I simply wasn't coping, so he told my parents and they brought me home, sent me to Marist Brothers in Observatory, Johannesburg. If anything, that was worse. The anti-Semitism among the kids and the sadism of some of the teachers was simply beyond my telling. At the Convent I had been the best or second best in English in the senior class. But after a few weeks at Marist Brothers, I would try and spell 'would' as 'w-o-o-g-h-l-d' or something. I could no longer spell. I lost it. I then came back to Randfontein and went to Krugersdorp High, a co-ed day school, where I was very happy.

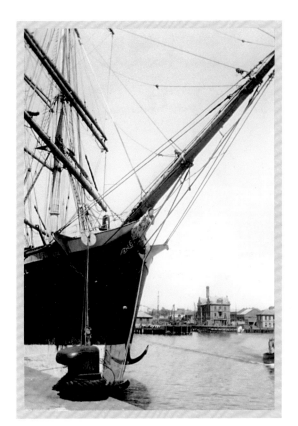

The Lawhill, Cape Town. Photographed to facilitate model boat building. January 1947

'We used to go to school by train, so the mine dumps were very much part of our scenery. The mines never stopped. There were only two days a year when the mines didn't work: Good Friday and Christmas Day. But for the rest they worked night and day, so at night you'd see these little streetlights on top of the dumps… The mine steam hooters went three times a day for the change of shift. They were markers of time, as is the noonday cannon in Cape Town. My father played bridge with the mine doctor and the chief engineer and, if there was a serious incident on the mines, those hooters would go and the engineer and the doctor would say, 'Eli, thanks very much', put their cards down and go off to see what was happening. It might have been a tribal clash in one of the compounds.

There might have been an overwind on a headgear with men injured and killed. The mines were always in the background of my world.

'My brother Dan was 18 or 19 when the war broke out. He'd had rheumatic fever as a child and was quite frail. But, because he'd been in bed for long periods, he had, by then, become a high calibre HAM radio operator. He ostensibly went to Durban on holiday, but in fact ran away to sea. My mother almost had a fit. He spent several years in the merchant navy and was torpedoed. Anyway, it was because of him that I became so interested in ships and building model boats. During the war there was no access to the harbours. Speaking about ships and shipping was *verboten*. But when the war ended, the harbours were opened up and, for me, this was a golden opportunity to look at ships on our annual holidays by the sea. In order to model my boats on them when I got home, I needed to make photographs. My

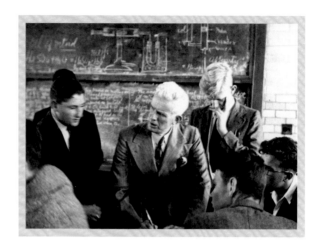

In the science class, Krugerdorp High School, circa 1947

mother lent me an old camera of hers, although at that time it was still very difficult to buy film. I quickly became very interested in the photographs themselves and began to look at magazines. Then it became an obsession. These magazines were extraordinarily potent. There was *Life* and *Look* and *Picture Post* and they were doing amazing things. They had some of the best photographers in the world contributing photographic essays, not simply illustrating written pieces. They were major pieces of work in themselves.

'I did photographs at high school – a friend cribbing in a Latin test, the tug of war, that kind of thing. When the school annual came out, they'd used a couple of my photographs.

'There were three of us, three sons. Nick, the eldest, was destined to go into the shop. But by 1935, when he matriculated, Hitler had been in business for three or four years and my father said, "No, you can't go into the trade. You need a profession." So Nick went to university and became a metallurgist. Dan, who had gone on to be a radio operator in the Israeli air force in 1948, came home eventually and opened his own place selling and repairing radios. My father hoped that I would join him in the shop.'

1948
Matriculated from Krugersdorp High School

'By then the war was over.

'The men who'd gone "up north" had gone there ostensibly to fight fascism which was very active here at home where there were many active sympathisers of the Nazis and virulent anti-Semitism. I can remember vividly Nat party posters outside my

'Working' the cocopans on Millsite tailings dump, Randfontein Estates Gold Mine. Part of an early attempt at a 'picture story'. 1949-50

Mother and child,
North Beach, Durban.
1949

father's shop with the grossly-inflated Semitic face of "Hoggenheimer". When the Nats came in, in May 1948, and suddenly the ruling party were these very people, it was a great shock. Instead of South Africa becoming a more liberated place, we were going in exactly the other direction.

'After matriculating, I said I really wanted to become a magazine photographer. My father would have liked me to go into the business, but he supported me on that completely. Dan came back from the merchant navy with a fine but damaged German camera – a Contax, the Zeiss equivalent of the Leica, developed in the 1930s. My father bought it from him to enable me to have a professional quality camera and I then started trying to take photographs of various things. But I had very little idea of how to go about things and the camera was irreparable. I didn't progress.

'I tried to get myself into magazines and for a year I *sukkeled* [struggled]. There were a few press photographers on the main papers, the *Rand Daily Mail*, *The Star*, the *Sunday Times*, and then there were commercial photographers, but very few people knew anything about magazine photography.

'I looked around for someone who might teach me, went from door to door with a box of prints to professional photographers and finally met a man who claimed he could teach me. I stayed with him for about three months, did quite a bit of darkroom work, and on weekends went with him to weddings. He would drape several cameras around my neck so that I looked very professional and my job was to ensure that no guest with a good camera got a good picture. I would have to bump or walk in front of them at the critical moment so that my boss was the only person who ended up with good photographs. When I left him, I discovered that the £10 a month he had been paying me, my father was quietly paying him. He was a real shit. I became extremely discouraged and went to work in the shop.'

David Goldblatt,
Nahoon, East London.
1951 [photograph by
Aviva Shoshani]

1950s
Tried shooting news events

'During the 50s I felt it incumbent upon me somehow to tell the world what was happening here and I started trying to photograph news events – not for the local press, but to send out of the country to magazines. I did a photograph of a black man walking up the steps of Johannesburg station. At the top there was a sign, "Europeans Only", that had not been there before and there was a 'blackjack', a policeman, telling him that he couldn't come up the steps because they were for Europeans Only. I was outraged. It was the first time that we'd seen such things. I sent the photographs off to *Picture Post* and

got a polite rejection, but then, when things started happening here in terms of the ANC's resistance to the pass laws and so on… the Defiance Campaign… I got a cable from *Picture Post* saying, "Please send us photographs". This was a great step. I photographed the beginning of the Defiance Campaign on Freedom Square in Fordsburg and sent the images off to the editor, but frankly, they were lousy. I was inexperienced. I didn't know how to bring things together. But what happened at that meeting on Freedom Square was very interesting. The security police were photographing people and I told of this in my captions. Such interference with political freedom was shocking to the editor of *Picture Post* and he wrote a letter to himself so he could put it in his letters column to express his outrage at what the South African police were doing. Today, there's no meeting that is not only photographed, but videoed. Besides being inexperienced, I found myself unable to deal with events of naked confrontation. I came to the understanding that I was not equipped in myself for the photography of violence. Then I began to realise that I wasn't terribly interested in events. As citizen, yes, but as photographer, not.

The start of the ANC Defiance Campaign Against Unjust Laws, Freedom Square, Fordsburg, Johannesburg. 1952

'I gradually developed the sense that it was the underbelly that drew me -- the values and conditions that gave rise to the events.

'I became interested in the possibility, photographically speaking, of suggesting things in stillness. This sense of stillness became quite an important factor to me aesthetically. That doesn't mean I didn't photograph activity or events. They were relevant to what I was doing. I mean, if you look at my Boksburg book, it's all about the small events of daily life. I was concerned to pinpoint the banal normalities of our white madness.

1952
Went to Israel

'Together with friends, I went on a three-month winter course in Israel, organised by Habonim, the Jewish Youth Movement. I now had my first Leica and, while I was in Israel, took some photographs that weren't bad. I came back and, rather to my father's disgust, because he was strongly against any kind of nationalism, including Zionist nationalism, I expressed a desire to become a doctor and go to live in Israel. It was then that we discovered that my father had cancer. Nick, my eldest brother, for whom I had great regard, said to me, "You can't go anywhere now. You're stuck in the shop." It would have broken my father's heart to have sold the shop, so I stayed on and gradually took over the management of the business. I registered for a B Com degree as a part-time student at Wits. My

interest in photography continued and I made a serious attempt at improving my technique… I found university extremely valuable. It wasn't simply the content of the courses. It was the demand made on one to think and express oneself coherently and in a reasonably directed sort of way.'

1955
Married Lily

Brenda, Lily and Steven Goldblatt, Johannesburg. Circa 1960

'We lived in Jo'burg in Westminster Mansions at the top of the Yeoville Hill next to the water tower. It was a lovely block. I had a darkroom in the dining room cupboard…

'There is a well known set of books by the famous American photographer, Ansel Adams, which he called ' basic', but which is an extremely sophisticated course in photography. I worked my way through it and got a much better command of technique so I could work in a reasonably predictable way. I think if you're going to be serious about photography you've got to have this ability. You can't always rely on a sort of random genius. Working entirely on my own, I developed quite stringent critical standards.

'Eventually we moved to Randfontein, by which stage we had Steven and Brenda. Lily was pregnant with Ronnie… I don't think I was ever a very doting father, but I changed napkins and so on…'

1961 to 1963
An end and a beginning
Started photographing Afrikaners, a theme that would lead to the publication of *Some Afrikaners Photographed* in 1975

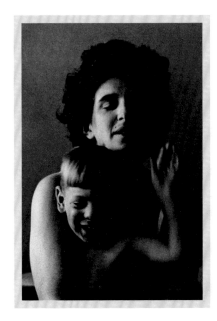

Lily and Ron Goldblatt, Randfontein. March 1965

'My father died in 1962, and on 15 September 1963, I handed over the keys of the shop to the men who had bought it and became a photographer.

'I'd become seriously interested in pure economics, so there were two choices: Either to become an economist and lecturer, or a photographer. I knew that the two things were, in a strange way, closely linked, but at the same time, they were mutually exclusive in a professional sense. I couldn't pursue both in the total way that I knew I needed to. One of the most important factors that made me go for photography rather than economics is that in my gut, in my balls really, I knew I needed something in my life that was related to the smell and the touch and the sense of reality. There was a great seductive quality about economics but it was essentially abstract. Somehow I knew photography would be it.

'To me, the greatest thing was the sense of freedom and of possibilities when I sold the shop. I can't tell you what that was like -- not to have this weight of goods pressing down on me and to have the freedom to go out and photograph. I've never been religious, but I still offer up a *bracha* [in Hebrew, a "blessing"] to say, "Thanks for this liberty."'

'I was in Lesotho in 1963 before I'd become a professional. The Communist Party had just been banned in South Africa and, on the sidewalk of the main street in Maseru, there was a man at a stand selling communist books and pamphlets. It was bizarrely interesting that a mile from there he would have been arrested. Using a telephoto lens, I photographed him. Afterwards, as I walked past, he said to me, "Am I an ox?" Since then, I have seldom photographed anyone without their permission.'

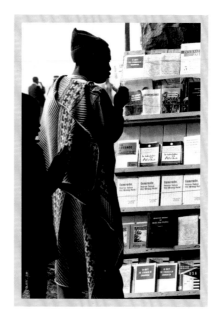

Communist literature in Maseru, Basutoland (Lesotho). Then illegal across the border in South Africa. April 1963

1964
Started working for South African *Tatler*
Travelled to the Marico Bushveld

'I began to work professionally, but I didn't have any clients. (I did take some money out of the shop, enough to support us for about a year, so it wasn't a completely reckless gamble.) The clientele I gradually got was mostly to do with public relations. Leyland Motors sold 100 new trucks to the South African railways and I was there for the handing over of the keys. Somebody had a fire and an insurance company would ask me to go and do pictures. I've always been freelance.

'There were two avant garde magazines in England at that time, *Queen* and *Town*. I sent pictures to *Town* and got an encouraging response from the assistant editor, Sally Angwin, a South African. She commissioned photography from me for an article on the Anglo American Corporation. Then Sally came back to South Africa and was offered the editorship of a magazine that, up till then, had been a social rag for the mink and manure set -- parties, fox hunts, that sort of thing. Desmond Niven, a descendent of Sir Percy Fitzpatrick, had bought this magazine and wanted to turn it into a kind of local version of *Queen/Town* and the South African *Tatler* was re-launched in 1964. Sally employed me on a lot of photography – fashion, the Sugar Barons of Natal, bankers, cars, horse racing... I learnt a lot working with her. She was a first class magazine journalist and editor who took no bullshit from me or anyone else.

'This was a completely different kind of scene from anything I knew. The art directors were a brilliant young couple – Norman

Fashion story on hats for *The Tatler*, Jan Smuts Airport, Johannesburg. 1964

236

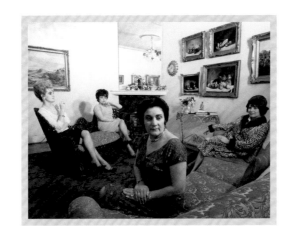

The founder of Joburg's first escort agency, Phyllis Peake, with escorts, Berea, Johannesburg. October 1964. For *The Tatler*

Alida and Sam Haskins, Johannesburg. August 1965

Lawrence Gandar, editor of the *Rand Daily Mail*, for the *London Sunday Times*. Johannesburg. April 1966

Seef, who's become the premier photographer to Hollywood, and his girlfriend Colette Hyman, who was the art director of a leading ad agency. They were very cutting edge…

'When *Unto Dust*, the second book of Herman Charles Bosman stories edited by Lionel Abrahams, was due to be published, I suggested to Sally that I go out to the Western Transvaal to see what I could find. So I landed up near Derdepoort, on what was then the Bechuanaland border, talking to a water diviner. I asked him of places like Abjaterskop and Droggedal and he directed me to an area called Nietverdiend. In the evening I came to a farmhouse, knocked on the door and said, "Do you mind if I camp in your garden?" The young farmer and his wife insisted that I sleep in their rondawel. That evening I accompanied the farmer when he went to the fields to organise ploughing, and it turned out that this was the farm Droggedal or Droëdal, which crops up again and again in Bosman's stories. The "conservative De Bruins" had lived on that very farm. In the next few days I met the people and found the places that Bosman wrote about. I discovered that the stories and the names of his characters were 'real'. They were the embroidered tales of the people he had met when he taught near Nietverdiend in the 1920s. Oom At Geel, who is in the stories and who is on the cover of my book, *Some Afrikaners Photographed*, was the chairman of the Nietverdiend School Committee. He sold Bosman the rifle with which he later shot his step-brother.

'My influences in those years, the 60s in particular, were primarily literary – Lionel Abrahams, Nadine Gordimer, Athol Fugard, Herman Charles Bosman and Barney Simon. Photographically the only South African who really influenced me was Sam Haskins, who became a good friend.'

'Although I was often away on assignments, I worked from home. The children were always welcome in my working space and felt at ease in my working life…

'Lily has always been strongly supportive of my work and amazingly tolerant of the demands of my freelance life with its frequent absences, irregular hours and wildly fluctuating cash flows.'

1965
Started photographing the dying gold mines, a theme that would lead to the publication of *On the Mines* in 1973

'I'd begun to work on two principal essays: Afrikaners, and the dying mines of the Witwatersrand. Having lived in a mining town all my life, I felt the need to explore the mining phenomena more fully. Access to mine properties was restricted, so you'd be poking around on a mine that

had closed 20 years before and out of the earth, seemingly, a mine policeman would crop up and tell you that you weren't allowed to be there. I generally tried to get permission from the head offices...

'The bathroom attached to the general manager's office had two baths so when he came up from underground, the GM would get into the one, wash off the coarse dirt and then get into the other for a final clean. These are fascinating aspects of mining society and its tools. On the Randfontein Estates, where I lived, they had the biggest steam hoist in the world – 6 000 horse power. It was a fantastic machine. I photographed an abandoned compound -- thousands of concrete bunks, and only found one where there was a sign of human habitation. A man had stuck some pinups on the wall, white women, presumably in those days there were no black pinups. And the lavatories that the black men were forced to use in the compounds, lines of ceramic seats. I tried to photograph what these things disclosed of mining society and the migrant labour system that had brought men from all over the subcontinent to work in it.

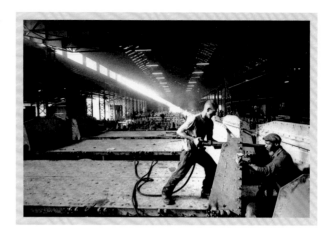

Building railway wagons at Barlow Head Wrightson, Germiston. For Barlows annual report. 1967

1968

Met Nadine Gordimer
Got the thumbs down in America

'As a boy, Richmal Compton's William books were great favourites and the Arthur Ransome books about a group of kids on the Norfolk Broads in East Anglia. Then there were people like Rudyard Kipling, who wrote about the Empire... I grew up with a sense of everything happening in other places. It was always London, New York or Karachi... This is why, when I read Nadine Gordimer's first stories in about 1949, I reached a turning point in my life. It was the first time somebody wrote with such immediacy of what I knew: the experience of living on the Witwatersrand. She grew up in Springs. I grew up in Randfontein. Her stories enabled me to see that my awareness was as yet unrealised, not out, but inward -- but that it could be made outward, it could be made evident. I was able now suddenly to think in terms of expressing something that was about this place.

'In 1968, when I was about 38 years old, I went overseas with a dummy of my book on Afrikaners that Sam Haskins had designed for me. Sam's publishers in London, the Bodley Head, said they would publish if I could find a co-publisher, so I went

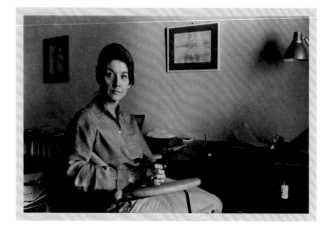

Nadine Gordimer in her study, Parktown, Johannesburg. July 1968

Fishermen putting to sea in a squall, Comores. 1968. For *Fair Lady*

to New York with about a dozen introductions to publishers. Saw them all and for the first and only time in my life I became suicidal. Aside from catching the Asian Flu, which was then sweeping the world, and being holed up in a lousy hotel, I felt like an ant. Wherever I went I got the same response: very warm when I walked in, but once the work had been looked at, a steel door came down. In New York, time is money and they're not going to waste time on you if you're of no interest. The Afrikaners and I were of no interest. They had the Southerners and my photographs weren't explicitly about apartheid, which was becoming a buzzword. They were non-emphatic things and I would have to explain, like explaining jokes, what they were about. Eventually one guy summed it up. He said: "Buddy you ain't got a gimmick." That was a turning point for me.

'I began to understand what had been happening during the making of that book. It was the realisation that I was involved in this place in a way that I couldn't be in another place. I suppose I could have moved and fitted in to mid-America, but I would never have had that visceral knowledge that came from my birth and growing in South Africa. The photographs I made and wanted to make came out of and assumed that kind of knowledge in my audience. They were too arcane, too parochial for outsiders. So I no longer worried about 'reaching' overseas. Nor did I want to live there.'

1972
Spent six months photographing in Soweto

Brenda Goldblatt modelling for an advert for Oshkosh Trucks. Circa 1972

'In 1970, I said to Charles Eglington, the editor of *Optima*, "Surely you should do a story on Soweto? The person to do the photographs is Peter Magubane." But Peter went inside – was imprisoned and in solitary confinement for a hell of a long time and then, when he came out, he was banned... Finally Charles said to me, "I think you must photograph it." So I went into Soweto with Sipho Sepamla and did a few photographs. But wherever I went I would draw a crowd of children. There was absolutely no way I could disappear, be invisible – a 'fly on the wall'. And so I stopped and I told Charles, "I'm sorry, but I don't know how to do this yet. Can you wait until I find out?"

'It took me two years. But then I woke up on an August morning in 1972 and knew what I wanted to do. I just had to go there with a camera on a tripod and simply declare myself – let happen what will. Almost immediately, out of the smog – in those days you could hardly see through the smog in Soweto – a young man emerged and said, 'I want to help you', and he became my mentor and translator, Joshua Moeketsi. On the fringe

of a *tsotsi* gang he had been asked to become its captain and had resisted. He and I became very closely involved and, for about six months, I went into Soweto several times a week and Joshua and I would drive around and photograph…

'I was partly influenced by the photographs of Bruce Davidson, who had done something similar using a large format camera on 100th Street in Harlem, New York. It was quite a leap from 35mm photography of life on the wing, as it were to a much more deliberate contemplative approach, which is what I adopted in Soweto. I acknowledged completely that when I went into Soweto, I was the "other". Freaky, foreign, white. There's no way I could have melted into Soweto.'

1973

Publication of *On The Mines* with Nadine Gordimer, Struik, Cape Town

'While working on the photographs of the dying mines, Nadine Gordimer's writing was very much in mind, so I asked Lionel Abrahams, who was a friend of hers, to introduce me to her. I showed her the work up to that point, in the hope that she might write something. She responded very warmly and so we began to work together. Her essay, *The Witwatersrand: A Time and Tailings*, came out of that collaboration.'

1974

Exhibited at the Photographers' Gallery, London

'My most rewarding exhibition was my first big one, which was on the observation deck of the Carlton Centre in 1974. People came for the view, but often stayed to look at the photographs and became so involved in them that I would have to go in the evenings to wipe hamburger grease off the prints. They were local people from Lenasia, Soweto, Yeoville, Boksburg, identifying and connecting with the pictures.'

1975

Publication of *Some Afrikaners Photographed*, Murray Crawford Johannesburg
Exhibited at the National Gallery of Victoria, Melbourne
Shot a series of photographs in public parks around Johannesburg honing in on the details of people's bodies, that would result in the publication of *Particulars* in 2003

'With *Some Afrikaners Photographed* it was a case of tough love. I believe I looked with real affection, even with love, but at the

Euan and Murray Crawford. Murray made possible the publication of *Some Afrikaners Photographed*. Johannesburg. October 1964

Young men at breakfast,
Transkei.1975.
For *Optima*

same time critically, and this was very uncomfortable for a lot of Afrikaners.

'I experience a hunger for recognition in almost everyone. With the exception perhaps of people who are often in the public eye and are now blasé about it – we all like to be noticed.

'I've learnt with photographs that if I've done my job properly I haven't made judgments for the viewer. They've got to find their way into the picture and, often, what they find is not what I saw.

'Generally speaking I haven't had any serious problems that I can recall of people I've photographed who've then become aware of the publication and felt that I've betrayed them. I learnt pretty early on that one of the things I had to be very careful to do was to honour my declared intentions.

'I fell out with one magazine because I refused to allow the editor to use captions that were completely false. Shortly after the Soweto uprising in 1976, I was in Canada and agreed to the use of some of my photographs by a local magazine, provided they used my captions. When I phoned to check what they had done, shortly before they were due to go to press, I discovered that they had attached captions that were factually wrong and grossly distorted my photographs. I told the editor, "If you attempt to use those captions I'll get a court interdict against you. I'll stop your press." He changed them.

'I felt I had to control my material. I never joined an agency, which was the obvious thing to do if you wanted to get into the international magazine market. If you could join Magnum or Black Star -- one of the big agencies – you'd get publication in a wide range of very good magazines. But that required that you hand over the material and let them do more or less what they liked with it. And I wasn't prepared to do that, so I kept out of the agencies right through.'

'At the beginning of the *Particulars* book, there's a picture of a young woman in a very short mini skirt. She was a prostitute and I saw her in Fordsburg sitting on bench… I came up to her and said, "I think you've got beautiful hands. I'd like to photograph them." And she did have hands that I liked, but it was the combination of her hands, the miniskirt and that little roll of fat that women have at the top of the thigh that I find very sexy, and is very womanly. But I didn't want to go into all of that detail. She said, "Well, 20 cents." And I said, "No, I don't want to pay. I think you're beautiful. I just want to photograph your hands." And she said, "20 cents." So I said, "Well look, I'm sorry then. Don't worry. I'll leave it," and I started walking away and she said, "Alright." And then she said to me, "Come, let's go to Swaziland." [To escape the apartheid law prohibiting sexual intimacy between whites and blacks, some would slip across the border to neighbouring countries such as Swaziland.] And I said, "Thank you very much, but I just want to photograph your hands." And then finally she said, "Ag, such a nice man." So yes there was an element there of concealment, I suppose.'

1976

Photographed Fietas during the Forced Removals

'I photographed Fietas – Pageview -- in 76/77, both before and during the destruction of the area under the Group Areas Act. I used to ride a bicycle because that was an excellent way of being able to stop wherever I wanted and set up a tripod. I became a very keen cyclist.'

1977

Exhibited at the Durban Art Gallery

1978

First of various exhibitions at the Market Theatre Galleries, Johannesburg

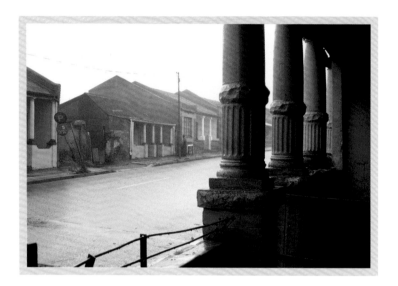

Fietas (Pageview) Johannesburg, before the forced removal of its Indian populace and the destruction of their homes and shops to make room for whites, under the Group Areas apartheid law. 1976

1979

Began photographing the new suburbs springing up around Boksburg, a theme that would lead to the publication of *In Boksburg* in 1982

'I was doing a commercial job for the JCI (which Brett Kebble has made infamous, but which was then a very respectable company) in Boksburg, and became aware of a whole new suburban phenomenon. Here was a town very similar to the one I'd grown up in, which was developing in new ways.'

1980

'In 1980, *Optima*, commissioned me to do a story on the whites of South Africa. They had asked Alan Paton to write and would I now photograph… I was going to set off on my motorbike – I then rode a BMW – and travel around South Africa. Then I realized that what I had been doing in Boksburg was precisely a microcosm of white South Africa, so I suggested that I intensify what I was doing in Boksburg.'

1980s

'During the 80s, my professional work centred more and more on *Leadership* magazine. [Editor and publisher] Hugh Murray and I developed a strong working relationship and I became responsible for the visual content of the magazine in quite a serious way.

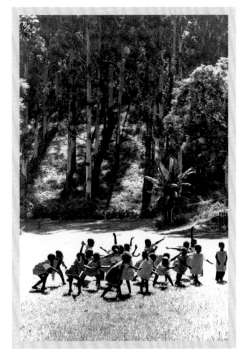

Nursery school children exercising, Eastern Transvaal. 1981. For *Fair Lady*

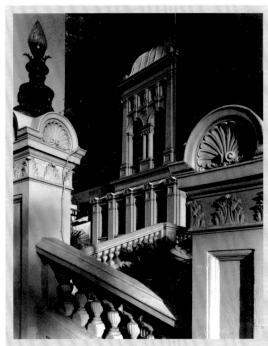

The Durban Club, 1980. For the Royal Hotel, Durban.

'As a photographer, I'm very aware of how people are when I'm photographing them and I definitely use that knowledge, but I'm also aware that that knowledge can be ruthlessly used against somebody in quite a subtle way… I did a lot of portraits for *Leadership* of politicians and businessmen and if I found that I really didn't like somebody – not because of his politics necessarily, but because I found him an odious person – I sometimes did a hatchet job quite deliberately. I wasn't above putting a well-known politician into a Gomma Gomma chair, knowing that he would be all knees in it.'

1981

Publication of *Cape Dutch Homesteads*, with Margaret Courtney-Clark and John Kench, Struik, Cape Town

1982

Publication of *In Boksburg*, Gallery Press, Cape Town

1983

Exhibited at the SA National Gallery, Cape Town
Started on the 15-year Structures project that would culminate in the publication of *South Africa The Structure of Things Then* in 1998
Started photographing the three-hour bus journey between the Wolwekraal depot in KwaNdebele and the Marabastad terminus in Pretoria, a series which led to the publication of *The Transported of KwaNdebele: A South African Odyssey* in 1989

1985

Exhibited at the Side Gallery, Newcastle-upon-Tyne and the Photographers' Gallery, London
British television network, Channel 4, made and screened a one hour documentary, *David Goldblatt: In Black and White*, subsequently shown in the USA [PBS] and Australia

'This was perhaps the lowest point of the South African struggle because it looked seriously as though we would go into a long night here. There seemed no prospect of relief. There was a State of Emergency. The government was locking up tens of thousands of people, mostly youngsters. People like Neil Agget

had died in detention. We'd lived through the death of [Steve] Biko. Both of my sons went into the army. It was a bad time…

'My exhibition that started at the Side Gallery toured Britain. When it was due to go to Liverpool, the council there asked the ANC if it was okay to exhibit my work and the London office of the ANC said no. They put out a boycott call on David Goldblatt because he'd defied the cultural boycott and because he did work for the Anglo American Corporation. A couple of key ANC supporters in South Africa sent a message to London that the boycott was ridiculous and it was relaxed. But it was a very intense period of total control and I realised that work such as mine could become critically important simply as documentary evidence, so I donated that whole exhibition to the Victoria & Albert Museum in London.'

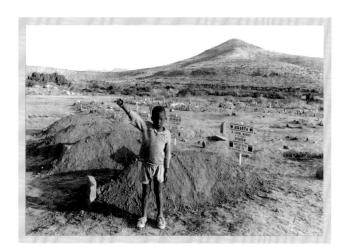

After the funeral of the Cradock Four who were assassinated by the Security Police, a child gives the salute of the then banned African National Congress (ANC), Cradock. 1985. For the *New York Times*

1986

Publication of *Lifetimes: Under Apartheid*, with Nadine Gordimer, Knopf, New York
Exhibited as part of the group show, *South Africa: the Cordoned Heart*, South Africa and the USA

1987

Hallmark Fellow at the Aspen Conference in Design, Aspen, Colorado, 1987

1989

Publication of *The Transported of KwaNdebele* with Brenda Goldblatt and Phillip van Niekerk, Aperture and Duke University, New York

'During the 80s, I came to feel the need increasingly to enable visual literacy among young township people, so together with a couple of friends, we raised funds to set up the Market Photography Workshop in Johannesburg. I've had little to do with the running of it. The people who have managed it and taught there have been full of ideals and the ability to put them into practice. It has worked remarkably well.'

President Robert Mugabe in his office, Harare, Zimbabwe. 1986. For *Leadership*

ANC activist,
now Justice,
Albie Sachs,
Johannesburg.
1990. For
Monitor

1990

State President FW De Klerk makes a speech unbanning the ANC and announcing the imminent release of Nelson Mandela from prison

'The critical year for me was not '94. It was '90, when De Klerk made his great speech in Parliament -- great in the sense that it was a speech of abdication. That was fundamental, like June 16 1976. I said to my friends at the time, "This is the revolution. It's happening right now."'

1992

Gahan Fellow in Photography at Harvard University

1995

Exhibited as part of the Johannesburg Biennale
Awarded the Camera Austria Prize for an excerpt from *South Africa the Structure of Things Then*

1996

Exhibited as part of *In/Sight, African Photographers, 1940 to the Present*, Guggenheim Museum, New York

1998

Publication of *South Africa: the Structure of Things Then*, Oxford University Press, Cape Town, and Monacelli Press, New York
First South African to be given a solo exhibition at the Museum of Modern Art, New York
Exhibited as part of *Blank_ Architecture, apartheid and after*, Rotterdam and Berlin

'On Good Friday of 1998 I went for a drive around the city of Johannesburg. It was the first time since liberation that I'd really stopped to look at what had been happening because I'd been so deeply immersed in the Structures project. I drove firstly into the centre of the city and, it being a public holiday, it was very quiet. It was as though I was driving through a bombed city. Shops I'd known since I was a child were bricked up. Streets were full of garbage. Buildings were decrepit and unpainted. And then I drove out to the north, where there seemed to be a manic pursuit of wealth

and luxury that was mind boggling… I found it utterly depressing. I came home and said to Lily, "For the first time in my life I don't want to live here. I feel as though suddenly I don't belong. It's a place that has become completely foreign to me."

'For a time I really felt like a stranger, but I began to look with a camera, which demands that you seek and convey coherence. As I began to do that my sense of involvement was reawakened.

'I started looking more closely at the city -- trying to photograph it. Because of rampant crime, I had to hire a man with a gun.

'What was most interesting for me was the contrast in the expectations of the capitalists, the owners of the buildings, and the hundreds of thousands of people from all over Africa who moved into them. Fond expectations of rising income from huge property investments, long into the future, were dashed within a very few years. And although this new, teeming Joburg inner city was in many respects anarchic, there was a strong substratum of people who sought within its congestion, to build a settled and respectable life for themselves and their children.'

'In the North, adverts appeared on sidewalks. Tymon, painter, phone so-and-so. Peter, painter, phone. Jimmy Mokwena, builder… This was not possible during apartheid. Africans were not allowed to trade in white Johannesburg. But this was no longer white Johannesburg. It was becoming a non-racial Johannesburg and here were people who were clawing their way into the economy. All you needed was skill, a paintbrush and a cellphone and you could be in business. You didn't need a secretary or an office, just basic tools and the preparedness to work. So these were to me very interesting facets of what was happening in the new South Africa.

'And of course in the north of Johannesburg there was this insatiable pursuit of wealth, which I found, and still find, appalling.'

1999

Exhibited at South African National Gallery, Cape Town
Started photographing South African landscapes in colour, leading to the publication of *Intersections* in 2005

'Irving Penn, the great American photographer, said he had not seen a memorable colour photograph. He had done some remarkable colour work himself. That's always stuck in my mind.

'I was invited in 1999 by the Art Gallery of Western Australia to participate in an exhibition entitled *Home* and to contribute a photographic project of my choice in Australia to that show. They thought I would want to photograph the South Africans in Perth. I told them I'd been to Boksburg. I got hold of a Rough Guide to Australia and read about a place called Wittenoom, in the far north, a town that had been decimated by the effects of mining blue asbestos. I had become interested in the subject because I had seen a friend die of mesothelioma, the terrible cancer you get from blue asbestos. I needed to photograph in colour because blue asbestos is blue. So I came to a link

Former homes of senior officials of Colonial Blue Asbestos Mine, now abandoned, Wittenoom, Western Australia. August 1999

between a new set of film emulsions and digital reproduction that enabled me to make prints in colour that previously I had not been able to do.

'I've found the venture into colour quite exciting, largely because new technology has enabled me to work with colour on the computer as I have done with black and white in the darkroom. Now I can sit at the computer with the image on screen and through Tony – Tony Meintjes who does all of my printing -- pump up the contrast, lighten the picture here, darken there and make the blue less glaringly "sunny skies and Chevrolet".

'Colour has been an added dimension, a way of looking at things with a more relaxed kind of approach. It has to do with the sense of liberation that came with post-apartheid South Africa, a sense that I didn't any longer have to feel guilty every time I looked at something that wasn't immediately relevant to the struggle. Not that I ever did 'struggle photographs', but I was always acutely aware of the need somehow to penetrate to the roots of the system. Today I don't feel anger and I don't feel fear in the sense that I did at that time. Obviously I'm concerned and depressed by many things that have happened, from Dainfern through to Mr Zuma, but it's generally not the same kind of concern. Yes, I'm afraid of men with guns and knives, but I'm not afraid of the security police. I'm not afraid that we're going to collapse into some appalling cataclysm.'

2000

Exhibited as part of *Eye-Africa*, Revue Noir, Cape Town, Europe and the USA
Exhibited as part of *Home*, Art Gallery of Western Australia, Perth
Exhibited as part of *Rhizomes of Memory, Three South African Photographers*, Henie Onstad Kunstsenter, Oslo

'2000? I've never been able to work up the enthusiasm for things like New Year's Day and Millennium Day. I mean they're just days.'

2001

Publication of David Goldblatt 55 (one of a series about photographers) Phaidon Press, London
Axa Gallery, New York
David Goldblatt Fifty-One Years, a retrospective exhibition co-curated by Corinne Diserens and Okwui Enwezor and produced by the Museu d'Art Contemporani de Barcelona (MACBA), began an international tour of galleries and museums
Publication of *David Goldblatt Fifty-One Years*, Actar and Macba, Barcelona
Exhibited as part of *The Short Century*, Museum Villa Stuck, Munich
Received an Honorary Doctorate in Fine Arts from The University of Cape Town

'When I came back from Australia, I realised I wanted to look at our country. Previously I had a clearly focused area of life that I wanted to explore – Boksburg, Afrikaners, Transkei, Structures. Now I just had a vague feeling that I wanted to explore post-apartheid South Africa… I decided I would go to every intersection of whole degrees of latitude and longitude (122) as a device for seeing South Africa anew. But it didn't work. As a start I went to 14 of these points and many of them were FASes (Fuck All Situations). I found myself trying to 'create' photographs, which is what I'd had to do lot of the time in my professional work, so I decided simply to drive around the country and explore whatever took my interest, which is what I've been doing for the past few years.

'I decided that I really didn't just want to photograph people. I felt I'd like to look at some aspect of South Africa that related to things that have happened politically and economically in this country. And so the idea came to look at municipal officials. I photographed them on a large format camera, knowing that the long exposures would demand a kind of stillness that I find most telling in portraits.'

2002

David Goldblatt Fifty-One Years exhibited at Museu d'Art Contemporani de Barcelona; Witte de With, Rotterdam and Centro Cultural de Belem-Fundacao, Lisbon
Exhibited as part of *Documenta 11*, Kassel, Germany

2003

Publication of *Particulars*, Goodman Gallery Editions, Johannesburg, [Awarded the Arles Book Prize for 2004]
David Goldblatt Fifty-One Years exhibited at the Museum of Modern Art, Oxford; the Palais de Beaux Arts, Brussels and Lenbachhaus, Munich
Exhibited as part of *Africa Remix*, Museum Kunst Palast, Duesseldorf

'I'm always concerned with the particulars – that moment, that dog, that pole. Not with a universal dog, not a platonic dog, not a universal pole. Not even with the concept of a dog pissing on a pole. It's that dog doing it at that moment that I'm concerned with. It's the immediacy that really grabs me.'

2004

Exhibited as part of *History, Memory, Society*, with Henri Cartier Bresson and Lee Friedlander, Tate Modern, London
The French National Art Collection acquires some 54 prints

2005

Publication of *Intersections*, Prestel, Munich
Exhibited at Museum Kunst Palast, Dusseldorf
Exhibited at the Johannesburg Art Gallery
Exhibited as part of *Faces in the Crowd*, Whitechapel, London
South African Broadcasting Corporation screened a 48-minute documentary by Greg Marinovich, *Conversations with Goldblatt*

'Art has, very largely, taken over what was regarded as reportage and there is an uncomfortable ground in the middle somewhere. I confess that I sometimes find myself in conflict over this very question. For years and years, I wouldn't begin to associate what I did with the art world. If people wanted to buy my prints, I discouraged them. I didn't ever want to say to myself: "That's a picture I could sell." I want to take photographs because of the thing itself – because the fact that it exists excites me, makes me itch. It's a sexual thing partly. Partly intellectual and emotional. And if I begin to think in terms of an editor or an art market, that vague concept out there, then that changes the imperative. I'm very wary of this.

'Photography is the flavour of the era. Let's not speak of the month. It's an era. It'll probably last five or ten years and then it will be something else.'

Goldblatt and the Isuzu 4x4 camper with which he travels South Africa. [Photograph by Francois Smit]

2006

Announced as the winner of the 2006 Hasselblad Photography Award

'I'm now 75.
'I don't need a holiday. My work is a holiday. I regard myself as being very, very fortunate. There are not many men that have had the opportunity of a second choice when they're already supposedly mature, which I did have when I was 32. There are notmany men who are really happy in their work and I am.'

BIBLIOGRAPHY

books and articles by david goldblatt (selected)

Goldblatt, David, and Nadine Gordimer, *On the Mines*, Struik, Cape Town, 1973.

Goldblatt, David, *Some Afrikaners Photographed*, Murray Crawford, Johannesburg, 1975.

Goldblatt, David, "Soweto and Hillbrow", in: *Exile* (CAN), 1976.

Goldblatt, David, and Margaret Courtney-Clark, with a text by John Kench, *Cape Dutch Homesteads*, Struik, Cape Town, 1981.

Goldblatt, David, *In Boksburg*, The Gallery Press, Cape Town, 1982.

Goldblatt, David, and Nadine Gordimer, *Lifetimes: Under Apartheid*, Knopf, New York, 1986.

Goldblatt, David, and Nadine Gordimer, "David Goldblatt: Home Land", in: *Aperture* (US), No. 108, Fall 1987.

Goldblatt, David, *The Transported of KwaNdebele: A South African Odyssey*, with texts by Brenda Goldblatt and Phillip Van Niekerk, Aperture and Duke, New York, 1989.

Goldblatt, David, "The Structure of Things Here", in: *Camera Austria* (AU), No. 46, 1994.

Goldblatt, David, "The Human Spirit and the Photograph: On Photographing the Invisible Subject", in: *This Critical Mirror*, Stichting World Press Photo Foundation, Amsterdam, 1995.

Goldblatt, David, "A South African Archive", in: *Camera Austria* (AU), No. 51/52, 1995.

Goldblatt, David, *South Africa: The Structure of Things Then*, with an essay by Neville Dubow, Oxford University Press, Cape Town, and Monacelli Press, New York, 1998.

Goldblatt, David, *Particulars*, Goodman Gallery Editions, Johannesburg, 2003

Goldblatt, David, "Michelle Sank", in *Next Level*, London, Edition 2, Volume 2, 2003

Goldblatt, David, *Intersections*, with an interview by Mark Haworth-Booth and essays by Michael Stevenson and Christoph Danelzik-Brueggemann, Prestel, Munich, 2005

books and articles on david goldblatt (selected)

Nicolas-Fanourakis, Dimitri, "A Radical Observation: Some Afrikaners Photographed", in: *Snarl: A Critical Review of the Arts* (SA), February 1976.

Osman, Colin, and Peter Turner (Ed.), *David Goldblatt, Creative Camera International Year Book 1977*, Coo Press, London, 1977.

Ozinski, Joyce, "Anatomy of a City", in: *Rand Daily Mail* (SA), Johannesburg, May, 7, 1981.

David Goldblatt: Thirty-five Years of Photographs, exhibition catalogue, with an introduction by Lionel Abrahams, South African National Gallery, Cape Town, 1983.

Patterson, Moira, "Totems of the White Tribe", in: *The Observer Magazine* (GB), London, April, 6, 1986.

David Goldblatt: South Africa, exhibition catalogue, The Photographers' Gallery, London, 1986.

Sorrell, Jennifer, "David Goldblatt: Less is More", in: *ADA* (SA), 1st and 2nd Quarters, 1990.

"Joyce Ozinski interviews David Goldblatt", in: *ADA* (SA), 1st and 2nd Quarters, 1990.

Watson, Steven, "A Version of Melancholy", in: *ADA* (SA), 1st and 2nd Quarters, 1990.

"Le regard témoin", in: *Constuire* (SW), Zurich, February, 28, 1990.

Oliphant, Walter, Andries, "The Photographic Moment and the Ethics of Representation", in: *Full Frame in Vrye Weekblad* (SA), No. 13, December/January 1991/92.

Gaule, Sally, Ann, "Photographs of Walker Evans and David Goldblatt: Seeing Through Different Prisms", in: *de arte* (SA), September 1996.

Bleach, Gordon, "Between the Fine Print and a Hard Place: David Goldblatt's South African Artifacts", in: *NKA: Journal of Contemporary African Art* (US), No. 9, Fall/Winter 1998.

Rosenblatt, Nina, "Sociology of the Object", in: *Archis* (NL), No. 12, 1998.

Lawson, Lesley, "David Goldblatt's Johannesburg", in: *Rhizomes of Memory: tre sorafrikanske fotografer*, exhibition catalogue, Henie Onstad Kunstsenter, Oslo, 2000.

Sassen, Robyn, "Structures Piled upon Structures", in: *H-Net Book Review* (h-safrica@h-net.msu.edu), February 2000.

David Goldblatt 55, with an essay by Lesley Lawson, Phaidon, London, 2001.

Fifty-one Years, David Goldblatt, with an interview with Okwui Enwezor and essays by Corinne Diserens, J M Coetzee, Ivan Vladislavic, Michael Godby, Chris Killip and Nadine Gordimer, Actar-Macba, Barcelona, 2001.

Laetitia Pople, "Kartograaf van social magte", in *Beeld*, Johannesburg, 25 May 2002

Wayne Ford, "Half Century", in *Image*, London, March 2003

Mark Durden, "Small Signs of Affection", in *Source*, Belfast, Spring 2003

Anthony Downey, "David Goldblatt 'Fifty-one years'", in *Third Text*, London(?) Summer/Autumn 2003

Tim Adams, "Apartheid in close-up", in *The Observer,* London, 2 February 2003

Ingeborg Ruthe, "der scheue Augenzeuge", in *Feuilleton, Berliner Zeitung,* Berlin, 20 August 2003

Brita Sachs, "Die Sporen des Schimmelpilzes", in *Frankfurter Allgemeine Zeitung*, 20 September 2003

Morgan Falconer, "Interview", in *Contemporary no 50,* London, 2003

Jan-Erik Lundström, "David Goldblatt: Fifty-one years", in *European Photography*, Berlin, Summer 2004

Claire Guillot, "David Goldblatt, du noir et blanc à la couleur", in *Le Monde,* Paris, 28 December 2004

Freddy Langer, "Kreuzwege im neuen Südafrika", in *Franfurter Allgemeine Zeitung*, 14 July 2005

Magdalena Kröner, "David Goldblatt. Intersections", in *Kunstforum,* Düsseldorf, September-October 2005

Bram Vermeulen, "Met de rug naar het drama", in *NRC Handelsblad*, Amsterdam, 2 September 2005

Steffen Lehmann, "Ein minimalistischer Alltagschronist", in *Leipzig-Almanach*, Leipzig, 21 August 2005

Michael Godby, David Goldblatt, Michael Macgarry, "The Search for Middle C", in *Art Southafrica,* Spring 2005

general bibliography (selected)

James, Ian (Ed.), *David Goldblatt, Photography Year Book 1966*, Fountain Press, London, 1966.

Nichts wird uns trennen: Südafrikanische Fotografen und Dichter, Benteli Verlag, Bern, 1983.

Badsha, Omar (Ed.), *South Africa: The Cordoned Heart, Twenty South African Photographers*, The Gallery Press, Cape Town, 1986.

Bunn, David, and Jane Taylor (Eds.), *From South Africa: New Writing, Photographs and Art*, University of Chicago Press, Chicago, 1987.

Gaulle, Sally, Ann, *A Comparison of Approaches to Documentary Photography of 1930s America and Contemporary South Africa*, M.A. Thesis, Wits University, Johannesburg, 1992.

Ergens: Thuis/Home, exhibition catalogue, Stichting Fotografie Noorderlicht, Groningen, 1993.

Black Looks: White Myths, exhibition catalogue, Johannesburg Biennale, 1995.

In/sight: African Photographers, 1940 to the Present, exhibition catalogue, The Solomon R. Guggenheim Museum, New York, 1996.

Home, exhibition catalogue, Art Gallery of Western Australia, Perth, 1996.

Blank_Architecture, Apartheid and after, exhibition catalogue, Netherlands Architecture Institute, Rotterdam, 1998, traveling exhibition, Haus der Kulturen der Welt, Berlin, 1999, Museum Africa, Johannesburg, 2000.

Walker Evans & Company, curated by Peter Galassi, exhibition catalogue, with an essay by Peter Galassi, The Museum of Modern Art, New York, 2000.

Eye-Africa: Revue Noir, exhibition catalogue, South African National Gallery, Cape Town, 2000, traveling exhibition, Europe, and the US, 2001.

The Short Century: Independence and Liberation Movements in Africa 1945-1994, curated by Okwui Enwezor, exhibition catalogue, Prestel, Munich, 2001.

Rory Bester, "Goldblatt, Magubane, Ruselo & Schadeberg" in *Art Southafrica,* Cape Town, summer 2005

acknowledgements

Thanks to Francois Hebél, Raymond Depardon, Florence Maile and Roberto Koch for recognising the importance of Goldblatt's work and bringing this to the Arles festival in 2006, to launch this exhibition and book. Finally my thanks to David Goldblatt, his integrity, stamina and vision are rare in this globalised world. It demonstrates that an individual voice still has the power to inform and inspire.

Martin Parr

I would like to thank very much David Goldblatt for his extraordinary talent and creativity and continuous support during the making of the book. Working with David has been a wonderful experience.
Many thanks go as well Martin Parr who kindly approached me with this great body of work.
Thanks to Rory Bester, Lionel Abrahams and Alex Dodd, for their invaluable contribution depicting the life and the career of David Goldblatt and Francois Smit for beautifully designing the book.
Our thanks also go to:
Linda Givon and the staff of the Goodman Gallery, Johannesburg
Krings_Ernst Gallery, Cologne.

Roberto Koch

Printed in Italy